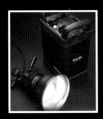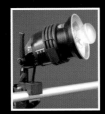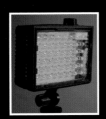

PHOTOGRAPHIC
LIGHTING EQUIPMENT

A Comprehensive Guide for Digital Photographers

Kirk Tuck

AMHERST MEDIA, INC. ■ BUFFALO, NY

Published by:
Amherst Media, Inc.
P.O. Box 586
Buffalo, N.Y. 14226
Fax: 716-874-4508
www.AmherstMedia.com

Publisher: Craig Alesse
Senior Editor/Production Manager: Michelle Perkins
Assistant Editor: Barbara A. Lynch-Johnt
Editorial assistance provided by John S. Loder and Sally Jarzab.

ISBN-13: 978-1-58428-993-7
Library of Congress Control Number: 2009911197

Printed in Korea.
10 9 8 7 6 5 4 3 2 1

CONTENTS

ABOUT THE AUTHOR

Kirk Tuck is a corporate advertising photographer working in Austin, TX. His recent clients have included IBM, AMD, Dell, Freescale Semiconductor, Cerilliant Systems, Time Warner, Texas Gas Services, *Tribeza* magazine, *SC* magazine, Motorola, Salient Systems, and many others. Before diving into photography, Tuck was a creative director for a regional advertising agency where he won numerous industry awards for writing, television commercials, and print advertising. A former specialist lecturer at the University of Texas at Austin, College of Fine Arts, he currently serves on the advisory board for the Austin Community College photo department. Tuck teaches lighting and photography classes across the country.

Kirk Tuck is the author of *Minimalist Lighting: Professional Techniques for Location Photography, Minimalist Lighting: Professional Techniques for Studio Photography,* and, most recently, *The Commercial Photography Handbook.* He was also the photographer for the bestselling cookbook, *Creative Mexican Cooking,* by Anne Lindsay Greer.

Tuck writes extensively on the subject of commercial photography at www.visualsciencelab.blogspot.com.

When he is not writing books or blogs or photographing, you can find him in the Rollingwood Pool with the competitive swimmers on the Weiss and Weiss Aquatics Masters Team.

Acknowledgments. No book I've written comes together without the help and support of family and friends. I'd like to say that my son, Ben, is a constant source of wisdom and rational thought. He is like a Buddha, teaching me patience and focus. The following friends are a constant source of encouragement and are good "reality checkers": Mike Hicks, Paul Bardagjy, Greg Barton, Steve Benasso, Steve Matthews, Anne Butler, Jerry Sullivan, and David Rubin The crew at Precision Camera indulges me like a spoiled child. The whole masters team at Weiss and Weiss aquatics keeps me disciplined and happy.

Most of all, I would like to express my awe and wonder for my lifelong muse, Belinda. She is as constant as the North Star, unimaginably kind and compassionate, and possessed of more grace and beauty than I ever thought possible in one human being. I also want to acknowledge you, the gentle reader. Without you, these books would have no purpose.

INTRODUCTION

If you boil photography down to its essence, it's all about the interplay of visual content and light. Most photographers use the light they find when they come across a scene or a person or an object that they want to photograph, but there is a separate breed of photographers who crave control over the images they create. We're not above using available light if it works, but we're equally ready to jump in and give nature a hand with a toolbox full of lighting devices, chosen to add a little extra texture or sparkle to a photograph. If you are like me, you just feel more comfortable knowing that, with a well-placed light, you can reduce a lighting ratio for better reproduction, reduce the texture of the skin on a woman's face, or create a lighting design that will give your work its own unmistakable signature.

Above—When it comes right down to it, we spend a lot of time and money on lighting equipment that is largely used to emulate the light we see every day in the real world. In this image of Heidi, I used a studio electronic flash softened by a very large, white umbrella. It reminds me of the light that sometimes streams through my windows.

While there are many books in the marketplace that offer you instruction in lighting, there are few, if any, that help you navigate through the vast array of gear available. There are fewer still that will help chart a course in putting together your personal arsenal of lighting equipment. This book attempts to cover every kind of light, from flashlights to the top-of-the-line studio electronic flashes, with suggestions for their

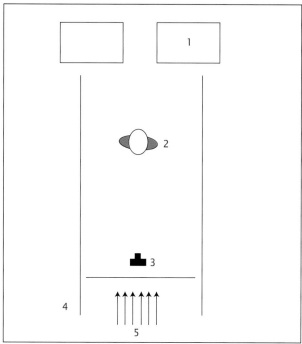

Photo—Sometimes we just need to modify the sun a bit to get the lighting that's right for the subject. This shot was lit by a hazy afternoon sun that was too contrasty to use directly. All it took was one 4x4-foot piece of cloth, held in the right place, to master the sunlight and make a flattering image. **Diagram**—(1) Building downtown, $1/8$ mile away. (2) Subject. (3) 300mm lens on a Nikon D700. (4) 4x4-foot white diffusion material on a Chimera metal frame, placed on a light stand. (5) Hazy mid-afternoon sunlight.

most practical use. It also covers the "supporting cast" of equipment such as light stands, battery/inverter packs, light meters, backgrounds, and more.

My goal is to help you make intelligent decisions when choosing and using the most appropriate gear for your projects, your style, and your budget. You might never need the incredible precision of a Swiss-made Broncolor studio flash, but it's good to know why they exist, what they are used for, and perhaps ultimately why you don't need one.

No matter what category of light you choose, you'll find that selecting a high-quality model from a reputable manufacturer may be a bit more expensive up front but will probably give you more reliable service in the long run. You'll also find that, in the case of studio lighting, the quality and availability of accessories is at least as important as the specifications of the core products.

In the past, I would have said that lights are "camera neutral," meaning that the lights work the same way no matter which format camera you use. That was true in the film days, but now the realities have changed. Digital cameras have shifted the playing field by delivering higher and higher ISOs with better and better quality. That means you'll need less power to deliver the same quality. Ubiquitous Photoshop postproduction has reduced the need for studio lights to be designed to deliver exactly the same amount and color of light with each pop. In the days of film, the tighter voltage regulation and the higher quality of the electronic pathway meant less variability in exposure. And in color slide film what you shot was what you got.

Even though Profoto (the professional standard for studio electronic flash, worldwide) has recently delivered a flash system to the market that claims to be accurately repeatable within a $1/20$ stop, the reality is that

the difference between ⅓ stop is the base level of our ability to discern change, and smaller variations are easily fixed in postproduction. The level of precision you need will depend on how you use your lights and what sort of subject matter you photograph. But in most cases, the relentless move to digital mitigates the need for much expensive engineering in your lights.

Most of us start our journey into photography as available light amateurs and move progressively to battery-operated flashes and then to studio flashes. Those of us who decide to pursue photography as a business move on to more and more expensive flash equipment. It's largely a matter of being able to achieve competence in the field you choose, with the right tools. Where you end up will depend on the subject matter you like to photograph and the style in which you like to photograph it. If you are committed to large format film cameras and large, soft light sources, you'll migrate toward powerful studio units but you'll be able to save a bit of money because recycle time will be less an issue to you. If you decide to make a living photographing weddings, you'll be able to achieve most of your lighting goals with a small, efficient trio of battery-operated flashes. As you'll discover, the sky is the limit, but your competence in using the lights is part of the equation.

So, let's get started and figure out where you need to be to make the images you love.

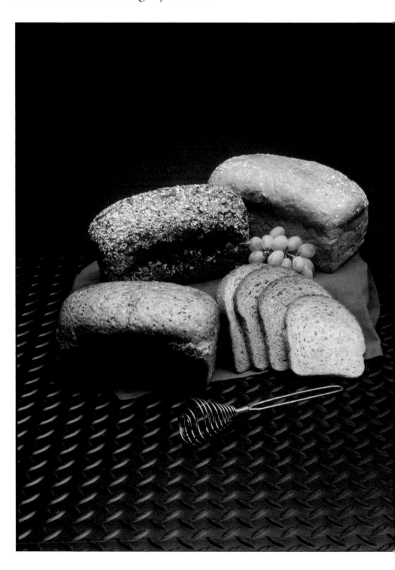

Photo—Lights and lighting tools are the bread and butter of photography. When you understand how light works, it informs and improves every shot you make. **Diagram**—(1) Black seamless paper. (2) 40x50-inch softbox with 2000 watt-second strobe, 3 feet above subjects. (3) Electronic flash head with standard reflector. Blue gel over the top of a 40-degree spot grid. (4) Bread and grapes on black deck plate surface. (5) Small white foam core fill card. (6) Medium format camera with 150mm lens. ISO 64, f/22.

1. THE EVOLUTION OF PHOTOGRAPHIC LIGHTING

Photography predates electric lighting. Think about that for a minute. Early photographers never had the option of plugging in a lamp and shooting after dark. It sure made for a shorter work day, but it made life tough for photographers to get results under any but the most optimal circumstances. Early films were so slow that they required exposures of up to a minute in full sunlight. Companies soon marketed chairs with neck braces attached so that photographers could try to make sure their clients didn't move during the long exposures. Many hand-coated film plates were ruined

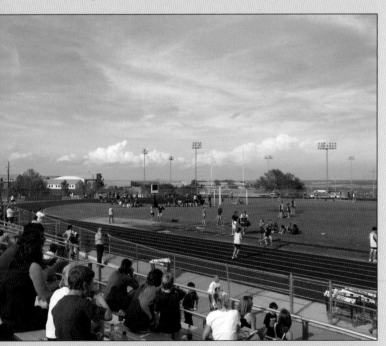

Above—A kids' track meet. Late-afternoon sky. The sun was modified by clouds low on the horizon, yielding beautiful light and just the right color temperature. I think most lit photographs are an attempt to emulate what we see all the time in nature. Cameras just need more help than our eyes.

by unavoidable blinks and even body movements caused by breathing!

FLASH POWDER

Photographers developed two strategies for dealing with the lack of light. They found ways to cope with long exposures and looked to artificial light sources. One early light source was called "flash powder." It was made of granulated potassium permanganate or ammonium nitrate and finely ground magnesium. It seems that most early photographers developed their own mixture, but one thing was true in every case: the mixture was extremely flammable, could be explosive, and the brighter it burned the more smoke it gave off.

Here's the way photographers (brave souls) used flash powder: First they would have to test the mixture, the distance from the subject to the flash powder, and the particular batch of hand-coated film they intended to use. Once they got a good idea of the right exposure based on their tests, they could move on to real subjects. All the cameras of the era were basically view cameras, so the photographer would evaluate the scene through the lens onto the dark, ground glass of the camera, focusing and composing on a very dim image. He would then close the shutter, stop down the aperture of the camera to his "pre-tested" f-stop, and put in a film plate. He would then pull the dark slide so that the film was open to the lens.

At this point, the photographer (or his unlucky assistant) would measure out a very exact portion of flash powder onto an elevated platform. When everything was set, the photographer and his assistant did a

Left—Once you master the basic lighting concepts, you'll be able to light quickly and spend the bulk of your energy building rapport with your subject. Rob Williams for Zachary Scott Theater. **Right**—Emotion in a shot trumps technical perfection. Doing both well makes your work good. Espy for Zachary Scott Theater.

precise little dance. As the photographer opened the shutter (generally a time exposure), the assistant would strike a flint or sparking device that would set off the flash powder. If everyone was lucky, all the people in the room would be blinded for a few moments by the flash. If they were unlucky, someone would be rushing to find water buckets with which to extinguish the fire.

The flash wasn't the quick $\frac{1}{1000}$ second that we've come to expect from modern electronic flashes. It had a burn time that, depending on the consistency of the powder, could last for up to a full second. But the purpose of these flashes was purely raw illumination. Early photographers didn't have the luxury of flashes that would freeze motion entirely. In fact, the 19th-century shutters were not even synchronized!

Pity the photographer doing early flash photography, as he usually only got to make one shot. No one wanted to wait around for a second experience after the uncomfortable brightness and a room full of acrid smoke.

PHOTO FLOODS

But things got better. Edison got to work on electricity and lightbulbs, and in just a few decades the movie industry got their hands on big, fat, high-output lights that, when coupled with advances in the speed of film, were able to be used reliably in most situations. The first large bulbs were called "photo floods," and if you shop carefully, you may still be able to find them for sale today. A cottage industry soon grew up, designing and making reflectors and holders for the lights. They were hot, did not last long (six to eight hours, at best), and weren't nearly as powerful as the newer generations of continuous lights coming onto the market.

Movie studios needed lights that were bright enough to fill in or compete with sunlight in order to tone down the high contrast of early movie film stock

and soon figured out how to put carbon arc lights into artistic service. With technology "perfected" in the last quarter of the 19th century, inventors had figured out that if one applied current to two carbon electrodes in close contact, they would spark. If enough current was supplied and the electrodes were moved away from each other, creating an arc, the ionization and heat would create an incandescence that would give off a tremendous amount of light. Here's the catch: the carbon rods used as electrodes burned down during the process, and this affected the distance of the gap. Many methods were invented to keep the gap in stasis, including solenoid motors that were actually controlled by the rising and falling resistance of the electrodes as they got closer or farther away from each other. No wonder well-trained crews were needed to make the lighting on early projects.

Fortunately, film kept evolving quickly and photographers settled on a range of high-quality photo floods with a myriad of well-designed socket and reflector fixtures for decades. While photography continued to evolve, the next revolution in lighting had to wait until around 1930. It was the introduction of the flashbulb.

FLASHBULBS

Flashbulbs were a convenient adaptation of flash powder made reliable and (relatively) safe. Most were made of thin, spun wires of magnesium, coated with a highly flammable primer and totally enclosed in a glass bulb. Flashbulbs came in many different sizes, depending on how much power a photographer needed and what sort of burn time could be tolerated. With faster films and reliable flash, the only remaining necessity was the ability to synchronize the time of the flash with the travel of the camera's shutter. Within a few years of the flashbulb's widespread adaptation, most cameras came equipped with synchronizing shutters. When the shutter hit the position where it was fully open, it would trigger a circuit that ignited the flashbulb.

A cool variation of the simple synchronization was focal plane (FP) flash sync. In some ways, the introduction of FP flashbulbs was an attempt to make lemonade out of lemons. Flashbulbs took a certain amount of time to ignite and start burning. The ramp up time was quick but not as fast as the flash from today's electronic flashes. The longer burning time of some flashbulbs meant that they could start burning and continue emitting steady light through shorter shutter speeds than the fastest shutter speed needed to hit full sync. In early focal plane shutter cameras, the sync speed (the shutter speed at which both shutter curtains fully expose the film to light) was around $\frac{1}{50}$ second. With an instantaneous flash, any faster shutter speed would only expose a part of the frame at a time. That caused a dark band on part of the film where no light struck. The faster exposure meant that less and less real estate on film was exposed by flash.

Camera makers and flashbulb manufacturers used the long burn time of FP bulbs to their advantage. If they started the triggering process of the flashbulb before the shutter started to open, it would reach its optimum brightness as the shutter started to travel. If the sustained burn time was long enough, the flash would continue to burn during the entire time the shutter traveled, thereby exposing the entire frame of film evenly with the flash's light. While it didn't do a good job freezing action, the FP bulb was a great solution for proper illumination as well as early fill flash. In fact, this method is similar to that used by Canon and Nikon's modern flashes when set to FP TTL.

Other flashbulbs gave quicker flash durations with quicker ramp up times and quicker decay times. They were used on focal plane cameras extensively but were optimally used on leaf shutter cameras, which can efficiently synchronize at all shutter speeds (the shutter opens to expose the entire frame at every speed).

For the first time, flashbulb technology made instantaneous exposures on location, in any lighting condition, possible for photographers at every level of proficiency. Bulbs were generally matched to reflectors, and "guide numbers" were given for the combinations. Photographers didn't have access to flash meters or any sort of flash control, so they were required to take the guide numbers and translate them into the right f-stop for a given distance and film sensitivity rating. It made several generations of photog-

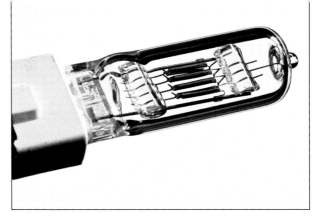

raphers quick at simple math. And it was important to get it right routinely because each flashbulb was a "one time use" light source. Once the bulb burned up its fuel it was discarded and a new one was plugged in. So much for the idea of "motor driving" one's way through a photo shoot.

Flashbulbs were very cool in that they moved photography out of the studios and into real-life situations like nightclubs, homes, and social events. As cool as they were, they were also quite hot. Many a finger, shag carpet, or fine piece of upholstery was burned or singed by the heat of a newly discarded flashbulb.

TUNGSTEN-HALOGEN BULBS

But continuous lighting didn't stand still. Lightbulb manufacturers went to work on two of the weak points of lightbulbs: they burned out too quickly and, as they burned out, they deposited carbon residue on the inside glass walls of the bulb, causing the color temperature to get lower and lower as the bulb was used up. The science guys realized that they could use a tungsten filament inside a quartz envelope, filled with halogen gas. The bulbs could burn hotter than conventional bulbs, and that was a benefit because the high temperature, in combination with the halogen gas, would keep residue off the sides of the glass envelope and continually redeposit the residue onto the filament. The result was bulbs that burned longer (the filament didn't deteriorate as quickly), burned at a constant color temperature (no residue on the envelope walls), and, an added bonus, they could be made in smaller packages than traditional incandescents.

The new bulbs were great for movie makers who needed consistent light output and color. And anything that was good for movie film was also good for still photographs. In fact, many of the film emulsions were identical in the two industries. This kept prices down for both camps.

A FLASH OF BRILLIANCE

In the meantime, a brilliant scientist at MIT, Dr. H. E. Edgerton, was working on a little project that would revolutionize the world of lighting. He learned

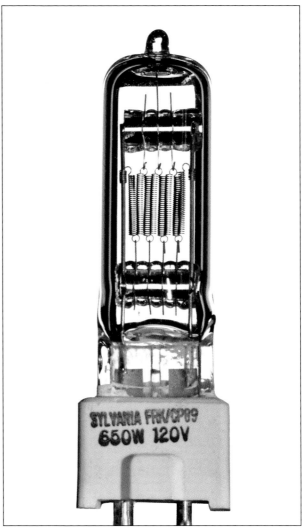

Above—One small tungsten-halogen bulb can generate a lot of light and an even greater amount of heat. Nearly 90 percent of its spectral radiation is in the infrared band. You can certainly understand why they call these "hot lights."

that by using a glass tube filled with xenon gas he could create a powerful and short flash of light that was repeatable. He placed electrodes at either end of a tube filled with the gas and applied a current to the tube to make the gas receptive to ionization. In that

Top—Tungsten-halogen bulbs burn at 3200 degrees Kelvin (K). Because of their construction, they hold that same color temperature over most of their working lives. This lamp is rated at 650 watts and is very popular in fresnel spot fixtures. **Bottom**—Rob from the *Flaming Idiots* photographed for the Zachary Scott Theater 2009–2010 season brochures. I still use hot lights instead of flash when I want absolute control over depth of field. Also, the introduction of the potential for movement seems to make the images shot with hot lights more dimensional.

state, when a high-voltage charge was introduced to the electrodes, the gas would create a temporary arc that gave off photons. His interest was in using a high-speed series of flashes to show the movement of objects. We now refer to this technique as "stroboscopic" flash. Regardless of his intentions, his invention of the electronic flash changed photography forever.

It is worth noting that he was able to produce repeatable flashes with a total duration of approximately $\frac{1}{1,000,000}$ second, capable of freezing just about any motion. His inventions were used to show the exact wing positions of hummingbirds in flight and the moment of detonation of an atom bomb.

All early electronic flashes required the use of A/C power, so a wall socket was a prerequisite for operation. In essence, the electronic flash worked like this: it took alternating current from a constant electrical source and used a diode rectifier array to convert the A/C current to D/C. The direct current was fed into a transformer, which increased the voltage. The output of the transformer was stored in large capacitors (the chemical equivalent of a battery). When the shutter of the camera triggered the flash circuits, the total charge from the capacitor was sent to the two electrodes, causing the xenon gas to arc in the sealed tube. This is still the basis, with a number of refinements, upon which modern flashes of all kinds are based.

By the end of the 1950s, companies like Honeywell were coming to market with battery-operated flash units that are the ancestors of today's Nikon SB-900s, Canon 530s, and hundreds of other units from a dozen or more manufacturers. The first generation of battery-powered flashes relied on heavy, high-voltage battery packs. They were often called "potato mashers" because they had a large handle with a flash head

on top. Inverted, they resembled potato mashers. These units were totally manual, with one power setting and no automatic features, but they were powerful, reliable, and much more fun to use than the flashbulbs they began to replace.

As handheld flashes continued to improve, photographers got more and more features. In the mid 1960s, camera manufacturers started making the accessory shoes atop cameras "hot," meaning that via a center connection the shoe could now trigger a flash. The introduction of this feature opened the doors to the flash design now used by everyone—a flash that sits atop the camera and is triggered by a hot shoe connection.

A new feature appeared on heavy-duty Honeywell Strobonars, Norman, and Lumidyne professional flashes: the ability to change the power setting of the flash. This gave photographers more flexibility in choosing apertures when shooting with flash. While this provided an added measure of shooting flexibility, it was no less demanding on batteries.

The next revolution was the introduction of what Vivitar called "thyristor" flash. In this widely adopted system, an electric eye could monitor the actual exposure (much like a light meter in a camera) and quench the flash burst when the proper exposure was achieved. Whatever energy was left in the capacitors was saved. This increased battery life and reduced recycle times. This system is still in use in all the "automatic" flashes that do not include a TTL (through-the-lens) metering system.

Other improvements over the decades have included articulated heads that can be aimed at ceilings for bounce lighting, flashes that use the in-camera meter to control the flash exposure (thank you, Olympus!) and, recently, infrared pulse code control of multiple flashes from one on-camera controller. The market for battery-operated, on-camera flashes is so much larger a segment than bigger flashes built for studio work that most innovations occur here first. Studio flash manufacturers from Broncolor and Profoto to AlienBees and White Lightning have attempted to make their flashes more accurately repeatable, more color consistent, and hardy enough to be flashed

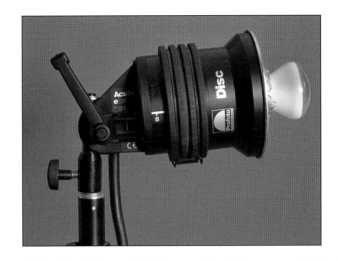

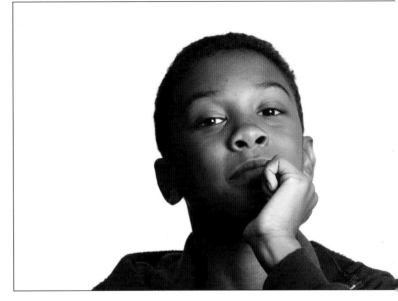

Top—The standard Profoto flash head, used in conjunction with that company's power packs, is something of an industry standard. This is the basic configuration with a small umbrella reflector. More expensive heads have more powerful monolights and fan cooling. **Bottom**—Portrait for the Austin Kipp School Annual Report. One large soft umbrella was placed to camera left and one softbox was aimed at the white background. Sony R1 camera.

hundreds of times in a row without shutting down or overheating.

The vast majority of photographers now depend almost exclusively on electronic flash as their primary lighting tool. That doesn't mean it's the only way to go. There are still many reasons to resort to other solutions for special cases. And the biggest "special case" could just be that the quality of the light matches the vision you want for your images!

FLUORESCENT LIGHTS: A DIFFERENT KIND OF "FLICKER"

While the vast majority of photographers seem to have a herd mentality, you might really enjoy some of the less widely embraced lighting solutions on the market. For the last twenty years, fluorescent lights have gotten a lot of buzz. These are not the whining, flickering green monster tubes you might remember from your childhood but electronic ballasted, color correct light

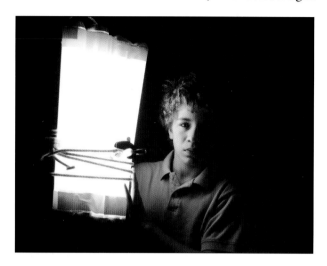

Top—There are a lot of fluorescent fixtures on the market, but if you have the time and inclination you can build your own assemblages that work well with digital cameras. No matter what tubes you end up using, I'd recommend you do a custom white balance and stay away from mixed light sources. When I white balance for Ben's face, look how the daylight from the window treats our gray seamless in the background. **Bottom**—The fun thing about visiting my favorite rental house is to see how they use some of the "grip" gear to make life better in little ways. (Grips are the movie crew members who handle the lights.) For instance, the person who sits under this fluorescent fixture in the front office hated the green cast of the overhead fluorescent and set up a Century stand with a grip arm to hold a diffusion scrim up under the light. She added a peach-colored filter to cancel out the green cast. Voilà, better lighting for greater happiness.

tubes that emit a lot of light for a little electricity. Like most aspects of lighting there was a good reason why these lights were originally pressed into service by photographers, but most people have forgotten why they enjoyed two decades of renewed popularity.

In the early days of professional digital cameras, the first solutions that made sense were digital scanning backs that were used in place of film holders in 4x5-inch view cameras and some medium format cameras. These cameras pieced together a very nice, high-res image working in a way that is very similar to a desktop scanner. A line of sensors moves over the film plane during a long exposure and records the information in the scene. Here's the rub: if you wanted a color photo, the scan had to happen three times in a row—one time for the red, green, and blue channels. Exposures were measured in minutes, so it was vital that the illumination be both continuous and consistent. At first, still life photographers (no moving pictures with these early cameras) tried using tungsten lights, but the heat given off was uncomfortable and could wilt or damage the products or objects being photographed.

Fluorescents with tight voltage control quickly became the lighting source of choice. And these scanning backs are still available, as they offer very high resolution at a much lower cost than their single-shot counterparts. Since the trendiest and most elite photographers were the first to adapt the fluorescents to studio lighting, they naturally attracted a throng of photographers who saw the light source as the "magic wand" of imaging but seemed to turn a blind eye to the skill of the practitioner.

There is a big performance gap between the high-output, precision fluorescent lights used by big studios and the smaller units made up of compact lamps. The biggest difference is in color correction and output. Most of the units aimed at the hobbyist market are much less powerful than the professional versions. The trade-off is an enormous difference in price.

LIGHT-EMITTING DIODES (LEDs)

Remember science fiction movies from the 1980s? The rows of flickering red and green LEDs were meant to

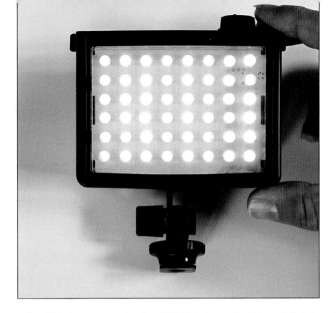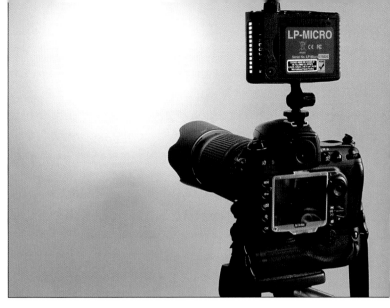

Left—This is an example of an LED lighting unit. Although it is barely 3x4.5 inches, it sells for around $300 (2009 dollars). These units are designed for use on video cameras, but I find one good use is as an "eye light." That's a small light source on the camera axis that brightens the eyes and adds a small catchlight without changing the overall exposure or character of studio lit portraits. This unit is battery operated. Right—With a small, battery-powered LED fixture in the hotshoe of a high ISO capable camera like a Nikon D3 or a Canon 5D Mark 2, a wedding photographer would have an easy time focusing and even capturing action. While the lights are tiny, when used with high ISO settings, they can pack a punch indoors.

convey "high technology" or the kinetic status of powerful, room-sized computers. Recently the technology of solid state lighting has proliferated. You can buy LED flashlights and reading lights and now, you can buy big panels of tightly packed LEDs that serve as light sources for photography. The panels are flat, easy to pack and take on location, and by dint of their ample surface area, the light source can be as soft as a traditional softbox. Sounds like we'd all want these, right?

Well, maybe, but I'm not sure you want to be an early adopter, and here's why: LEDs have the benefit of being tuned to very specific color temperatures, but they are not "full spectrum" devices, which means that getting a good white balance can be a bit problematic. The lights don't have the output of much less expensive tungsten solutions, and it's hard to get "focused" or "spotted" effects with the current crop of affordable LED lights.

The flip side is that LED lights have 100,000-hour life cycles and are quite energy efficient. This is definitely a category to watch as the intensity of the lights will surely increase while the low noise/high ISO performance of digital cameras gets better as well.

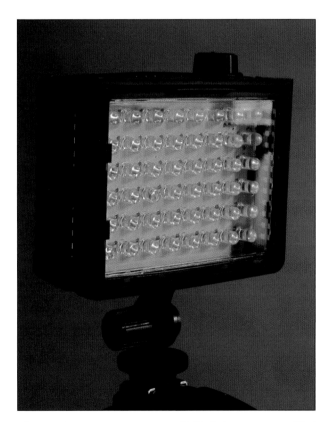

Above—The current generation of LED lights, as exemplified by this micro light from Lite Panels, uses row after row of small, daylight-balanced LEDs to produce a cool, constant light source with a working life of up to 100,000 hours. Although the light source is small, these units are interesting. LCDs were developed first for video, but photographers who are crossing over between the two disciplines seem to love them. They are lightweight, efficient, and relatively well color corrected.

HYDRARGYRUM MEDIUM-ARC IODIDE (HMI) LIGHTS

If you need a really great, continuous, daylight-balanced light source and you have an ample budget, you might want to look into hydrargyrum medium-arc iodide lights (HMIs), the modern adaptation of the arc lights I talked about above. The HMI uses an arc instead of the filaments found in incandescent lights to create light. Since the traditional market for arc lights of all varieties has been the film industry and not the photo hobbyists, the fixtures are built to extremely high standards and are priced accordingly. Figure around $2000 for a basic one-light system with its attendant electronic or magnetic ballast. The required ballast is the part of the system that triggers the arc and then controls it while in use.

Think of them as really high output, daylight-balanced lightbulbs that have to be tethered to a ballast box to work. The replacement bulbs alone can cost $500 and up!

HMIs have two big advantages for people who cannot use electronic flashes: they are daylight balanced and are 2 to 5 times more efficient than tungsten systems. But the problem with any continuous light source is that they are not effective at freezing motion. Finally, directors of photography, the people who design and implement the lighting for movies, think that the quality of the light from HMIs is sweeter and of higher quality than just about any other light source on the market.

There is always a tendency among photographers to think only of electronic flash when considering systems for their business or personal use, but there is an evolution in our industry that started with the Nikon D90 and the Canon 5D Mark II. It is the addition of high-quality video built into both of these very popular cameras. The popularity of YouTube and of millions of web sites that incorporate video lets you know that people are starting to blur the divisions between different art disciplines like video, music, and still photography. If you are equally invested in video and still imaging, it makes good sense to have a lighting system that will satisfy both of your lighting needs. Eliminating the need for a second lighting system saves money and allows both disciplines to coexist on projects that demand both media. Probably the best choice for extensive multimedia and still work would be the HMI. Too bad they are so pricey!

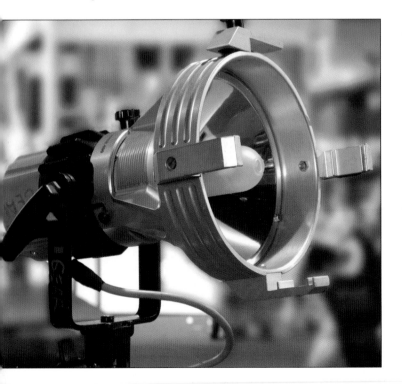

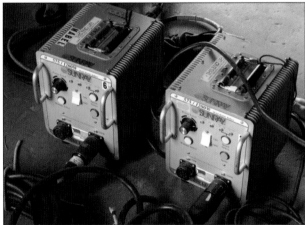

Left—This head is part of an HMI system that outputs 400 watts of daylight-balanced power. The efficiency of HMIs give this unit the same effective output as a 1000-watt fixture. **Right**—These are ballast packs, the second part of every HMI system. Note the enormous surface area of the heat sinks on either side of each unit as well as the robust handles and controls. Units like these are used on movie and television sets around the world and are made to work for many hours each day with total reliability. These parameters are reflected in their initial purchase price.

2. ELECTRONIC FLASH: THE INDUSTRY STANDARD

You are following your passion and becoming a photographer in the most committed sense. You've done photography for years, using the light that nature provided you. Now you want to grab the reins and take control of every facet of lighting for your images. But where to start? Let's look at all the choices available to you in the electronic flash category first.

There are really just two categories of electronic flashes: battery-powered units and those powered by A/C current. In the battery-operated category, the most prevalent units are the plastic flashes that are made to fit in the hot shoe of a camera, use four AA batteries, and have a laundry list of automated features. There are professional units that use battery power, but these are higher-powered units that are configured like studio flash systems with a separate flash head and power pack. They lack any sort of automation.

In the A/C category are self-contained monolights (the flash head and the power-generating electronics are all included in one package). The other variation are studio flashes that consist of a battery pack around the size of a car battery and a separate head at the end

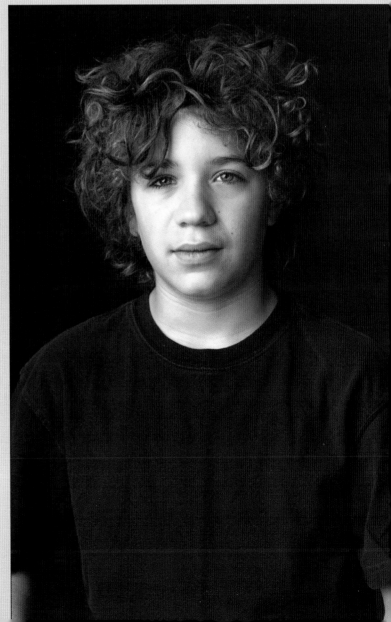

Photo—This portrait of Ben was taken with a Leaf Afi7 camera at ISO 50. One big softbox was placed to the left of the camera. We needed lots of flash power to pump through a big softbox and two layers of diffusion material. **Diagram**—(1) Gray back wall, 14 feet behind subject. (2) Ben Tuck, subject. (3) White wall, 8 feet from subject. The white wall adds fill light. (4) 54x72-inch softbox with two layers of white diffusion material. Powered by one 1200 watt-second flash head. (5) Leaf AFi7 medium format digital camera with 180mm 2.8 Schneider lens. ISO 50.

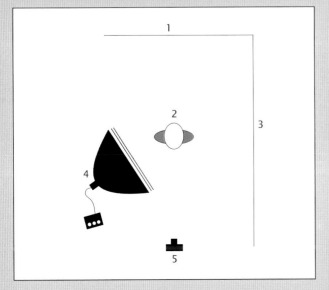

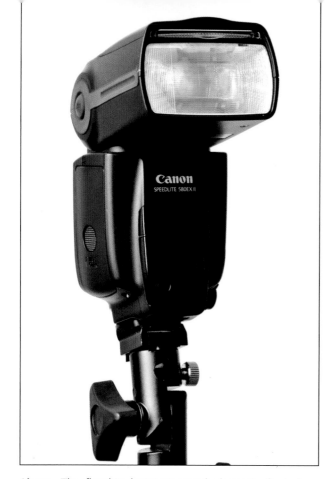

Above—The flagship battery-powered electronic flash from Canon is the 580 EX Mark II. It has every conceivable bell and whistle you'd ever want—from infrared control, to fractional power, to high-speed synchronization capabilities. Every manufacturer has something similar, and they have become the de-facto standard for lighting with digital cameras. (For a more complete treatment of techniques with portable flash, see the book: *Minimalist Lighting: Professional Techniques for Location Photography,* from Amherst Media.)

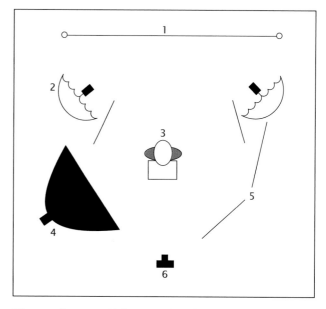

Diagram for page 19 images—(1) White background. (2) Two 300 watt-second monolights shot through 32-inch umbrellas. (3) Subject and box (product). (4) 54x72-inch softbox with a 600 watt-second monolight. (5) 4x8-foot foam core panels. (6) Nikon D300 with 16–85mm lens.

of a 10- or 15-foot cable. The power packs can generally handle and distribute power to two to four separate flash heads. They are unmatched at providing high levels of power and repeatability and are generally built to last for years or decades. But let's start with the most popular category and understand the plusses and minuses of each.

ON-CAMERA FLASH

"On-camera flash" is the generic category for flash units that take two or four AA batteries and have a "hot foot" connector that allows the flash to perch on top of the typical camera's accessory shoe. Vivitar, Metz, Sunpak, and others make wide varieties with different menus of features. All of the major camera companies also sell a line of flashes customized for use on their brand of cameras.

In one regard, these flash units are all the same: batteries send electrical power through a circuit that increases the voltage, the higher voltage power is stored in one or more capacitors and then, when triggered, they all produce light by arcing through a xenon gas filled glass tube. In their strictly manual mode, most of the flashes are interchangeable. (Exceptions are the Sony and Minolta brand flashes, which use a connecting foot that only fits into a proprietary Sony hot shoe.)

At the bottom end of the budget are basic automatic flashes powered by two AA batteries. In the context of small flashes, "automatic" usually means that the flash unit has a sensor on the front somewhere and it will read the exposure and stop putting out light when the sensor reaches a certain threshold. The sensor is preset so that it always looks for a specific quantity of light before quenching the exposure. There is generally a scale or a dial that works like a small mechanical calculator telling you what aperture to set for a given ISO value. These flashes are simple and were designed with color negative film in mind (the

Above—A series of studio shots done for EcoBox. Art director: Greg Barton. These were all shot to be dropped out to white in postproduction. (See the diagram on page 18.)

A model shot for a Time Warner Cable campaign. I used a standard white background setup, with one medium softbox from just to the right of the camera.

inaccuracy of the flash's automatic exposure is nicely balanced by the wide exposure latitude of that family of films).

These flashes generally give you the choice of the automatic flash setting or full manual output, with no settings in between. Another downside of these units is their meager power. You will not be able to use these small flashes effectively with very many modifiers or accessories.

The step up from basic flashes are the units that take four AA batteries, have a range of both manual flash controls and automatic settings, and put out a reasonable amount of flash power. These are a workable solution even if you need to stick them in a small softbox or use them in conjunction with an umbrella. The grandfather of this category is the Vivitar 283 "system" flash, which was one of the first flashes to accept a range of accessories that included a control for reducing flash output over a 4-stop range, a high-voltage battery pack capability, and even a range of modifiers that would fit over the "business end" of the flash to widen the beam of light for use with very wide angle lenses or compact the beam to get good exposures over a greater distance with telephoto lenses.

Most of the flashes in this category are referred to as "cobra" flashes because the flash is built in two parts—the bottom, which holds the electronics, batteries, and controls and the flash head, which houses the flash tube and its reflector. The connection between the two is jointed and, in some cases, rotatable.

In the past, you couldn't expect to do professional work in a wide variety of specialties using only battery-powered lights, but, with the advent of good digital SLR cameras with very usable high ISO capabilities, the battery-operated flashes have become more and more widely accepted.

If you are entering the world of professional photography and plan to do a lot of work on location, battery-operated lights can be an efficient and relatively cost-effective way to get started. If you are looking for great lighting tools, however, you'll want flashes that have high efficiency and fairly high output capabilities. And if you work with them every day, you'll probably want most of the neat features that have become available.

We'll use the Nikon SB-900 as a prime example of this category of highly capable flashes. To start with, the flash can pump out enough power to give you an f/11+ aperture from 10 feet away at full power (in a normal room). The flash has the ability to be used

Photo—Large softboxes with extra diffusion take extra power to generate medium f-stops with slow sensors like those found in medium format digital cameras. This shot was taken with ISO 25 film in an older Hasselblad camera. **Diagram**—(1) Mottled canvas background. (2) Small 16x20-inch softbox with 1200 watt-second pack and head. (3) 4x6-foot white foam core for fill. (4) Subject. (5) Hasselblad film camera with 180mm lens, black & white film, ISO 25, f/8 aperture. (6) 54x72-inch softbox with extra diffusion. Softbox was powered via a 2400 watt-second pack and head.

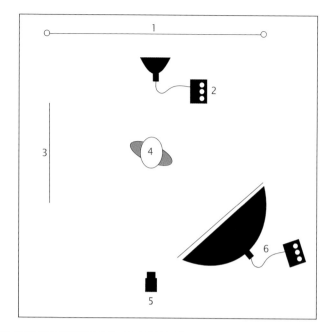

manually, and the manual power output can be set in a range from full power down to $\frac{1}{128}$ power. This can be vital when using the flashes to supplement existing light in combination with new, "high ISO friendly" digital cameras. The new generation of top flashes also offers highly intelligent power management that will allow you to squeeze extra life out of every set of batteries. These flashes have all the traditional options such as TTL metering and auto modes that make them usable even with older, manual cameras—plus manufacturers are even starting to weatherproof some of the units!

Where the new generation of top flashes come into their own and exceed more expensive studio flashes is in their seamless automatic control when used with the latest cameras. The SB-900 can be set to "remote" mode and controlled by the pop-up flash in most of Nikon's latest flashes or by an accessory infrared controller (the SU-800). Here's what I mean by controlled: you can set up any number of SB-900s, SB-800s, SB-600s, or any combination and control their output from your shooting position. You have the option of grouping the flashes into three distinct groups, and within those groups you have the ability to control all of the flashes in a TTL mode, an automatic mode (in which each flash unit's sensor measures the reflected

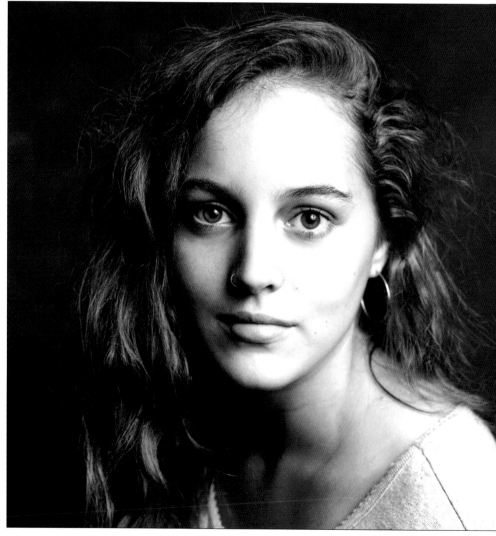

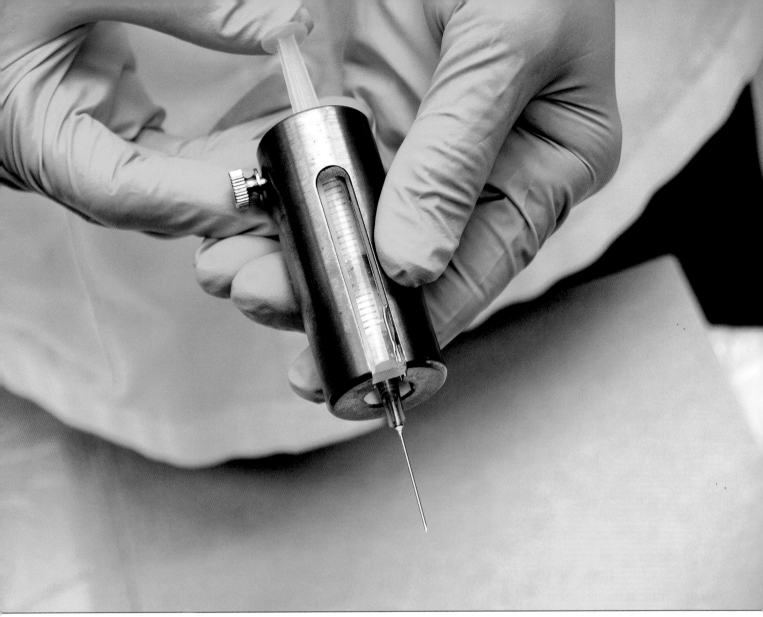

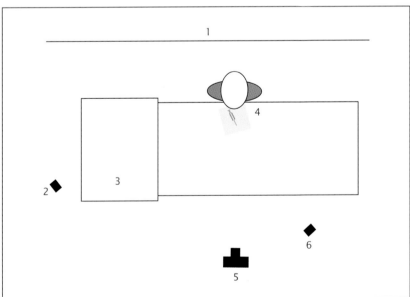

Photo—This shot of a syringe shrouded by a lead alloy protective shield is a great example of using small flashes on location. The room was not lit for photography, so I put two flashes on stands about 5 feet away from my subject on either side and bounced them both off the white acoustic tile ceiling for a smooth, soft-shadowed light. **Diagram**—(1) Yellow back wall. (2) SB-800 on manual $1/2$ power, aimed at white ceiling. (3) MRI machine. (4) Subject with a syringe. (5) Olympus e-300 with 14–55mm lens. RAW file. (6) SB-800 on manual half power, aimed at ceiling.

light that it "sees" and turns off automatically when it hits proper 18 percent gray readings), or in a manual mode where you can set the power level.

If you want to get really crazy with the off-camera capabilities, you could set all of the flashes in group A to TTL operation, all of the flashes in group B to auto operation, and all of the flashes in group C to manual operation (or any combination). Nikon calls its flash system CLS and Canon has flashes that offer the same capabilities. A bagful of these highly controllable flashes may be the only light source a busy location photographer needs in a routine working day.

My strategy is to use these kinds of lights when I'll be doing reportage-style shoots. A good example is the work that I do for an Austin-based radiology practice. We recently had a project that called for me to go around to three local hospitals and a number of clinics and make images of doctors reading the results of scans. The doctors go into special reading rooms with dim light and evaluate the medical scan images on a group of flat-screen monitors. Each reading room is different and, since time is money in the medical industry, we need to move quickly and with repeatable results.

I usually go in with three small lights. I'm using one Nikon SB-800 and two SB-600s. The first thing I do is raise the general illumination with one flash bounced off of the ubiquitous white, acoustic tile ceiling. A second flash might get bounced at low power off a white wall that is at 90 degrees to the sight angle of the physician. A third flash in a small softbox is used in front of the subject to simulate the look of light coming from the screen. These are all used in a manual mode at very low power. They are used to supplement the light coming off the bright screens and provide detail in the shadows that would be missing if we only used ambient light. Occasionally, in a dark-walled room I'll use one of the lights in a small umbrella as a back light or a rim light in order to provide some separation between the subject's head and the dark wall. I have largely settled on using three light sources and the Nikon SU-800 flash controller because I can stick each flash on a different channel. That gives me the

flexibility of controlling the output of each flash, in precise increments, from the camera position. This is a real advantage when you've taken the time to position a flash in a hard to reach position like a ceiling installation with a scissor clamp or behind a piece of furniture. The small size of the units is also a distinct advantage, as they can be placed in areas far too small for a more traditional studio flash unit.

I light in steps. First, I take a test shot using just the available light. Then I add a general fill to bring up the room level to match the screen images. (You don't want the screens to burn out when you raise the camera exposure to try to get detail in faces and background areas.) Once the balance of fill and screen intensity is set, I add the main light on the doctor's face. The third light, used as either a back light or additional fill from the camera position, is added last.

The benefits of a battery-operated flash system, when used on location, are small size and weight for easy transport, high flexibility in positioning and power setting, very controllable output, and quick setup and tear down. They can be easily used with umbrellas on stands and can even be taped to walls and doors. The downside of using these sophisticated, small lights is that they are not a good choice when you need a lot of power over a long time period. They are my top choice for fast-moving assignments, but when I set up a seamless background and shoot portraits with large softboxes I require more power and faster recycling times. It's also nice to have modeling lights and effective ways to mount softboxes.

I rarely use the flashes in the way I think they were designed to be used, mounted directly on the top of a camera and pointed straight at the subject. Used that way they give a flat, boring, and contrasty light and diminish the differentiation in quality that moves clients to use a professional in the first place.

I'm not suggesting that cash-strapped new photographers rush out and invest $1500 in three Nikon SB-900 flash units. You can get the power and flexibility you need by buying one of the top-of-the-line flash units (because it can also be used as a flash controller for the other flashes) like the SB-900 or the discon-

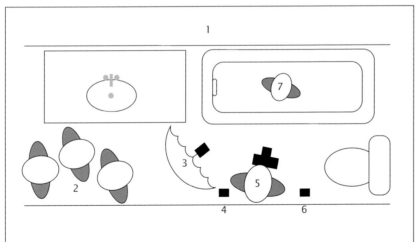

Photo—We created this image for Texas Gas Service. We were shooting in a small residential bathroom to match the average demographic of a TGS customer. I used battery-operated flashes for two very compelling reasons: (1) I didn't want to take any chance with electrical currents that would be strong enough to kill someone if someone made a mistake or standard flash units got splashed and (2) The space was small and I wanted lights that didn't come with cords and big space requirements. We bounced two SB-600s off the ceiling at ¼ power and used one SB-800 in a 32-inch Westcott umbrella as a main light. **Diagram**—(1) Tile wall. (2) Client and agency entourage. (3) SB-800 at half power, shot into 32-inch umbrella with black backing, placed just over my shoulder. (4) SB-600 at 1/4 power, bounced off white ceiling. (5) Photographer with Nikon D700, 12–24mm lens used at 18mm, SU-800 controller to trigger. (6) SB-600 used at ¼ power, bounced off white ceiling. (7) Subject in bathtub.

tinued but wonderful SB-800 and then grab several of the SB-600s (around $200 each) for additional lighting. The SB-600s provide the same kind of power, the same automatic setting of the flash reflector for various lens focal lengths, and the same ability to be used in the CLS system. They lack the ability to use external battery packs and cannot be used as "master" controllers to trigger other flashes in the system.

The top models in the Canon and Nikon lines have many features that you will find useful. They can all be used with auxiliary battery packs that radically reduce recycle times. That's especially important if you need hundreds of full- or half-power pops during a job. (Be sure to read about your flash's cooling

needs. The manufacturers suggest limiting the number of full-power flashes per minute to prevent heat damage!) The top-of-the-line flashes can also be used in your camera's hotshoe as a controller to set and trigger groups of other CLS-capable flashes.

Before moving on to discuss bigger flashes, I really must say that while using the full range of capabilities offered by the latest flashes with wireless control is a pleasant and efficient way to work, you need not buy the latest and greatest of the battery-powered flash units to get the same great lighting on location. Many practitioners are using previous generation flashes or older manual flashes to good effect. The basic requirements are flashes that allow the power to be reduced in controllable steps and that can be triggered with standard sync cords.

The ability to accept sync cords gives you the flexibility to trigger the flashes with optical slave units, radio slave units, or even synchronization cords in place of the IR triggering and control of the latest units. The cost savings can be enormous. In most interior locations with white ceilings, I could easily use inexpensive ($25) optical slave units to reliably trigger inexpensive ($75–$100) but capable flash units. Using the flash units outdoors is a bit more challenging as optical slaves in full sunlight are dicey. And the power requirements are much greater.

MONOLIGHTS

If you need high power, superfast recycling times, sturdy construction, and a quarter-million-shot reliability, consider an A/C powered flash system.

With big pops and a relatively low price, the monolight is a nice compromise for the power hungry. (*Note:* In Europe, where Balcar pioneered the concept, these lights are generally called monoblocks.) This is the category to explore when you've decided that you sometimes shoot thousands of frames in a day, need fast and consistent recycling times, and need enough power to push the light through a large softbox (maybe with an extra level of diffusion) and still get a decent, medium f-stop at a low (100–200) ISO. Welcome to the units that plug into the wall.

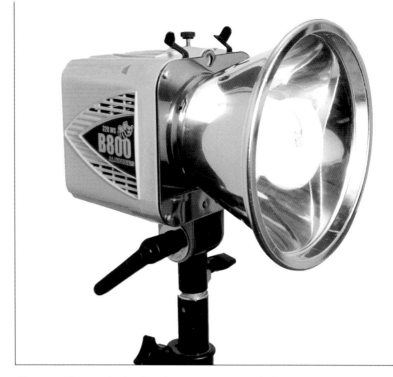

Above—Without a doubt, the AlienBees B800 monolight is one of the real bargains in still photographic lighting. The units are powerful, reliable, inexpensive, and easy to use. With appropriate care they will last a long, long time. They also use a common front accessory mounting system that was first introduced by the Balcar company. It makes attaching accessories quick and easy. Each unit comes with a standard reflector.

These lights are evolutionary descendants of traditional "power pack and light head at the end of a cord" electronic studio flashes. In the early days, the available studio flashes had very heavy power packs (they used large metal transformers) that weighed thirty to fifty or more pounds tethered to the flash heads. The heads were able to be made reasonably light because they did not have to contain the power supplies and controls, only the actual flash tube and modeling lightbulb. This meant that they could safely be used at the top of a tall light stand.

One box could feed power to multiple flash heads, but all the flash heads had to be connected to the power pack in order to work. And the high voltages that needed to be transferred from the power pack to the flash tubes meant that cables needed to be fairly short so that energy wasn't lost to the wire's electrical resistance. This meant that the flash heads couldn't be placed in remote positions without a lot of effort. Well-heeled photographers got around the distribution "issue" by dedicating a power pack to each head, a very expensive solution!

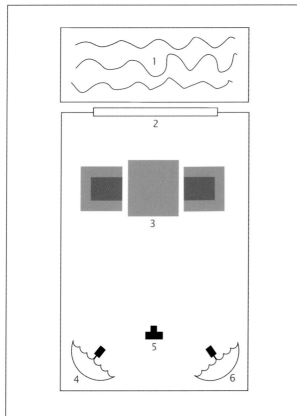

Photo—The club room at the Nokonah. The secret to lighting rooms like this is not to over- or underexpose the interior. **Diagram**—(1) Exterior pool. (2) Windows. (3) Furniture. (4) 600-watt monolight fired into white umbrella. (5) Fuji S2 camera. (6) 600-watt monolight fired into white umbrella.

As the size and weight of power supplies began to shrink, it became practical to package both the electronics and the flash tubes in one self-contained package, and the monolight was born. At twelve pounds or less it was relatively safe to place a monolight at the top of a strong studio stand, just as had been done with dedicated flash heads. Now a separate and self-contained unit could be placed wherever there was access to electrical power. Lights could be placed in adjacent rooms, across the studio, or even across a parking lot as long as there was a way to trigger them all at the same time.

While most monolights are not as powerful as the traditional pack and head configurations, there are a number of models from different companies that are more than powerful enough for just about any

modern photo shoot. Basically, a modern monolight is a self-contained lighting instrument that can accept a wide range of light shaping accessories, provide a consistent and powerful light source and, when used in multiples, offers more placement flexibility than traditional systems.

If we look at a general selection of monolights from different manufacturers, we find more similarities and common features than we do differences. From the most expensive to the least expensive, we find that nearly all of the units feature: (1) a modeling light (This is a continuous light such as a household lightbulb or a tungsten bulb that sits in the middle of the round flash tube and provides a guide or model of how the flash will look when it fires. The modeling light is quite useful in giving a photographer a general idea of how light affects composition. The modeling light also gives illumination in addition to the available light which helps as an aid to focusing.); (2) a power range control (This allows a flash to be used at full power or to be set at reduced power settings. Most monolights have a dial that offers continuous reductions in power from full to ¼ or lower. Many of the newer and more expensive models use digital circuits to set power reductions. This adds precision and repeatability as well as allowing you to set the power to very low levels.); (3) an optical slave (Nearly every unit features an optical slave that will trigger the unit in response to a flash from another unit. This works well for people who work in conventional studios because the optical flashes are good enough to reliably trigger most of the time. Most manufacturers also offer the option of getting UV coated flash tubes that are more color neutral.). All of the units have some method of accepting standard lighting umbrellas, and all come with stand adapters so that they fit on standard light stands.

At the lower end of the price spectrum there are companies such as AlienBees, which make feature-rich monolights at budget prices. The AlienBees monolights have all of the above features and use interchangeable reflectors in an attaching system that also allows users to mount accessories like softboxes easily. The trade-off is in the quality and finish of the materials. The outside casing of the lights is made of Lexan plastic, and all of the switches, knobs, and stand adapters are plastic. Used carefully, the units can give good service for many years, but they are not sturdy enough to take the pounding that a working and traveling professional might put them through. And their stand adapter (the connection that anchors the monolight to a light stand and allows you to tilt the monolight up and down) is not really up to the task of holding the largest softboxes securely. But, even at their bargain prices, the AlienBees units come complete with a cooling fan to ensure that the electronic components work efficiently and reliably.

At the higher end of the spectrum are monolights from Profoto. This Swedish company makes a line of monolights that are the standard at rental studios and

Below—The mid-sized AlienBees monolight has everything a starting photographer needs to get a studio going, including a decent modeling light, good power ratio controls, fan cooling, and a low purchase price. This side view shows the relationship between the flash tube and the modeling lamp.

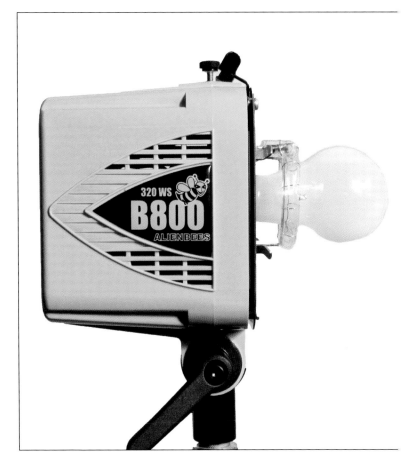

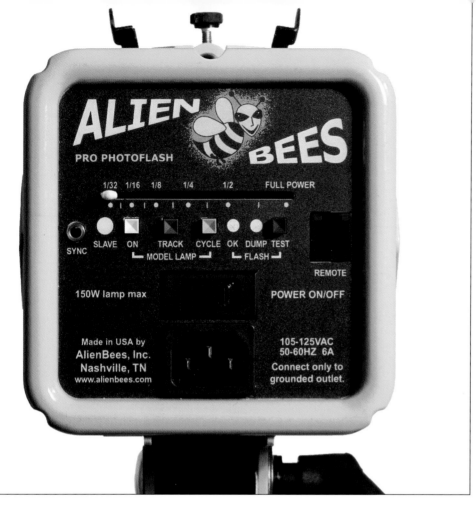

Above—Let's take a quick look at the rear control panel of this monolight. At the top, you'll find a power ratio control. This is one of the many features that make monolights indispensible for modern photographers. You can go from full power to –6 stops in one smooth slide, and you can stop at any point in between. On the next row down, we find (from the left):

· a socket for a traditional synchronization plug that allows you to trigger the unit with a wire or with radio triggers.
· a slave sensor that "sees" flashes from other units and triggers nearly simultaneously.
· a group of three buttons that control the modeling lamp. (The left button engages or disengages the modeling lamp. The second button, "track," works with the power ratio slider so that when you lower the flash power you simultaneously lower the power to the modeling lamp. This can be useful when you want to see the relative ratio between several units used at different power settings. The third button allows you to set the modeling light so that it goes dark each time the unit fires and then comes back on when the unit has fully recycled. It can be a good feature for people who tend to shoot too quickly.)
· two control indicators. (The OK lamp indicates that the unit has recycled, and the Dump indicator lets you know when the power has been dumped from the unit's capacitors after you set the power ratio switch to a lower setting. This keeps you from making the mistake of taking a meter reading right after lowering the power and being fooled by a more powerful flash than you'll get after the "dumping" is complete.)
· a "test" button that triggers the flash. (Unique to the AlienBees is a "remote" socket that uses standard telephone connectors to hook up a wired remote controller. I've never used one, so I can't comment on their effectiveness.)
· the unit's illuminated on/off switch. It's great having an illuminated power switch because you can tell at a glance whether a unit is on or off.

gear rental facilities that cater to professionals. The reason for their popularity is their very solid construction, using the highest-quality materials, and their high level of reliability. While the list of features is almost identical to the lower-priced monolight units in other product lines, many feel that the quality of light the units give off is better and more consistent.

Though there are several other companies who are trying to compete for the low-end price point slot with AlienBees, at this point they seem to have the greatest penetration into the market, and customers are generally happy with their offerings. It doesn't hurt that the company is located in the United States, sells and services the products directly, and has earned a great reputation for customer service. While Profoto shares the high end of the monolight market with other European companies such as Elinchrome and Broncolor (the Visatec line), the middle of the market has fewer clearly defined front-runners.

In the mid-market segment, monolights priced from around $400 to $800, there are traditional players like Calumet, Bowens, Elinchrome, Hensel, Photogenic, SP-Systems, Sunpak, Multiblitz, Dynalite, Interfit, and Speedotron. Each offers a range of features and performance. Only you can judge the relative importance of the special features over the quality of construction.

Most people use monolights in the 125 to 600 watt-second range.

(To put the power range into perspective, 125 watt-seconds is about twice the power generated by the bigger hot shoe, battery-powered camera flashes.) It's a range that offers more than enough flash power while keeping them lightweight enough to be safe on tall light stands. Profoto and Broncolor make 1200 watt-second units as well.

To summarize the benefits of monolights:

1. They are infinitely scalable. If you need additional light sources, you can keep buying and renting additional units and use them concurrently until you are satisfied. You will need an electrical outlet for each unit.
2. You can add more powerful models to gain more output at a lower price than upgrading a traditional power pack.
3. They are lighter and easier to transport than conventional power pack systems.
4. If you have multiple lights, you travel with redundant backup equipment. (What the heck does that mean? Well, if you have four monolights and one

breaks, you still have three units that work, so your shoot won't necessarily come to a complete halt. In a pack and heads systems with one power pack and three heads, your shoot will come to a screeching halt if the power pack has problems. This alone compels many photographers to choose monolights.)
5. If you have a way to trigger them, you can put monolights as far apart from each other as you need. This is a huge benefit over conventional pack and head systems.
6. You can mix and match lights! Although you should optimally use monolights that come from a single manufacturer so that the light temperatures are consistent and the accessories are interchangeable, that's not always an option. With monolights, you can use borrowed or rented units from any mix of companies on the same shoot with decent results.
7. The per-unit price is much lower than a typical pack and one head system from the same maker.

Left—This is the back end of a Profoto monolight. While the design touches are different than those on the back of an AlienBees monolight, the basic features are much the same. The important difference is the little sliver of green circuit board right above the socket for the AC power cord. That circuit board can be removed, flipped over, and reinserted, and doing so will change voltage parameters so that the light can be used on both 120- and 220-volt systems around the world. Right—Where monolights are concerned, the Profotos have a pretty standard collection of features—multi-voltage capability, wide ranging power settings, audible and visual recycle alerts, a wide range of modifiers, and a sleek design. Need more power? There is also a 1200 watt-second unit.

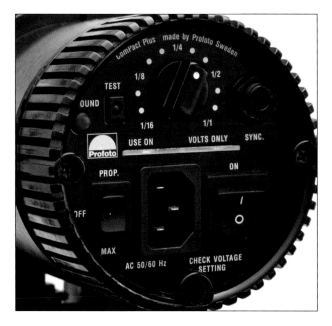
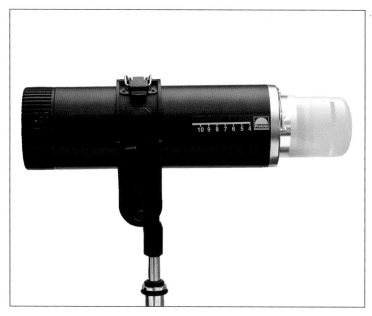

Wonderful, right? So, what are the downsides of using monolights?

1. They are heavier than dedicated flash heads from pack and head systems so they are less stable on top of light stands. This can be a problem if you are working on location with small children running around.
2. Since each monolight has its own set of electronics, they can quickly become more expensive than multiple-headed systems employing the pack and head approach from the same supplier.
3. You will need an electrical outlet for each monolight.
4. If you are on a remote location or far from A/C power sources, you will need a long (and heavy) extension cord for each unit.

Most photographers find that monolights at some quality level satisfy the majority of their electronic flash lighting needs and find that buying only as many units as they need at one time is a cost-effective way to grow a lighting system. But you may, because of the way you shoot, need more power through one light than you can get with a monolight. You might also need to make use of the lighter-weight flash heads offered by the pack and head systems in order to safely use the lights on long boom arms or when fastened by clamps to overhead structures. If that's the case, you might be in the market for a power pack and a little herd of flash heads.

PACK AND HEAD SYSTEMS

Suppose you wanted to light a large group of people in a studio or at a large location, and you wanted to design the light so that it went through a large 12x12-foot scrim covered with several layers of diffusion (a technique employed by a contemporary superstar magazine photographer). Suppose the client who requested this shot also wanted you to shoot the image on a slow medium format film or a low ISO medium format digital camera such as the Phase One 60+, which offers a low ISO of 50. You calculate that the scrim should be about 20 feet from your closest subject and that to successfully cover the 12x12-foot area your main light needs to be 20 feet away from the surface of the diffusion material. Finally, suppose you find that you'll need an aperture of f/22 to get sharp focus from the front to the back of the group. All of a sudden, you might find yourself in the market for a 5000 watt-second flash. Well, they don't make 5000 watt-second monolights, and they certainly don't make 5000 watt-second battery-powered flashes. All of a sudden, you are in the market for a traditional electronic flash system with a separate power pack and head.

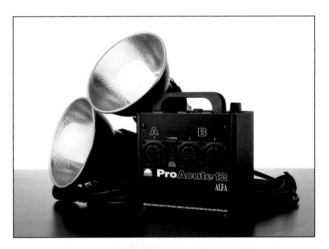

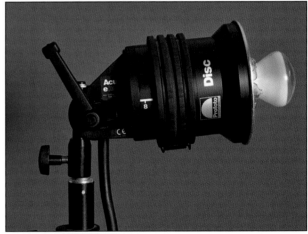

Top—The Profoto Acute 12 is a great example of a pack and head system. Each head has a thick, 12-foot cord. The head itself is useless until it is plugged into one of the three sockets on the front of the generator or "pack." This unit is 1200 watt-seconds. **Bottom**—The standard Profoto flash head, used in conjunction with that company's power packs, is something of an industry standard. This is the basic configuration with a small umbrella reflector. More expensive heads have more powerful monolights and fan cooling.

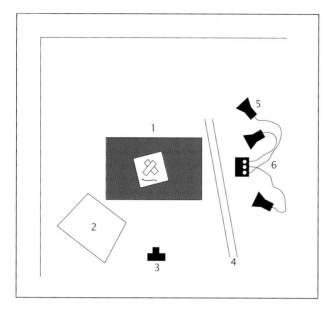

Photos—Fun with food: These shots were lit in much the same fashion—yet the styling and point of view make them seem different. When you light food, your best bet is to light with a big source from one side and a little to the back of the food and to add fill to the front with white cards. (1) Table with plate of food. (2) 4x4-foot white foam core card. (3) Fuji S2 camera. (4) Two 72-inch diffusion panels placed 6 inches apart and very close to the food. (5) Background light. (6) Two 400-watt lights aimed through diffusion panels, powered by a 1200-watt generator.

The example I gave is a bit extreme, and there are only a handful of units on the market that would work on that project. Three that come to mind are Profoto, Broncolor, and Speedotron. The packs with that kind of power weigh a ton (30 to 60 pounds), cost a fortune ($5000 and up), and recycle fairly slowly at full power.

It may seem like a silly example until you realize that people are doing shoots like this every day. Even more people are looking for a power pack that will pump out 2000 watt-seconds while firing at that power and recycling and firing again in a second or less. You may also find a larger number of people who need to use fast duration flash to freeze subject motion while still delivering high power. All of these people will be in the market for special features that are only offered on specialized power pack systems.

With monolights, you can have a unit that is relatively powerful or has a very fast flash duration, but rarely will you find a monolight that can do both at the same time. That's why the overwhelming majority

of international-caliber fashion photographers, who use flash in studios, choose to work with pack and head systems.

There are two reasons why professional photographers buy power packs in the 1200 to 2400 watt-second range. The first reason is that they need all the power they can get in one big pop (or a series of full-power pops to build exposure) in order to get small apertures with low ISO captures so that they can get the depth of focus that is critical to their styles. In large format food photography or product work, there is no substitute for raw power. The second reason to buy ample power is to turn it down to lower settings in order to reduce the flash duration.

Hint: A trick we have used for years when trying to reduce flash duration is to plug more heads into the power pack. Each added head cuts the flash duration in half! If a power pack is turned down to minimum power and the flash duration through one head is $\frac{1}{500}$ second, then the same pack with four heads plugged in will give you $\frac{1}{2000}$ second. Alternatively, if you just need $\frac{1}{500}$ second but you need four times the power, consider putting all four flash heads into your lighting accessory and turning the power up to full. You will get a fairly fast flash duration with more power.

Separate pack and head systems have migrated from mainstream to a more high-end tool as the middle of the market has become monolight territory. The group for which pack and head systems has the most allure is without a doubt the studio photographers, who demand absolute control and consistency. Power packs and heads are designed to work in systems. With rare

FLASH DURATION

Let's take a second to talk about flash duration. Even though we think of the duration of an electronic flash as being extremely short, it is all relative to the speed of the object you are trying to photograph.

If you are trying to freeze the motion of a model lounging on a white seamless background, nearly any flash that functions will probably do you well. If, on the other hand, you are trying to freeze a dancer in mid-leap, you might need a flash that has a duration of $\frac{1}{2500}$ second. If you are trying to freeze the motion of a hummingbird's wings, you might need a flash with a duration of around $\frac{1}{12,000}$ second. If you are trying to stop a bullet in midair, you will need a highly specialized flash capable of emitting a flash for somewhere close to $\frac{1}{1,000,000}$ second. Only the most specialized, custom-constructed units would work with the bullet, but a small battery-operated flash used at a very low power might work for the hummingbird.

As a very general rule, flash duration is a function of how long it takes to squeeze a certain amount of electrical power through a flash tube. The smaller the flash tube and the smaller the capacitor that stores the power, the shorter the flash's duration will be. A small, 125 watt-second flash unit may have a flash duration of $\frac{1}{500}$ second at full power, $\frac{1}{1000}$ second at half power, and $\frac{1}{5000}$ second at one-quarter power. If you need to freeze motion at $\frac{1}{5000}$ second, you will quickly find that the small flash unit will only give you a tiny amount of power.

Even if you were able to use it all efficiently, you might find it was only enough to allow you to shoot wide open apertures at high ISOs. If you are shooting motion for fashion or dance, you'll want to shoot at sharp, medium apertures and at low ISOs for the highest reproduction quality. If you go the other route, you'll find a conventional, large power pack of say, 2000 watt-seconds used at full power might only give you a flash duration of $\frac{1}{200}$ second, which isn't even fast enough to freeze the motion of a person walking slowly.

What you really need for fast action and high output is a fairly specialized pack and head system that was designed precisely to give you a combination of speed and power. One such example is the Profoto Pro 8A 2400 Air pack with its separate flash head. This power pack can give flash durations as fast as $\frac{1}{12,000}$ second while still providing decent power. Used at $\frac{1}{4}$ power, the flash duration is in the neighborhood of $\frac{1}{2500}$ second. And the unit can recycle at a power level of 600 watt-seconds somewhere in the neighborhood of four or five frames per second! There are no monolights and few other power packs that have anywhere near this performance, but if you need it, there is no ready substitute.

Photo—Portrait of Charles Allen Wright, professor at the UT School of Law and attorney to the late president, Richard Nixon. This two-light portrait was made under tight time constraints for *Private Clubs* magazine. **Diagram**—(1) Bookshelves. 32-inch umbrella with black backing. Optical slave and ¹/₂-power Vivitar 285 flash. (3) Subject. (4) Rolleiflex twin lens camera with ISO 100 color transparency film. (5) Metz CL4 "potato masher" flash used at half power and triggered via optical slave. The flash was fired into a 40-inch umbrella.

exceptions, heads from brand A don't fit or work on brand Z and vice versa. Even within brands there can be several different lines or families of flash that are not cross compatible. Speedotron Brown Line heads can't be used on Speedotron Black Line power packs, and Profoto D4 heads can't be used with the older Acute packs.

As the product and price differentiation has widened between power pack systems and monolights, the upscale power packs are where manufacturers introduce the most cutting edge technologies. A few generations ago they were unheard of, but now all advanced power packs rotate charges through all the capacitors in their banks in order to keep all the channels consistent. This ensures longer life and better operation. Some packs can be programmed to give multiple "pops" (flashes), which is a technique for adding more exposure to a scene when you only have a limited amount of power and need a bit more to shoot at the aperture you need in still life work.

The huge switches on a 1970s vintage Norman power pack I owned would give you uncalibrated, full stop reductions of power, while current offerings from Profoto and Broncolor can give you a digitally calibrated range of power settings from full all the way down to a tiny 5 watt-seconds—repeatably! Broncolor has made color consistency an exact science. (I remember in the "good old days" having to test the

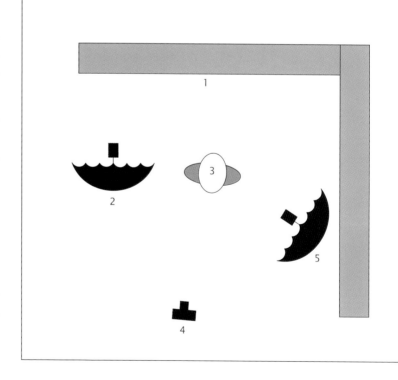

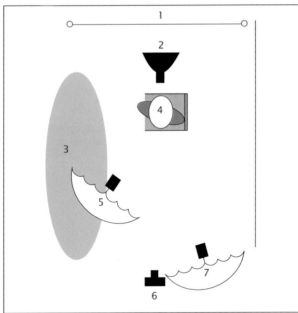

Photo—A thoroughly modern corporate headshot. This image was made with three lights—two in umbrellas and one in a softbox. Diagram—(1) Blue seamless paper. (2) 300 watt-second monolight on a stand shot into 12x16-inch softbox for background light. (3) Huge, unyielding conference table. (4) Subject. (5) 300 watt-second monolight fired into a 45-inch Softlighter fitted with a front diffuser panel. The light was used at $1/4$ power. (6) Nikon D700 with 70–300mm lens. (7) 300-watt monolight, fired into a 60-inch Softlighter with diffuser. The light was used at $1/4$ power.

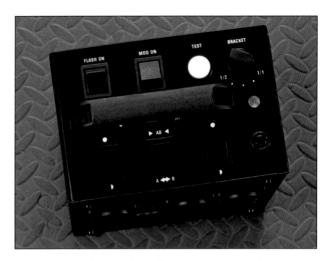

Above—This is the top of a Profoto 1200 watt-second power pack that I've had for well over a decade. It works every day. There are three outlets for flash heads on the front of the unit and basic controls for sending power to all flashes, breaking up the power into two sections and controlling the power with toggle switches that give full- or half-power settings. This box works with all voltages for international use. The design is very straightforward.

color output of other studio strobes at every power setting and devise a filter pack for each setting so that our color would be consistent as we changed the power up and down.)

Today, Profoto has a power pack that will recycle at 20 frames per second while maintaining optimal color balance. In time, each of these innovations will filter down to other product lines from the company and, if pushed by the market, less capable companies will also adapt versions of these technologies. High-end flash manufacturers brought out products with built-in radio triggers over a decade ago, while domestic companies are just now learning how to reliably incorporate this feature into their packages.

Companies like Dynalite have made a good business selling the virtues of their small power packs and their tiny flash heads with the argument that a photographer can get one pack and three heads for less than the price of three monolights. Additional heads are less expensive to replace or add. For years, Profoto's Acute 600, 1200, and 2400 watt-second power packs and their companion Acute flash heads have been favorites of photographers looking for well-built lights with a minimum of things that can go wrong. I've owned one of each and have found them to be absolutely

indestructible but not as flexible in use as their more expensive packs. Older Acute packs lacked the ability to really ratchet down the power, and as more and more photographers have made the transition to digital with its higher ISO indices, we are all finding that our single biggest lighting problem is not running out of power but having so much power that we can't turn it down far enough.

The power pack segment of the market is seeing a big change. The manufacturers are content to let the monolights rule the bottom and middle of the markets and are eking out a niche at the high end of the electronic flash market. If you are a portrait photographer or you shoot exclusively with a 35mm style digital camera, you most likely won't find the traditional box and head system to be much of an advantage over a selection of monolights. And what's more, you probably won't need nearly as much power as photographers did in years past.

If you are planning to shoot mostly in the studio and need a lot of power at your disposal, you'll find that the power packs still have a lot of relevance. Let's go over the plusses and the minuses.

The advantages of power packs:

1. Heads are lighter and easier to use in softboxes and on boom stands than most monolights.
2. Power and modeling light settings are conveniently located on the power pack instead of on the back of the flash head. This may save you a number of trips up and down ladders.
3. You get more sheer power for your investment.
4. One power pack may provide power for two to six heads. You need only one power outlet for the whole system.
5. With a fan-cooled power pack and fan-cooled flash heads, you'll be able to cycle the lights all day long at full power without overheating issues or reliability concerns.
6. Systems with incredibly fast recycling specifications are available. They are a natural choice for kinetic fashion shoots.

7. They feature the latest innovations in triggering, computer controls, and accuracy.
8. They offer the ultimate in electronic flash power for incredible lighting setups.

The disadvantages of power packs:

1. The sheer cost of the best systems. With lower-priced competitors shifting away from power packs and toward monolights, there are fewer low- to mid-range cost options available for people who prefer shooting with power packs.

Top—This is an older electronic flash generator hooked up to a number of flash heads. Newer boxes are safer and much more efficient. **Bottom**—A Speedotron Brown Line flash head hooked up to a small softbox. This example of 1980s flash technology is still in use today by a frugal studio.

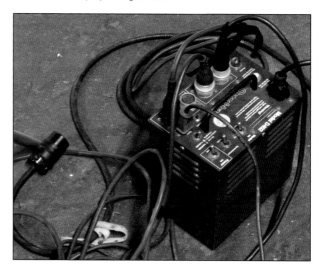

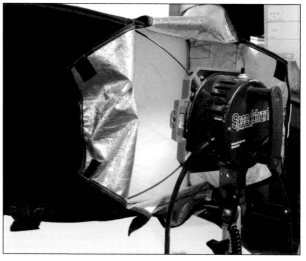

2. The centralized power pack is crucial to the operation of all the heads. If the box fails, everything stops.

3. The boxes are bulky and heavy.

4. Each light must be tethered to the power pack to function. This limits how far away each light may be placed. (Extension cords for the lamp heads are available, but they are costly and rob power (1 stop for every 15 feet of additional run) from the head.

5. Some power packs are not as flexible in their controls for each individual head.

6. Some power packs can't be turned down far enough to be useful for photographers who want to use bare light or wide apertures.

THE HYBRID BATTERY-POWERED STUDIO FLASH PACK

A few years ago, I wrote a book about using small battery-powered camera flashes to do various kinds of photo projects. Working with the little flashes on interior locations and in the studio was relatively easy because I rarely came across room lights that were too strong to overpower with the smaller units. The one

Below—Being able to ignore the need for extension cords and wall sockets is a wonderful boost to a photographer's creativity and productivity. There are a number of high-powered pack and head systems that run on internal batteries. I chose the Profoto unit because I use their studio lights, and all of the accessories are interchangeable.

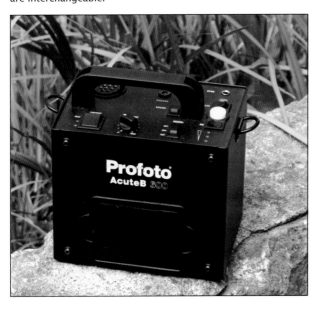

situation in which the pint-sized flashes struggled was outdoors, where they had to compete with the sun. I tried all kinds of workarounds, like using multiple flashes or finding cameras with very high sync speeds, but nothing works like raw flash power in those situations.

I did my research and discovered that none of the units powered by conventional batteries had what it takes for my demanding use. I want to be able to use a large white umbrella or softbox at least 6 feet away from my subject and get a flash exposure, in conjunction with my camera's regular flash sync that would give me a full stop above sunlight. In this way, I could properly light my subject (usually a portrait) while dropping the background illuminations (areas lit by the sun) by a full stop. I finally settled on two options. I got a motorcycle battery and inverter system made by AlienBees (the Vagabond 2) and one of their 600 watt-second monolights. This got me into the exposure ballpark, but the pack weighs over 15 pounds and is very bulky to carry around. Then I discovered a class of hybrid systems that were all very well built and easy to handle. These are small power packs with self-contained, high output batteries. They are complemented with flash heads designed specifically for use with the hybrid power packs. Three companies compete fairly evenly in this arena. They are Profoto with the Acute 600B system, Elinchrome with their elegant Ranger series, and Hensel with their very powerful 1200 watt-second Porty systems. I took a long, hard look at the Hensel Porty, as the extra power would theoretically give me a full stop more leeway in exposure, but in the end the ability to use all of the reflectors and accessories I already owned with the Profoto light I use in the studio helped me make my choice. I went for the Profoto Acute 600B, and I've never looked back.

The batteries are the limitation of these systems. Each system from each manufacturer gets around 150 to 175 full-power flashes from a battery charge. Your options are to carry several charged replacement batteries or to just use these systems when you are out on location and looking for that one great portrait that

can only be taken miles from the closest power strip. Get your shot and then head home.

This is my go-to light when I photograph executives on location, so I never have to search for somewhere to plug it in. If I am on the factory floor, I don't have to worry about OSHA regulations and taping down cords. If I'm outside, I know I'll get the power I need. While these systems are expensive, nothing compares to shooting what you need at the settings you want, anywhere you want to go.

If you've ever had a power screwup on location, you'll know what I mean. Indulge me for a moment and let me tell you the story about the scary job that started turning my hair gray. I'd won an assignment from Dell to photograph the CEO, Michael Dell, along with the president of Wal-Mart as they unveiled a joint venture to market video products in Wal-Mart. Both gentlemen were scheduled to arrive at the Round Rock, Texas, Wal-Mart at precisely 8:00AM for a photo shoot and a videotaped interview. I would have them for five minutes and we would be shooting in front of a really nice display. My assistant and I arrived around 5:30AM and met up with the advance team from Dell. We figured out the shot and started designing the lighting. We were using two different power packs and four flash heads. The video crew had a couple of 500-watt tungsten lights in little umbrellas. By 7:30AM we were set up, and all the lights had been tested. This was back in the days before digital, so we'd taken plenty of Polaroid tests and gotten the approval of all involved.

One of Michael Dell's assistants called to tell us that they had arrived in the parking lot and would be at our location in five or six minutes. Now, I don't know what possessed a particular Wal-Mart employee to wheel over a vacuum cleaner and start cleaning the carpets in our area, but he did. He plugged his big industrial vacuum into the same set of outlets the video guys were using, flipped the switch, and started to clean. Seconds later, the vacuum hit a really dirty patch and the motor revved up. The next thing we knew, the circuit breakers for the whole area tripped and our little square of the store went dark. The assistant manager of the store, who had been assigned to escort us, regretfully informed us that we would have to wait until the engineer came in to turn the lights back on. "When will that be?" we asked in a panic. "He should be here by 9:00AM" was his answer.

The video crew and one very nervous photographer rushed into action. We ran out to the hardware section of the store, grabbing extension cords off the shelves and ripping them out of their packaging as we sprinted back to our position. My assistant lunged like a diving wide receiver to plug in anywhere that light was still shining and then ran back spooling cable as quickly as she could. We connected our cables and got the lights back up as the CEO and president rounded housewares and came toward us. We were sweating bullets and puffing like we'd just climbed a mountain. I smiled, shook hands with Mr. Dell, and directed them into position. Six minutes later, they ambled back up the aisle to the front of the store and were gone.

Had I been using the battery-operated units, I would never have batted an eye. All the power in the store could go down and I'd still be ready to shoot. What's that really worth?

FLASH FACTS

There are a few basic things you need to know about flash that will make your life easier. Let's go through them.

Synchronization Speed. Since a flash exposure happens in a really short amount of time, your camera can only properly use the light from the flash if the entire sensor (or film) plane is completely uncovered by the shutter curtain or blades and the mirror is completely up at the moment of the flash. All of this has to be synchronized mechanically. On most digital SLRs, there is a top speed limit for all conventional flashes, which is often $1/250$ second (on bigger formats and on cheaper digital SLRs it is usually a bit slower, maybe $1/125$ second). Once you use a faster shutter speed than your maximum sync speed, the shutter in your camera becomes more like a slit that travels across the sensor plane rather than a version of fully opened theater curtains. If you try to use a flash at a faster shutter speed

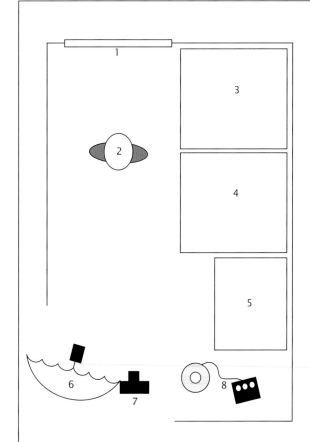

Photo—Another shot for Texas Gas Service. We were doing several locations around town and I wanted the speed that comes from bringing your own power. I used a battery-powered pack and head system from Profoto called the Acute 600B. We put the pack on the floor, set it to ¼ power, and put a head with a standard reflector on a stand, and bounced the light off the ceiling. A Nikon SB-800 was aimed into a 40-inch white umbrella for fill. It was set up nearly on axis with my Nikon D700 camera. **Diagram**—(1) Window. (2) Kid with teddy bear. (3) Dryer. (4) Washer. (5) Storage. (6) SB-800 flash, at $^1/_2$ power, fired into 40-inch white umbrella. (7) Nikon D700 with 28–105mm lens. (8) Profoto 600B with standard reflector at $^1/_4$ power, bounced from ceiling.

than your max sync speed, only part of your frame will be exposed. This is good news if you are trying your hand at experimental photo art. It is bad news if you have a paying client in tow.

Synchronization. This may seem obvious, but somehow your camera has to get the message to whatever flash you use that the shutter is open and *now* is the crucial time to fire. The simplest way to do this is

via direct, physical contact. In the case of a hot-shoe-mounted flash, the camera sends a triggering signal or voltage to electrical contacts in the foot of the flash that screams, "now! now!" The flash goes off immediately, and everything is great. Another option is a sync cord. The flash and camera are connected with a two-wire cable. The camera sends a signal through the wire, and the flash triggers. As long as the contact points are physically sound, everything works great. It gets a bit more complicated if you want to fire the flash without wires.

The low-tech method of wireless flash sync is the optical photo slave. A small "slave" unit is attached to a remote flash. This unit uses a kind of transistor that sends out a voltage spike or signal to the flash when it "sees" a quick increase in light. It is generally triggered by either a flash attached to the camera or an infrared signaling unit (or transmitter) which sends out an infrared light when the shutter is fired. Optical slaves are fairly inexpensive and work well indoors. They are much less effective in areas with high light levels and are especially bad when used in bright sunlight.

A variation on the white light optical slaves are the "pulsed" infrared slaves. These are more sophisticated than the optical slave because they can be triggered without additional white light contaminating the scene and, since they can be pulsed, the receivers can be set up on channels to reduce misfires caused by other people's flashes being used in the vicinity.

Moving up the evolutionary ladder, we come to the newly ubiquitous radio slave receivers and transmitters. These are exactly what they sound like. A transmitter on the camera or attached to the camera's sync terminal senses the triggering voltage and sends a radio signal to a receiving unit attached to the flash. The receiver triggers the flash. The Pocket Wizard radio trigger has dominated the market for the better part of a decade but is now being assailed on all sides by much less expensive versions made in China and elsewhere. With radio triggering, more dollars spent means greater distance ranges and more reliable operation.

The current hot technology is the Nikon CLS and the Canon ETTL system. In both systems, the camera uses either a built-in flash or a hot-shoe-mounted controller to send pulses of visible light or infrared light to control the output of individual flashes. It makes off-camera flash quite simple, especially if you are willing to work with TTL automation. Generally, you'll need to be using relatively current digital cameras and current flashes to gain this level of automation. In both systems you need to make use of the hot shoe on the camera as part of the control circuit for the lighting

Top—A lot of photographers are scared to shoot in the sun—especially in the not so pretty hours of 10:00AM to 4:00PM. Who can blame them? The light is raw and contrasty and most shoe mount flashes don't have the oomph it takes to push enough power through an umbrella and then compete with direct sun. But if you bring along a Profoto 600b, a Profoto 7b, a Hensel Porty, or an Elinchrome Ranger, you'll have the power and the autonomy you need. **Bottom**—Just plug in your flash head, set the power levels, and find a camera with a fast sync speed. I photographed this image and the one just above with a Canon G10 compact camera. If you need sync speed, this is a great camera. You can sync non-dedicated flashes up to $^1/_{2000}$ second. It's a good way to control how light or dark the background will be rendered.

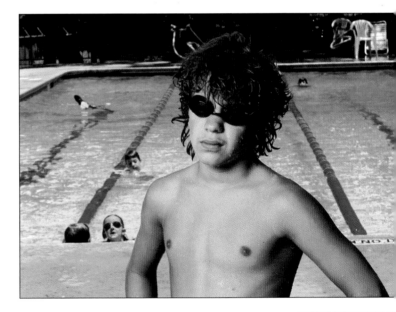

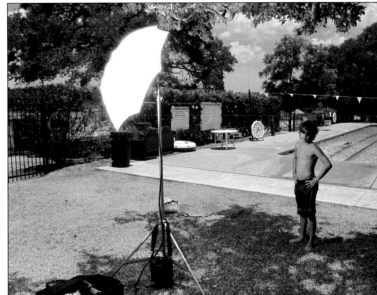

system. The camera meters the flash exposure through the lens, and when it senses the correct exposure it sends a signal via the hot shoe contacts through a digitally coding transmitter (either a system "master" flash or a dedicated system controller) which tells the flash to halt its output.

Whether to choose radio triggers like the Pocket Wizards or dedicated flash systems will depend largely on how you need to light and how big an area you need to cover. While the camera systems tend to be "line of sight" solutions (generally, they work best in small, bright rooms), the radio slaves have a much larger range and are much more reliable in areas with high light levels as well as outdoors. Most professionals use both systems on fully manual exposure settings, changing the relative output of the lights by setting different power ratios. There are trade-offs in both systems. The dedicated camera systems require the use of more expensive flash units and are not usable with other brands of flash units. The radio trigger solution allows you to use less expensive non-dedicated flash units, but the cost of the radio triggers and receivers themselves is higher.

The bottom line is getting reliable triggering every time, and that's where radio units such as the Pocket Wizards have the edge for professionals.

Flash Duration. As mentioned above, most flashes don't have instantaneous flash durations. They range from a duration of $\frac{1}{125}$ second for bigger, older generation power pack systems to around $\frac{1}{10,000}$ second for battery-powered units used at very low power settings. Here's the relationship: the more power that needs to go through a single flash tube, the longer the burn time of the flash will be if all other things are equal. They are rarely equal.

What does this mean in real life? If you are a still life shooter, not much. If you shoot portraits, not much.

Left—This is a very inexpensive optical slave (think $30) that works very well indoors. It sees flash from a main flash or trigger flash and triggers whatever flash it is attached to. It has both a standard PC socket and a hot shoe so it can be used with a wide range of flash units. **Right**—Radio slaves have a number of benefits: they "see" around corners, trigger reliably, and do away with the need for sync cords. Here's one Velcroed to the side of my flash unit. I often use small flashes as accent lights in the studio.

In fact, where fast duration flash comes into its own is with sports, dance, action, and with products that need to be captured exploding (champagne bottles), being poured (beer, wine, water, Coca Cola), etc. Some portrait photographers actually prefer longer duration flashes because the potential for tiny subject movements makes the fine detail look a little smoother.

Here's how you shorten the duration: turn the power down. The lower the power, the shorter the duration. If you are using a pack and head system, plug in more heads. The more flash tubes the power is distributed to, the shorter the total duration. Be aware though that when you change the duration of the flash you will have changes in the color temperature of the light itself. Flashes tend to be at their lowest and most accurate color temperature when used at full power, becoming progressively bluer as the duration shrinks.

Hint: Many small pops add up to one big exposure. If you select your flashes correctly, you'll probably have enough power for just about anything you might come across, but every once in a while you'll find a still life project that calls for sharp focus from front to back of a subject that's close to the camera, and that means you may have to really stop down. And in still life, most people use the lowest ISO they can find on their cameras to ensure the lowest noise and best color. So what do you do when you have your softbox covering your flash, the light is perfect in terms of direction and quality, but you do the math and figure out that you need two more stops of power in order to correctly expose the scene at the f-number you need to set? Well, you could rush out and buy a power pack that is four times as powerful as the one you are using or you could save money and do some math. If you add two pops to your first pop, you will get one more stop. If you then add four more pops to the last two, you will build up a cumulative exposure that will get you to that extra stop. It's a simple logarithmic progression and a neat trick for doing more with less gear. It works with any size or type of flash, but you'll need to subdue the existing light so that it doesn't become part of the overall exposure. That means blacking out the windows and turning out all the lights including mod-

eling lights. Obviously, this won't work when you are shooting outside or in an environment where lighting can't be controlled, but it's a great quick fix for what seems to be a routine issue encountered by car and still life shooters.

A word to the wise: just because you have a very short duration flash doesn't mean you'll freeze motion in locations that have high ambient light levels. Most cameras can only sync to $\frac{1}{250}$ second, and most smaller flashes can only deliver so much motion stopping power. If you are shooting in an environment like a sunlit exterior and you are trying to freeze motion your limiting factor will be the relatively slow shutter speed. At $\frac{1}{250}$ second you won't quite be able to freeze a runner moving parallel to your position or the swing of a hand in a golf swing. Be sure to consider these factors before you shell out a lot of extra money for a fast flash duration. Along the same lines, most of the stop action you see successfully done of leaping dancers, etc., is done in a dim studio or dimly lit location so that the ambient light isn't a big factor.

Color Temperature. All manufacturers specify a color temperature, but the honest ones specify a range. That's because, with few exceptions, the flash output tends to get bluer as the power gets lowered. Additionally, units without very precise voltage regulation tend to have variable color consistency from shot to shot. Even if you are buying the best units around, all of your efforts at getting great color could be jeopardized by the coating of the flash tube. If the glass tubes are uncoated, they allow a lot of ultraviolet (UV) light to be emitted. If whiteners or certain bleaches are used in fabrics (especially man-made fabrics) or in the fabrication of products, the high levels of UV will cause a fluorescence that turns colors either more blue or more magenta than they should be. These color anomalies can be very hard to correct for after the fact.

The solution is to buy flashes with UV coated tubes to inhibit the transmission of UV light waves.

Photography is never as simple as you might think. There are always details that can derail the best of plans. That's why it is recommended that you test new flashes thoroughly before using them on important

Top—Whether you use electronic flash or continuous lighting, your most important decisions aren't which gear to use but how to get the lighting effect you have in mind. **Bottom**—I never seem to realize just how important reflectors are until I get into the middle of a studio shoot and start to fine tune. For this shoot, there was a white card on the posing table bouncing light up under my model's chin, but it wasn't enough, so I added a round reflector over to the right. The black panel to the left has white on the other side and works as a reflector. On the far side is a piece of foam core, which adds some side fill. A black panel in the back toward the center of the frame cut spill light from the hair light.

projects. There isn't an option to buy UV-coated flash tubes for battery-operated units or most inexpensive monolights and power pack systems, but you can buy sheets of UV filtration and cut them to size if you find yourself with unexpected color shifts.

There's another color "gotcha" to be aware of: We use a number of light modifiers in our quest to soften and manipulate the small light sources of our flashes

and make them work for our vision, but you need to know that the quality of the fabrics used on umbrellas, softboxes, bounce reflectors, and scrims can be highly variable. The bleaching agents used to make the front of your softbox really white may make your images really blue or impossible to correct in Photoshop. You've probably realized that white fabrics also tend to yellow over time and make light sources "warmer" (lower color temperatures). This isn't a real issue in the digital age until you need all the lights on a set to have the same color temperature. It can be maddening to use several different brands of umbrellas to light a background while using yet another brand of softbox, only to find that different zones of your important image have big color shifts that defy the remedy of a "global" color balance correction. And this can be a major problem, which might cause you to lose a picky commercial client or spend a fortune in retouching fees.

The answer is to test all of your accessories and understand what might cause a shift and how to correct it. Most umbrellas are so cheap relative to day rates, model fees, etc., that it makes sense to change them out en masse every couple of years and to replace them with units that come from the same manufacturer, and if possible, the same manufacturing batch.

SAFETY TIPS

The following are some important safety tips for working with electronic flashes:

1. Follow the operating instructions! On older packs you could be courting trouble if you don't follow the instructions to the letter. Many units were not made to be "hot pluggable." They were more like SCSI than USB. All the stuff they say in the instructions is there to ensure that you and the expensive unit you've purchased live longer and work better.

2. Electricity and water never mix. Unless you bought super special underwater light units (you'd be well aware of it if you did), you should never use them in or near water. You're pushing your luck if you use them in 100 percent humidity.

Photo—Tungsten can beat flash for several reasons: the pace of shooting seems slower and less forced, the control you have over depth of field is enormous, and it's easy to focus with lots of continuous light. **Diagram**—(1) Gray canvas backdrop, 8 feet behind subject. (2) 200-watt fresnel spotlight aimed at canvas background. (3) Subject. (4) 60-inch Balcar zebra (white and silver) umbrella with diffusion, placed 4 feet from subject and powered by a 500-watt tungsten fixture. (5) Pentax 645 camera with 150mm lens used 10 feet from subject. Black & white ISO 100. Wide-open aperture. (6) Black card used to increase shadows.

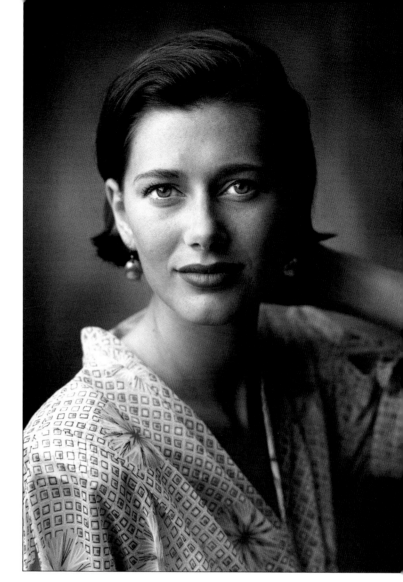

3. Stay grounded. Every A/C monolight and power pack I know of comes with a three-prong electrical cord and should be plugged into a grounded outlet. It's just plain stupid to work around this straightforward safety feature. The little adapters don't make life easier, they make potential death easier. Make sure you are grounded, especially if you are using a sync cord, because you will be connected to the camera.

4. When the manufacturers say "no user serviceable parts inside," they mean it. Here's the deal, and it applies across the board to battery units as well as our plug-in-the-wall units: inside the box there are things called capacitors that are round, pretty, and lethal. Many folks think that bleeding off the power by flashing their unit after turning the power switch to off will drain the capacitors and make them safe. No dice. Even after a few pops they retain an unhealthy dose of real sizzle. A camera repair man I know once gave me a demonstration: he had a big shoe-mounted, battery-powered flash opened and he put a screwdriver blade across the two contacts of the capacitor. There was a nasty spark and a loud pop and the screwdriver started to weld itself to the capacitor. It's 330 volts (give or take) and it's enough to give you a really spirited shock. Given a big enough unit I'm sure that the dose from a bank of capacitors could be fatal.

5. Anchor the weight! This safety tip is for all kinds of light units, not just flashes. If you have a flash head, monolight, or a little battery unit on a light stand or a boom, you've got to make sure you've anchored the whole assembly to the floor so a falling unit doesn't injure or kill someone. People

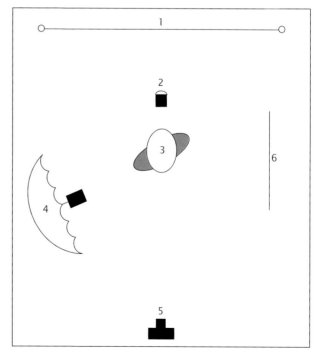

don't always pay attention to those cords criss-crossing the floor.

6. Protect your eyes. This one seems obvious, but bigger units can put out quite a lot of lumens, heat, infrared, and UV, and the closer you are, the more power you get, so don't look right into a full-power flash! At best, you'll get some spots in your vision until your cones and rods recover. At worst, you could blind yourself. Professional flash units are tools, not toys.

7. With any flash over 400 watt-seconds, don't apply correction or color gel filters directly to the flash tubes or they will melt and stick to the tube. If your flash has tungsten modeling lights, you'll have to be careful that the heat buildup doesn't cause damage to fabrics, filters, or accessories.

Cautionary tale: I saw it happen with my own two eyes. Many years ago I was a teaching assistant for two commercial photography instructors at the University of Texas here in Austin. My job was to come in and run the labs for the students—a job I shared with several other teaching assistants. Our shifts overlapped, and one day I came in only to find the previous TA had left early.

Our students were working with giant Calumet 8x10-inch view cameras equipped with 4x5-inch reducing backs. This was twenty years before the advent of digital imaging, just after the invention of electricity. All of the students were doing tabletop still life assignments. Back then, we used Calumet 400 watt-second packs. These packs came with an exciting feature: a piggyback battery that increased the power of the units to 1600 watt-seconds. They also came with a flaw: before any cable was attached or removed, you had to turn off the power and pop the flash over and over again until all the power in the capacitors was drained. If you didn't, the units would arc a bit between the connections, and each time you did that it would lay down a layer of oxidized carbon that worked to insulate the connectors from each other. Over time, the units would build up oxidation and build up internal resistance until they gave up and either died qui-

etly or, more likely, died in an exciting explosion of smoke and loud noise.

I walked into the lab and saw that an ambitious young man had decided to do a beer shot. The products—beer cans—sat in a giant pile of real ice. The photographer was using four power packs with four piggyback batteries to get the light levels he needed. He was standing barefoot on the linoleum floor. He had a light meter hooked up to a sync cord that was connected to one of the packs—probably the one sitting right under the Plexiglas table from which water was dripping as the 40 pounds of ice melted. The cord ran through an ever growing puddle of water. Upon closer observation all four power packs were sitting in an enormous puddle of water.

I walked over and asked him to put the meter on top of a little taboret and walk away from the set. He argued with me for a minute but eventually moved to dry ground. I explained the malevolent physics to him and we decided we would reach in with a wooden (nonconducting) broom handle and turn off each box before the water shorted them out. I leaned over and clicked off the power on the first unit and BAM! there was a deafening retort. The lights in the entire wing of the building shut off, leaving us in the dark. This being the late 1970s, several people pulled out their cigarette lighters for supplemental lighting, and we proceeded to shut down all of the other power packs before the power was restored. When the lights came back on, we carefully bled two of the other packs with our broom handle, but two of the packs had been completely destroyed. The cases bulged out and were smoking.

When we picked up the closest destroyed pack we found a hole in the floor at least an inch deep and maybe 6 inches around where the unit had tried to arc through to a power cable in the floor. The engineering staff were amazed that no one was killed. Suffice it to say, I've never been cavalier about studio power packs again.

In fact, one of the early selling points of the European packs like Profoto was that you could add or remove a flash head without having to turn off or bleed the unit or take out extra health insurance. Now most,

but not all, units are much safer than ever, but I treat every older model like we treat rattlesnakes here in Texas. They can be deadly. True story.

CHOOSING A FLASH SYSTEM FOR YOUR STYLE OF PHOTOGRAPHY

The Photojournalist/Magazine Editorial Photographer. Before I get started with any recommendations, you've got to understand that if you are anything like me, you'll start with a logical plan and then, years from now, you'll find yourself surrounded by an odd assortment of all kinds of lights. Okay. You've been warned, so let's go.

If your business (or hobby) has a photojournalistic bent (think wedding coverage) and you tend to move quickly from location to location unencumbered by assistants and crew, you'll likely want to look for lighting solutions that are lightweight and easy to carry and implement. Since just about everyone is using cameras from Canon and Nikon, the logical choices would be flashes from one of those systems. You might want to start with two so you have a backup in case you run into trouble. The sweet spot seems to be three battery-powered flashes and either a wireless, radio triggering system or a dedicated controller that sits in the camera's hot shoe. Three flashes bounced off the ceiling of a typical room will give you a nice, soft light for many uses. Adding a couple of small umbrellas and three portable light stands gives you enough flexibility to set up a standard portrait shot with a main light, a light on the background, and an accent or fill light. People have made entire careers with nothing more and done beautiful work. When working in this style, the important thing is to be able to incorporate the existing light on location into your overall mix. The fast ISOs of the latest digital cameras go a long way toward making up for any lack of power.

The above recommendation would work well for reporters, wedding photographers, most stock shooters, and a large number of other location shooters. In a pinch they can be used in the studio to do basic photographs, but you would soon tire of changing the batteries constantly over the course of a typical

Top—The whole idea of lighting is to subdue those photons and force them to do your bidding. This cup is lit by a large, soft bank of light. It looks to me just like a coffee cup next to a big window, filled with northern light. **Bottom**—My tripod is probably my most important piece of gear after my camera. A stable platform makes shooting with continuous light at long exposures possible, and when I use flash it helps me lock in on my composition. My preference is for the Gitzo carbon fiber models, but there are wonderful tripods available from a number of vendors. Check out models by Velbon, Manfrotto, Benbo, Induro, and an old favorite, Tiltall.

THE ANATOMY OF A GREAT TRIPOD

The current generation of VR (Vibration Reduction [Nikon]) and IS (Image Stabilization [Canon]) lenses does not obviate the need for good support. After a good camera and lens, I consider a great tripod to be the next necessity on the list. If you need to match ambient light in very low light conditions, you'll need a sturdy platform, because as cool and worthwhile as the new technologies are, you can't depend on them for long exposures and you can't rely on your own steady hands to keep the framing of a shot exact as you bracket for exposure and variation during your shoot.

1. You really want to spend the money to get a sturdy and stable tripod that can hold your camera where you want it

A good test for tripod system stability is to give your camera a good slap with your hand. A good system will stop shaking or vibrating almost immediately; a lesser system will keep shaking for a second. This ballhead's fluid-dampened mechanism is quick to adjust and holds my heaviest camera and lens combination without any creep or movement.

I want my tripod to extend a foot or two above me without having to use the center column. An extended center column reduces stability.

without any sort of movement or vibration. This means you'll need something fairly stout. You should be able to tap your camera on the side and see an immediate cessation to any vibration or movement.

2. It should have long legs. To get the most out of a tripod, you'll want a set of legs that get you all the altitude you'll ever need without having to extend the center column of the tripod. I'm short (5 feet, 8 inches) but I sometimes stand on a small, three-step ladder, and I want to be able to raise the legs up so I can use it at that height without extensions.

Those legs should be as adjustable as a good dancer's. Good tripods have legs that extend out at modest angles from the center position and that can limit your use of your tripod on uneven ground and in unusual places. The best tripods are the ones with legs that can be extended at up to 90 degree angles from center. That way, you can be more flexible in setting up and can get the tripod down lower for low-angle shots.

4. The head is the vital part. I have a friend who bought a really bad head for his tripod. First of all, it was way too small. Second, it was poorly made and wobbled a bit even when it was tightened all the way—with strong hands. Third, it had a tiny quick release mechanism that wasn't robust and wasn't secure. Once he spent the money on a really great camera, the remarkable shortcomings of his tripod head became obvious. I finally intervened and demanded that he replace it. Now he's gone from rarely using his tripod to taking it along at all times and using it whenever possible. A great head can be a ball head or a three-way pan head. It doesn't matter as long as it is sturdy, stable, and connects securely with the camera. Easy adjustments make a good tripod head a pleasure to use. If it has a quick release, the release should have a large base and the receiving part of the quick release should have a locking mechanism as a safety feature. All things being equal, using a good tripod, when compared to no tripod, will almost always make your images better. In fact, I would say that a good point-and-shoot camera on a tripod has a better chance of taking a good, detailed image than the latest pro lenses connected to a Nikon D3 not on a tripod.

5. I own a couple of nice, carbon fiber tripods, but my favorite has always been a wooden, German made, Berlebach tripod. Maybe it's just

If you are using a quick release on your tripod head, be sure to use the locking feature to prevent unexpected release. On this Manfrotto head, the locking mechanism is the brass-colored spring-loaded pin that keeps the gray lever from being engaged.

love to use ball heads on my tripods. This is a good, economical choice. It is quick to adjust and locks firmly in place. I prefer to use heads without quick releases. Every added feature seems to compromise overall performance just a bit.

Tripods are not always used on level floors. You'll find tripods with legs that can be set at variable angles are good tools for working on uneven ground. The Gitzo tripod shown here has locks at two positions.

because I live in Texas, but the reality is that wood just doesn't absorb and transmit heat the way metal does. Also, the wooden tripods are much less expensive than the carbon fiber models. Finally, well-built wooden tripods seem to have less vibration than similarly sized jet-age materials.

shoot and you would miss the fast recycling time of other options—not to mention the convenience of a nice set of modeling lights and the ease of using most light modifiers as you can with monolights and power pack systems. Still, it is a good starting point and photographers who work both in the studio and on location might find that they need more than one system to meet the diversity of their day to day work.

If you light with this minimalist assortment of lighting instruments, you'll find the most important accessory you can have is a good tripod. A tripod allows you to use low shutter speeds to mix in ambient light without adding any blur caused by camera shake. (See the discussion on the anatomy of a great tripod on page 46.)

The Generalist. For the generalist who needs to shoot a bit of product, portraits, senior portraits, and a mix of on-location corporate work and might need a bit more power than what comes out of a battery-operated unit, we've got monolights.

Monolights just might be the sweet spot for most working photographers. Here's a confession: I've worked with a wide range of electronic flash equipment over the years, but the solution I find to be most effective and efficient are monolights. Their self-contained and independent nature have an appeal to me that probably speaks volumes about my pessimism. In a nutshell, I go into every shoot expecting stuff to go wrong, and sometimes it does. I always bring two (or more) cameras just in case. I also bring lenses with overlapping and complementary focal lengths and twice as many sync cords and Compact-Flash cards as I think I will need. So it should come as no surprise to anyone that I found single power pack based systems a bit scary. One box and four heads. Sounds like it should work out fine, but in the back of my head there's the constant thought that if that pack goes down, I'm sunk. Without the central power pack the four heads are just ornamental.

That's where monolights come in. When I go on location I can pack the three monolights that I know I'm going to use and still have space for two extras. They all take the same accessories and electrical cords, so why not carry around a bit of insurance?

If I were setting up a small studio and wanted to get my feet wet without soaking my wallet, I would plan to get three medium-powered monolights (e.g., something in the power range of 300 watt-seconds each—that's about three times the power of a top-of-the-line, on-camera flash). For my money I would be looking at something like the AlienBees AB800 units. They have all the features I would need to do just about any kind of standard portrait shoot and enough power to shoot everyday studio shots of small products and setups. Three units can be very flexible, and they can also be used on location.

If you plan to step up to a premium-priced spread, go ahead and jump to something like the new Profoto D1 series monolights. They use some of the best light modifiers around, and clients think they look cool.

But whatever you do, don't consider mixing and matching units from different manufacturers. I speak from sorry experience. I owned Profoto monolights, but I was going on a location shoot for an annual report and I needed something that would run off of a big battery pack. At the time, the most cost-effective solution was the new Vagabond battery and inverter pack from AlienBees. I did my research, and it seemed that not all flashes worked well with the Vagabond. The maker would only guarantee compatibility with their own AlienBees lights. I didn't relish the prospect of being in a remote location and wrecking my day-to-day gear, so I bought a couple of the AlienBees monolights to use on the job. The project consisted of flying around the United States and making shots in wastewater treatment plants! Talk about hazardous duty. One wrong move and the lights would be toast.

They worked well on the road, and I started using them on and off in the studio. Pretty soon we did one of those routine, big-set-against-white shoots, and I needed four electronic flashes to keep the background evenly lit. I didn't bother breaking out the power packs, I just used the AlienBees and mixed them with the Profoto monolights. I didn't catch it on the LCD panel on the camera, but imagine my chagrin when I sat down to edit files on my big monitor only to find vastly different color casts in different quadrants of my photos. The Profotos, being much better corrected for UV, were warmer, and the AlienBees lights were much bluer. Since they were all mixed into different parts of the scene, I couldn't do a global correction to fix the images. Instead, I had to take the client's selected images and make very careful clipping paths around each object or person in the scene. It took hours. I've never mixed lighting brands on important shoots again!

At some point, you might want to start shooting fashion with a white background that needs to be evenly lit and bright. In this case, you will come to appreciate the scalability of the monolights. You can easily add two more units to light your backgrounds at a relatively low cost. I use my monolights indoors and outdoors, with inverters and with just about every accessory you can think of—and I rarely run out of power.

But recently I did run out of power, and that's when I turned to a higher-powered system. I was testing the latest medium format digital camera systems and was trying to shoot the way we did in the medium format film days—with long lenses stopped down to f/11 or f/16, ISO cranked down to 50 for those absolutely smooth and creamy skin tones (with *no* noise). I was using some really power hungry, giant softboxes with several extra layers of white silk in front of them to make the light soft and luxurious. My 300 watt-second monolight, in the softbox 10 feet away, was giving me f/5.6 at full power, and I couldn't use my multiple "pop" trick with a living, breathing subject.

Out of the equipment closet comes my Profoto Acute 2400 watt-second power pack and an Acute head. I tossed the head into the box, hit the test button, and came up with a nice, juicy f/16+ on the light meter. I clicked the power ratio switch one notch down to get f/11 with a faster recycle time, and I was ready for some nonstop portrait shooting.

Some people are always going to need more power. If you can make good photographs with monolights, there's no reason to pursue the power pack systems. Most of the makers of cheap pack and head systems have exited the market and what's left is either specialized or priced like Bentley automobiles. (Full

disclosure: I bought my packs and heads back in the early 1990s when the dollar was beating up the Euro like a mugger in an alley, and we often needed the heavy-duty stuff when we shot on 4x5 sheet film at f-stops like f/45.)

Disclosure aside, if you routinely shoot with larger format cameras, in the studio, with setups that need lots of noise-free detail, you just might be in the market for a power pack and head electronic flash system that will give you an efficient 1200 to 4800 watt-seconds.

What kind of real-world scenario are we talking about? Well, the first power/light hungry situation that comes to mind is the shrinking business of automotive photography and specifically photographs done in the studio. Cars are big, and when you shoot them, you really stretch the optical limits of your lens and camera system to get depth of field over the whole car, front to back. Most car shooters are using medium format or large format cameras, and f-stops start at f/16 and get smaller (f/22, f/32, f/45, etc.) from there. Car clients are notoriously picky about any noise in wide areas of color because it can look as though the paint job on the car is spotty. This means it is de rigeur to shoot at the lowest ISO your camera can handle. Many medium format shooters choose ISO 50. Put all these numbers together, factor in the almost standard use of enormous light banks, and you'll find yourself wanting entire banks of 4800 watt-second strobe boxes.

The same is true in the world of furniture photography and even catalog product photography (at the high end). The monster power market of pack and head systems is shared by several American companies, several European companies, and one Japanese company. In North America, the favorites are Speedotron (with their Black Line systems) and Norman (with their PD 4000 packs). The Europeans are represented with systems from Profoto and Broncolor, and the Japanese have Comet. These are not the only companies at the party. Paul Buff of the White Lightning company recently introduced his Zuess line of packs and heads, but they currently top out at 2500 watt-seconds. Calumet and Bowens also share product lines.

But the big five listed first have a large share of the high-end marketplace, with Profoto being the current favorite supplier of lighting gear to the big rental studios and gear rental facilities.

Another application would be a fashion shoot with medium format cameras in a large studio shooting groups of models with sharp focus throughout. Or maybe you'd like to do the huge group photographs for *Vanity Fair* (if there are still magazines in existence when this book is published) like Annie Leibovitz. Trying to keep fifty or sixty people in sharp focus while keeping the light nice and soft takes a lot more lumens than a little lick of light from a portable flash.

When you buy a big pack and head system, you'll be looking at a number of variables from total output to minimum power output. How color accurate is the system? How reliable? Is there a broad range of light shaping accessories? Is there a service network in your country? How many heads can be plugged into a single pack? What is the minimum recycle time at maximum power? And, how can the power be creatively divided among all of the heads?

Let's start with the first question: going from total output to minimum output. In the old days you could only turn a power pack down so far. They were built for the big bang, and there are engineering considerations that come into play when you try for the opposite extreme. The top of the line, processor-controlled packs from the big players can now be adjusted from 4800 watt-seconds down to a tiny 25 watt-seconds with ease—and they can do it in a fashion that makes the flash power and color temperature consistent. When you shop for a system, make sure that you can turn the pack down far enough to do the kind of work that calls for delicate power control. The first thing that comes to mind for me is using the flashes to do portrait work with smaller format cameras and wide-open lenses. In these situations I constantly find myself using the lowest settings on my 300 watt-second flash units and, in many cases, I still have to cover them with diffusion screens or brass screens in order to drop the power down far enough. Nikon is not helping when they make the base ISO of their cameras 200.

Part of what you are paying for when you get the high-priced spread is consistency. No matter what kind of work you shoot, it's a pain to have to make a slightly different color or density correction to each file in a series of images. The better units boast as little as $\frac{1}{10}$-stop variation from one flash to the next, even when the packs are recycling at maximum speed. (Researchers maintain that most untrained observers can only see the difference in density of $\frac{1}{3}$ stop in a direct comparison between two otherwise identical frames.) More consistency calls for tighter voltage regulation and oversized components, which adds up to real costs for manufacturers.

While big packs don't travel as much as monolights and other mostly portable systems, the people who need them are usually big commercial studios or very high-end shooters who count on these units to work perfectly every day, year after year. A company producing a product with known reliability issues would be out of business in no time. The tiny (comparatively speaking) market for theses multi-thousand-dollar systems is very well networked, and word travels at the speed of light. But the trade-off for ultimate reliability is always price and weight. There's no way around it.

The two biggest considerations I think most buyers will have after the nonnegotiables of reliability and consistency will be the recycle times and the availability of really good light shaping accessories. In the past, you could either buy a pack in the 1200 watt-second range, which could recycle at full power in less than a second, or you could buy a 4800 watt-second pack that would recycle in 4 or 5 seconds at full power. The two extremes were marketed to two different kinds of shooters. In the last decade, "power users" have demanded a lot more from their gear. Now they want it all. They want to be able to shoot fast and big at the same time. Profoto and Broncolor have responded with the units they want but at a price that will give pause to most photographers, professional or otherwise. The bottom line is that if you need them, you'll buy them because they do one thing that other units can't do: put out a lot of clean accurate light quickly, over and over again.

I think you'll know when you've hit the point when you are in the market for one of these systems. They are not for newbies or the financially faint of heart. When I started out, the pack and head systems were much more prevalent than monolights, and the smaller systems from companies like Novatron were more cost-effective than the few monolights that were on the market at the time. My first pack was a crudely fashioned little metallic-gray, 240 watt-second box with three sockets for flash heads on it. I had two flash heads and there was no control for separating the power between the heads or turning the power settings up or down. One head had a switch on the back that would drop the power to that head by a stop. The heads were pretty flimsy affairs made with a metallic reflector and a meltable plastic casing.

It was very important to turn the main power off and bleed the capacitors before adding or removing flashheads. (*Note:* "Bleeding capacitors" means turning the pack off and repeatedly punching the test button until the unit no longer flashes.) There were very few safety features. Fortunately, I never had a failure or a close call, but I was happy to see the system go when I was able to upgrade to a sturdier and more powerful system from another manufacturer. I used three different flash systems before I settled on power packs, heads, and monolights from Profoto. At the time, I bought into the system. I had many shooting days a year that called for shooting in the studio with a 4x5 view camera on light-sucking sets, with slow, fine-grained films. The power packs and heads were good for those situations because we could easily put a flash head in a softbox and hang it down from a high stand. We'd be able to control the power output for the head from the pack position rather than going up a ladder every time we needed a tweak.

Most of our sets required raw power, but fast recycling was rarely needed. My inventory of studio lighting gear included two of the Profoto Acute 2400 power packs, a 1200 watt-second pack, a 600 watt-second pack, and eight flash heads. From time to time, my assistants and I would use every light in the house!

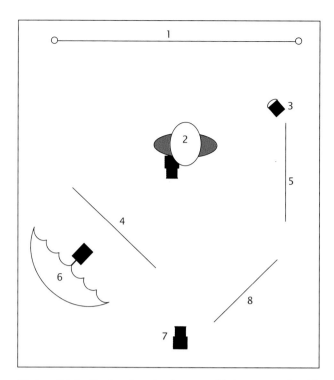

Photo—Originally shot for a book cover, this image was lit with a large soft light from camera left and a small soft light on the background. The modulation of tones creates the feeling of depth and form. You don't get that kind of modulation with flat lighting! **Diagram**—(1) Brown canvas backdrop. (2) Subject. (3) 300-watt fresnel spot, feathered. (4) 4x4-foot white diffusion panel. (5) Black panel for increased contrast. (6) 40-inch white umbrella with 1000-watt tungsten flood. (7) Old Mamiya 645 with 200mm lens. Tungsten-balanced negative film. (8) Small white panel for fill.

We added the Profoto monolights for the many assignments that called for the crew to go on location to photograph CEOs and corporate officers. Three monolights gave us more portability and flexibility while also providing a certain safe redundancy. If one light failed, we'd still be able to move the shoot forward. As I've mentioned before, with a pack and head system, if the pack goes down, the shoot is over.

Nothing beats raw power for getting the job done when your set is big, your sensor is bigger, and you are using the largest and softest lights you can get your hands on. You'll also be happy with more power if you are pumping light through gridded heads with color effect filters slapped onto the working end of a light.

When you go out shopping for pack and head systems, the marketplace can be downright scary. Here's why: the companies who make the pack and head systems (Profoto, Elinchrome, Broncolor, Bowens, Speedotron, Norman, Comet, and now White Lightning) always emphasize their most impressive products front and center in their advertising and marketing. Packs now come with built-in programmable flash triggers, IR triggers, radio triggers, digital displays, precise digital power ratio controls, and even flash duration controls. And when you buy the latest gadgets you pay a tremendous amount for the last 5 percent

of these companies' research and development. In all but the most stellar studio working environments, if you ask the working pros, the most important feature on the big boxes is power. Second is reliability. Labor-saving features come in as a far distant third priority.

The bottom line here is that if you need power like this, chances are you've assisted in a big city or have worked your way up the lighting ladder and you already have a good idea of exactly what you need to buy to compete!

Above—One of a series of food shots done for Word of Mouth catering. I was working quickly, shooting a dozen different dishes before the dishes were whisked out the door for an event. I used two small flashes bounced off the high, white ceiling, giving me a soft, smooth light and the ability to move around a large table, shooting almost continuously. I used a Nikon camera and flashes.

3. CONTINUOUS LIGHTS

FROM FLASHLIGHTS TO MOVIE LIGHTS

While most photographers used tungsten movie lights as the basis of their lighting kit in the 1950s, the 1960s saw the quick adaptation of electronic flash in all of its forms. Wedding photographers pitched the flashbulbs for the gentler and less laborious "potato masher" flash units with their umbilically attached high-voltage battery packs. Neighborhood portrait studios were courted by Norman and Photogenic, with their lines of lower-power, cost-effective pack and head systems. By the 1970s, every professional studio photographer worth his salt had acquired and was using some sort of electronic flash system in his daily work. Everything was okay until that one day when a smart fashion photographer, shooting on a film set, noticed that the light from a huge daylight-balanced, HMI movie light was really easy to balance with daylight and the light was beautiful. Maybe it was the large fresnel (a glass front of concentric rings that focuses light into a tight spot without the attendant hard edge) on the fixture, or maybe it was the fact that the light didn't "freeze" motion like a flash. Maybe there is something in the spectrum of the HMI light that makes skin tones look better. It's all subjective. Whatever the reason, fashion lighting with HMIs became all the rage in the late 1980s and through most of the 1990s. Even the Victoria's Secret catalogs were photographed with HMIs.

In another convergent evolution, many trend-setting fashion photographers were being hired for their proven "eye" and their ability to produce complex shoots. Clients realized that these talents would translate to directing, shooting, and producing music videos and television commercials. Since many campaigns are shot simultaneously, on the same stages, HMI lighting just made good economic sense. When the big guys start a trend, it always trickles down to a greater number of photographers down the line.

Light manufacturers quickly adapted and started producing lower-output HMIs that were more affordable for studios and individual practitioners. However, the bottom line is that with sticker prices of $3000 and up for a single light that won't even freeze motion, the vast majority of us will rent these when we feel that we need them for a project. Of course, we will start thinking about ways to get some of the same effects for a lot less money—and as a group, we photographers are pretty crafty and adaptable.

After I worked on a television commercial location set that made liberal use of HMI continuous lights, the first thing that went through my head was, "Hey, I could do this in the studio with regular old tungsten lights!" So I started doing my research and slowly buying and using tungsten lights.

In the past ten years, I've lit objects and people with an amazing assortment of light sources (in addition to electronic flash) including flashlights, fluorescent kitchen light fixtures, LED panels, movie lights, car headlights, and even the screen of my laptop computer. Your selection of continuous light sources is limited only by your imagination, the availability of a power supply, and its relevance to your subject.

Here are what I realized to be the primary differences between the instantaneous light of electronic flash and continuous light:

1. Because the short exposures of flashes tend to freeze a scene in a way that is not typical of our visual perception it reveals more detail with more acutance than we are used to. Since we don't see with such clinical precision, it seems less real than a scene with less acutance.
2. The longer duration exposure with any continuous light source blurs micro detail in any animate object while maintaining micro detail in surrounding inanimate objects, giving images a slightly greater perception of depth.
3. Since exposures with continuous light are additive (they build over time), they can express a certain passage of time as is evidenced by the blur of movement.
4. Since flash is (to our eyes, at any rate) instantaneous, we cannot judge the visual effect of a flash exposure until it is captured on an image sensor or film. This makes fine tuning light and its effects more difficult.
5. Since continuous light sources blend with ambient light and work with our persistence of vision, it is much easier to understand how the subject or scene will look when captured.
6. Since we can see the effects of light modifiers like softboxes, grid spots, optical spots, and barn doors on lights, it is much easier to build finely tuned lighting designs with continuous light sources.

Essentially, there is a dichotomy between instantaneous and continuous sources. All flash sources have similar characteristics and all continuous lights have similar characteristics. Whether you choose to light with LEDs, tungsten, fluorescent, or HMI lights, they will give very similar effects if the size of the light source remains constant.

So how do you choose which tools to use? I go through a process when I choose a lighting instrument. It goes something like this:

1. I ask myself, is it for me or for a client? If it's for a client, I need to choose an instrument that is optimized for the job at hand. If I'm photographing a person, the safest way to go is with a flash setup. If it's for me, I have the option of trying something new even if it might fail, and I'll go with a continuous light source.
2. Do I have to take color temperature into consideration? If I do, I'll need to pick a light source that will match daylight, like an HMI. If I'm in a studio and can control the light coming in, I am free to pick any continuous light source that I want.
3. Do I need a lot of power? For instance, one of my favorite ways to light a portrait is to use a very large scrim (white fabric sheet) to soften the light from a large light source. If I want my light source to cover a 6x6-foot scrim, I'll usually need to place the light source about 6 feet away to get a good spread of light. The scrim also soaks up a couple stops of light. In this instance, I usually select a fairly powerful tungsten fixture like a 1000-watt tungsten light.
4. Am I working close in with a wide-open aperture? Can I get by with less light? If I'm using a soft fluorescent fixture in very close to get a wonderful falloff from my light source on the subject, I can get by with using less light and taking advantage of a different lighting effect.
5. Is the light I'm using going to give me the visual effect that I really want? In many cases, the success of an image depends on the design and integration of your light source with the light that already exists. The more tools you have at your disposal, the better.

Let's go into more detail about each type of continuous light source.

HMIs

You'll remember that HMIs are a lot like arc lights in that the bulb encloses a glowing arc of bright light that results from electrical current jumping continuously between two conductors and exciting the mercury vapor and halide additives into glowing brightly. HMIs are similar to pack and head electronic flash systems in that the head, which contains the bulb, is tethered to

a pack and the pack is used to step up the voltage and modulate it correctly to achieve the arc. In the case of HMIs, the pack is called a ballast. There are three inherent advantages to the HMI lights. First, the output is up to four times as efficient as a tungsten lightbulb with the same current draw. Second, it has multiple spectra and gives a truer rendition of all colors than tungsten and a much greater accuracy than fluorescents, which are famously plagued with having a very narrow output spectrum. And third, HMIs are balanced for a color temperature of between 4800 and 5600K, which makes them compatible with daylight.

HMIs are always used with a glass UV filter in front of the light source when photographing people in order to cut down on harmful UV spectra radiation.

HMIs are available in multiple sizes and outputs. The smaller units start at 125 watts, while units intended for very high-end movie production can go up to 18,000 watts. Most movie production companies rent HMI fixtures for each project since every project requires different tools. Most major cities have rental houses that can supply you with a range of HMIs that are appropriate for photographic projects. If you use units in excess of 1200 watts, you might also need to hire the services of a specialized electrician who works in the movie industry because the load drawn by the larger units will easily blow the circuit breakers in a typical office or home location. The larger fixtures (2000 to 18,000) are usually set up as 220-volt units and are either powered from truck-mounted diesel generators or special "tie-ins" that are done by the above-mentioned electricians. "Tie-ins" and really any electrical work is well beyond the scope of this book, and I look at it much as I would fixing my own flash equipment: expensive suicide.

I recently priced daily rentals on a popular 1200-watt Profoto HMI (yes, the same people who bring you the monolights and packs), and you can rent one in Dallas for the day for around $200.

So, when would you use one? Any time you are shooting video and stills with the same lights and you need to match the color temperature of daylight. Say you are in an interior like a kitchen and several large

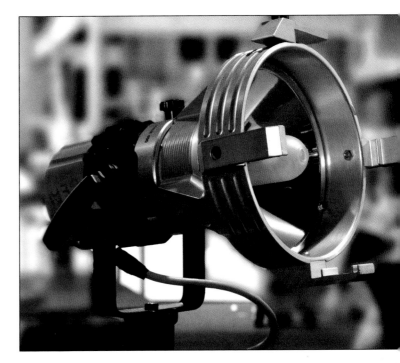

Top—A small HMI head or fixture. It's a 400-watt, daylight-balanced continuous light that requires an electronic ballast to operate. This one is fairly small and is usually used in a small, heat-tolerant softbox. **Bottom**—When one needs to light big sets, challenge the sun, or just pump out a lot of lumens, few lights beat these 5000- and 10,000-watt lighting instruments. You'll need a crew to lift them, put them on stands, and move them around. You'll also need a better power source than the typical household resources.

windows are predominate light sources. If you need to fill and still shoot action, the HMI is perfect. I also have friends who shoot fashion in NYC and they love using some of the medium sized HMIs to shoot in the studio when they want the slightly soft effect and the ability to raise the shutter speed on their cameras and use their prime lenses close to wide open. The effect is very nice, with a very narrow depth of field.

For me, given prices that range from $2000 for a small light to over $20,000 for a big daddy light I'll stick to renting them for the two or three times a year I might need them. And if you rent them for a paying job (is there any other kind?), be sure to bill the cost to the job/client. These are not part of the gear that clients should expect you to have on hand.

Environmental and safety note: HMI bulbs use a rich mixture of mercury which is toxic and very harmful to the environment. They must be recycled by experts, so be sure to turn in spent bulbs for proper disposal. Replacement bulbs are frightfully expensive ($500 and up), so handle them with care and protect the bulbs during shipping and ground transport.

**BRIGHT, CHEAP, AND EASY TO USE:
MEET THE TUNGSTENS**

While not nearly as sexy as HMIs, regular tungsten lights are really the mainstay of continuous lighting for most still photographers and video production houses. Although they are not as efficient and not balanced for daylight situations, they are very inexpensive, very flexible, and relatively easy to use. From the cute little Lowell pro lights with their little 250-watt peanut bulbs right up to the larger Arri fresnel spot fixtures in the 2000-watt range, the hot lights are the family that does most of the heavy lifting for video and small-budget film productions.

In a sense, these lights are just like the little halogen desk lamp that might be sitting on your desk right now. As you'll no doubt remember, the bulbs are little enclosed environments with a filament suspended between two electrodes. Electricity flows across the filament, and the resistance of the filament causes the filament to heat up and glow. The difference between a regular household lightbulb and the tungstens is that the envelope is filled with a halogen gas that keeps the residue, generated by heating the filament, from sticking to the insides of the glass and redepositing the residue onto the filament. The bottom line is that these bulbs have a fairly long life, and over the course of their lives they hold their color temperature well.

These bulbs are locked in at 3200K, and as long as the line voltage doesn't vary, the color temperature won't. This is a great thing, because once you've got your white balance set, you won't have to mess with it again during the shoot.

When dealing with hot lights, the difference between bulbs may have an effect on how much light they put out—but little else. What makes this lighting family so versatile is the vast range of fixtures that are available. They range from small spotlights (with fresnels) to open-faced fixtures that allow the bulb to be moved closer to or farther away from the reflector to change the pattern of the light beam to large softlight fixtures that mimic the look of small softboxes but with higher efficiency. These continuous-light soft fixtures are generally made of metal and and provide a larger, white reflector surface surface to soften the light of the tungsten bulbs.

Photographers will be most interested in light fixtures that supply the most flexibility in designing various lighting setups. An open-faced flood light like the Lowell DP is great for bounced light and those times that your need to soften the beam of light through a scrim or other big modifier. And here's an interesting aside: while your flash uses a dedicated flash tube, most tungsten fixtures can accept various strength bulbs in the same fixture. My Profoto ProTungsten fixtures can use 500, 650, and 1000-watt bulbs. This is a wonderful thing because you can choose the bulb that gives you the amount of light you need and lower the current draw from the wall socket to prevent the circuit breakers from popping.

I started using tungsten fixtures back in the 1990s when I was experimenting with video production. We did several music videos (including an award-winning CMTV video of Billy Joe Shaver's "The Hottest Thing

in Town," directed and produced by Steve Mims/ Austin Filmworks) and a number of corporate productions with a few small cases of lights. After I got into it, I got a couple of small (200 watt) spotlights and started using them to do a style of black & white photography that was popular in the 1940s and 1950s. The small beams added drama to the images and gave them a style and look that was the opposite of the soft light that dominated the late 1990s.

My favorite fixtures, in descending order, are as follows:

1. Small fresnel spotlights. I love these because when you focus the light you can get really tight beams with very soft edges. These are great when you've got a nice lighting setup going and you just want to reach into a background and add a little kiss of light, or when you need to add just a little "slash" of accent to the light. The current draw is minimal, but since the light is concentrated it is amazingly strong in its small circle.

2. Various sizes of variable focus, open-faced fixtures. These are lights with reflectors behind the bulbs that have some sort of mechanism that moves the bulb closer to or farther from the reflector. This makes the beam wider or narrower and gives you a bit of control over the spread of the light. I like to use these with barn doors so I can keep light off the things that don't need it. These lights are naturals for bouncing off of walls, ceilings, and white reflector boards. They are also great when aimed through scrims of most sizes. These are the least expensive fixtures because they have the fewest moving parts and optical parts. Think of them as the most lumens per dollar spent. (Two strobe manufacturing companies came out with their versions of the open-faced fixtures, which allowed users already invested in the systems to make use of many of the light modifiers they had already invested in for their electronic flash units.)

3. Big fresnel spotlights. No doubt, when used directly, these lights give a really nice looking tight spot with very soft edges. My problem with the

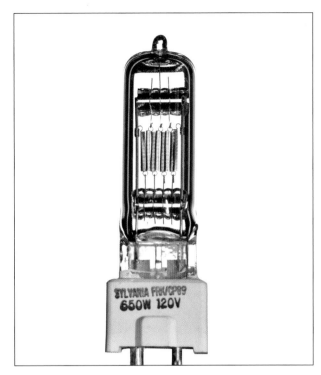

Above—This 650-watt tungsten lamp is typical of the lamps found in hot lights that would appeal to still photographers. Hot light fixtures are great for photographers who will be traveling in countries with different line voltages. Rather than mess with heavy transformers, most pros bring lamps for each voltage (120 or 240) and switch them out. That way, all the lights are multi-voltage without much hassle. I used my Lowell DP lights and my Desisti spotlights extensively on a trip to Russia, and all that was required were plug adapters for the different wall socket configurations and a small box of 240-volt lamps. It makes for a compelling argument in favor of hot lights.

bigger ones is that they put out too much light for most of my uses and produce a lot of heat.

4. Dedicated softlights. I am not as fond of these. Most of them are hard metal fixtures that use one, two, or three bulbs in an indirect design. The bulbs shine into a big curved metal reflector that gives soft light by dint of its size. These units are big, heavy, not as soft as a light pushed through a large scrim, and awkward to pack and transport. They were designed to be used permanently mounted from the ceilings of television studios and were made to pump out lots of fairly soft but directional light to illuminate news anchors in a consistent way. They weren't designed for photographers who go on location and need a fast and effective lighting instrument.

Top—This is a classic fixture used on movie sets all over the world. It's a Mole Richardson 2000-watt, tungsten-halogen light with a focusable beam and a fresnel lens. It is a wonderful combination of power and control. **Bottom**—Nearly every hot light is designed to be able to be used with barn doors that can block off light from parts of a scene. The four-door variety is more useful than a two-door model.

If you are always looking for new and innovative ways to light portraits, or you need to also shoot video, you probably want to pick up a useful hot light kit. Lowell is one of the leaders in this kind of light, and they make a kit that is remarkably flexible. The fixture is called a DP Light. It can be loaded with a 500, 650, or 1000 watt bulb. The fixtures come with screens to shield you and your models from the effects of a shattering light-bulb. A very valuable accessory would be a set of four-door barn doors. These lights are available in kits with three lights, light stands, and accessories for under $1000.

I love these lights and think they add a tremendous amount of lighting range in any situation where you aren't trying to overpower the sun. If there is a bit of sunlight contamination in a room that you are shooting in, you can always use blue gels to match the 3200K color temperature of the DPs with the 5500K color temperature of daylight.

The best way to use these open-faced fixtures would be bouncing them into reflectors or scrims. The worst way to use them would be to shine them directly onto your subject without modification. In this scenario the light will be harsh and the shadows hard-edged. But you never know, this could be the next hot style for Flickr.

If you sent me out to buy hot lights for my studio, I'd be looking for two spotlights and two open-faced lights. I'd pick up one 300-watt Arri or Desisti fresnel spotlight and probably a 650 fresnel from the same manufacturer. Then, if I were being rational, I'd pick up a couple of Lowell DP lights with accessories. If I were being more emotional and less rational, I'd go with the two open-faced fixtures that I've really come to love, the Profoto ProTungstens. These lights can be equipped with 1000-watt FEL bulbs or 650-watt bulbs. Here's what I like about the ProTungstens: First, they can be used with nearly every light modifier that Profoto makes for their line of electronic flashes, which is exceptionally broad and good. This includes speed rings for softboxes, magnum reflectors, high-efficiency reflectors, and much more. Second, the Pro-Tungstens are fan cooled, which means modifiers stay

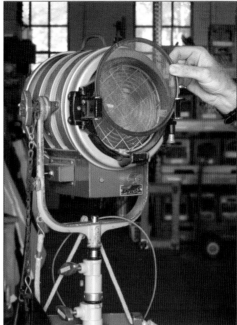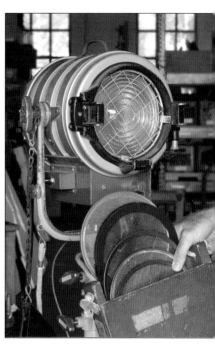

Left—Since tungsten-halogen lights can't be dimmed without lowering their color temperature, their output is controlled by placing various heat-tolerant wire screens in front of the light. **Center**—The wire screens that reduce light output in continuous lights are color coded. Each color denotes a different light-blocking ability. **Right**—Here is a set of light blockers for this particular Mole Richardson light. Time is money in the movie industry, so every light that might need these modifiers has a set, in a wooden box attached to the lighting instrument, ready to use at a moment's notice.

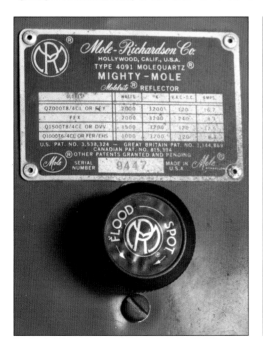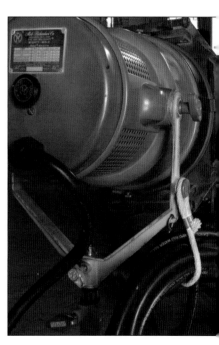

Left—One really cool feature of many tungsten spots is the ability to fine tune the beam they put out. It's a mechanical process in which turning a knob on the back of the light fixture moves the lamp closer to or farther away from the polished reflector that helps collimate the light beam. It's this ability to widen or narrow the beam that gives movie lights an extra creative capability beyond what we can get with conventional electronic flash equipment. **Center**—I love all the little touches on movie lights, like a handy loop and post to corral the power cord when the lamp is not in use. Here's a close-up. **Right**—Here's how it fits together on a stand.

Top—Having the gear where you need it when you need it is the key to an efficient shoot. **Bottom**—Let's face the facts: even though you know your hot lights and modeling lights get hot, impatience sometimes rules and you reach for one of those hot metal fixtures only to howl in pain seconds later. Grips who work on movie sets and who routinely handle hot lights always have a pair of "set gloves" ready to go. They have leather pads on the palm side as well as a layer of heat-resistant materials. These puppies will keep blisters at bay. I also wear mine when unloading and loading gear and when setting stuff up. No more seamless background paper cuts for me! You can use other gloves, but these are so cool.

cooler (and this extends their useful life). The downsides of the ProTungstens are the fact that they are no longer being made and that the fans make them too noisy for video work with sound.

In favor of tungsten lights:

1. The number one advantage of all continuous lights is "what you see is (mostly) what you get" lighting. Unlike flash, you'll be able to see exactly how the light falls on your subjects.
2. Low initial cost. While the cost of monolights has dropped a lot, tungsten lights are still relatively cheap to buy. Adding professional accessories adds to the cost but they also add to a light's capabilities.
3. They can be used for video and film projects. Flash, obviously, cannot.
4. They are very rugged and will withstand years of hard use.
5. They come in so many specialized forms that it's probable that there exists a perfect light for whatever effect you have in mind.

Reasons not to like hot lights:

1. They get really, really hot. After the first day on the job, most new grips rush out and buy a good pair of insulated gloves. Burned hands and fingers aren't fun.
2. They don't put out enough light to freeze fast action for still photography. You'll need to resign yourself to shooting slow moving subjects or subjects that just don't move at all.
3. Tungsten lights are balanced for a color temperature of 3200K, which makes them look very orangy-red when compared to daylight. That's okay if they are the only light source on the scene, but if you are trying to balance with sunlight or fluorescents, you'll need to do some filtering.
4. Hot lights aren't "green." Tungstens draw the most current per output of any light sources. They are absolute power hogs, and you'll need to pay attention to the maximum current capabilities at your shooting location or circuit breakers will pop left and right. And the household wiring could heat up dangerously!
5. If you work with tungsten lights indoors in the summer, your air conditioning bills will go up.
6. Finally, you really have to be careful what you put in front of these lights while they are on. A 1000-watt fixture can melt color correction filters in seconds and heat up a model in minutes. They are efficient in converting electricity into heat!

Note: My friend Paul Bardagjy is an architectural photographer who makes a great style and a good living

A RECENT PROJECT DONE WITH HOT LIGHTS

I was asked to photograph actors for a season brochure for Austin's Zachary Scott Theater. I chose to use hot lights to get a different look than we'd captured before. I wanted the background to go gracefully out of focus, and I wanted a large, soft source with a dark shadow to the opposite side.

I went with a setup that I've used many times before: I placed a large 78x78-inch white silk on a frame over to the left side of the camera. Five or six feet from that I set up one 1000-watt tungsten fixture with a Magnum reflector, and I proceeded to tune the reflector to get the smoothest beam possible with the least falloff from side to side.

I added a gray painted canvas background 25 to 30 feet behind the subject and focused in a tight beam from a 300-watt optical spotlight. A panel to the opposite side of my large scrim controls the contrast and depth of my shadows.

I love photographing people with continuous light because the rapport between the subject and the photographer is never interrupted by bright flashes and the beep that tells me, "I'm recycled and ready to go."

The images on these two pages show what the whole setup looks like in pieces.

I don't use the big scrim and the hot lights very often. When I do, it reminds me more of movie lighting than the kind of light I see from photographers day in and day out. It is the kind of lighting that makes the resulting images stand out.

 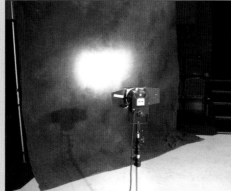

Left—Here's what it looks like from the other side. Notice that the fresnel lens on the spotlight makes a smooth transition at its edge. Center—I can't tell you why, but I start every project by setting up my background and working backward from there in setting up my lights. Here is a not-so-sharp shot of my background setup with a Desisti spotlight shining on the gray canvas. Right—This is what the scrim setup looks like from the right side of the background. The scrim is angled down toward the subject so that some light comes from overhead. The panel on the other side is being used with its white side toward the subject.

 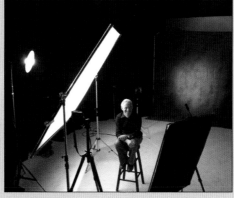 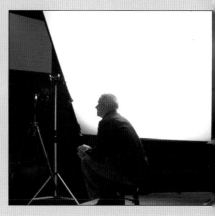

Left—This is a behind-the-scenes look at my main light, a Profoto 1000-watt tungsten fixture with a Magnum reflector. I'm interested in an even spread of light over the majority of the scrim. Center—Here's a view of the setup from the right of the camera position. Now we're all set up and ready to shoot. Right—The view from the passive reflector side.

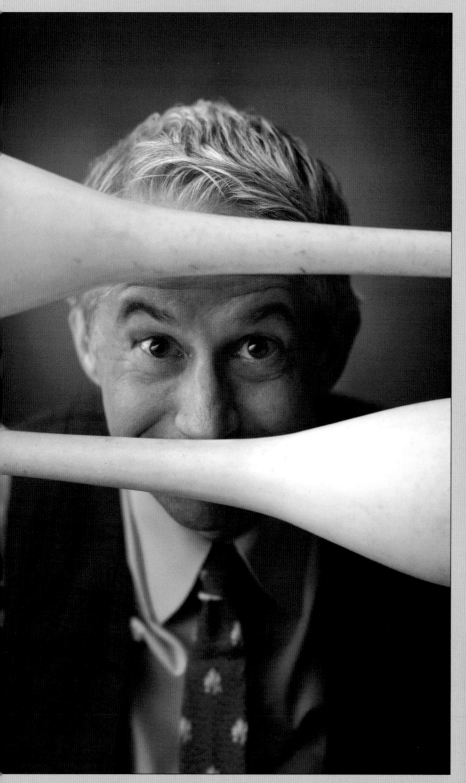

Above—And here's what we get when we finish putting it all together: Rob Williams from The Flaming Idiots, juggling pins for the camera. I think you'll agree that it's a different look than what we get from electronic flash and smaller light sources. **Top right**—Rob Williams in a serious moment. Note the soft falloff of the circle of light on the background and the way the light wraps around into shadow. **Bottom right**—No lighting changes are necessary, even when we introduce the reflective metal knife.

Left and right—*We've switched actors but not our basic lighting setup. This is Martin Burke in character as the lead of* The Drowsy Chaperone.

Left and right—*Diva Judy Arnold shows us why this lighting is so versatile. Her red dress maintains its snap and saturation while the large light source size is magic on her dark skin.*

using little tungsten spotlights called "Dedolights." They are low-powered spotlights that give him amazing control over the size and character of his lighting.

One more point in their favor: fresnel lenses. These are single-element optics that collimate or focus light from a fixture into a narrower beam. Unlike a snoot, these lenses give the light a soft transition at the edge. The light from these will be familiar to anyone who's seen the work of movie star photographers from the 1930s and 1940s. If you are trying to replicate that style, you'll find most other light sources fall short. While it's true that some flash manufacturers make fresnel attachments for their light heads, you'll really want to use hot lights so you can see exactly where that narrow beam is being aimed. It's really a wonderful tool for dramatic lighting. The larger the fresnel lens diameter, the nicer the effect. That's why some pros buy bigger fixtures than they might need (in terms of power) and then "lamp" them with lower-powered bulbs. The look created by fresnel lenses got so popular that several studio electronic flash manufacturers have made housings that will adapt a flash head to a fresnel lens. These are brutally expensive because so few are made or sold, but they give light a quality that is very similar to that from the traditional tungsten and HMI features. (*Note:* Please see pages 61–63, where I have provided a look at some work done with hot lights for a local theater.)

FLUORESCENT LIGHT GOES MAINSTREAM

Pushed by demand for energy efficiency, lighting manufacturers have flooded the market for residential replacement lightbulbs with the latest in fluorescent technologies. The self-contained ballasts are quick to start, and the light is much nicer in quality and color than it was a generation ago. The lamps are much more energy efficient than the incandescent lightbulbs they replace and they last many times longer. An offshoot of the ramp up in research and production for the larger marketplace is the availability of higher output, more color correct fluorescent lighting systems for photographers.

And it comes at a really good time. We'd all like to shoot a little greener and stay a bit cooler. It's also a convergence of technologies: while the fluorescents we're using today wouldn't have been powerful enough in the age of slow films and even slower cameras, they are a perfect match for the fast sensors in the latest professional digital cameras from Nikon, Canon, Pentax, and Sony.

Ten years ago, the lighting suppliers to the movie industry were early fluorescent adopters. An innovative company called Kino came up with a line of small,

Above—The compact fluorescent bulb is changing the way people light. Used in clusters, they can equal the light you'd get from a typical tungsten fixture with much less heat and orders of magnitude less energy use. The next step is LED lights, which are showing up in the lighting arsenals of film and video producers.

color correct (your choice of daylight- or tungsten-balanced) fixtures with electronic ballasts that made them flicker free. They were immediately adapted for use in small spaces where a small soft light could make all the difference in a shot. Kino also came out with larger long-tube fluorescent fixtures and tubes with a high output that could be used as main lights in smaller scenes. The beauty of fluorescents is that the long tubes and their attendant reflectors already give a soft light by dint of their surface area. If you need more light, you can usually gang more tubes together to make the light as big and soft as you'd like.

For many movie and television shoots these lights are becoming studio standards for closer shots because they can bathe the actors in a soft, directional light with very little of the heat that would be generated by traditional hot lights. Along with Kino (I love the name Kinoflos, by the way) Lowell came out with a line of fluorescent fixtures based around traditional, long-tube bulbs. These also included flickerless ballasts and could be folded up into hard cases for traveling.

When high-output compact fluorescent bulbs came out there was a rush of companies that were designing fixtures that used highly polished metal dish reflectors, along with multiples of the compact bulbs to make high output, open-faced lights. The top tier of manufacturers commanded high prices, and these instruments are designed to be used in television production at the highest levels. Many are designed to be installed in ceiling-mounted grid rails and are used to light nightly newscasts and other studio programming. I mention these expensive lights for both historical perspective and as an introduction to lights aimed squarely at budget conscious photographers.

While there is a lot to like about the Lowell and Kino fluorescent systems and their even pricier cousins, it was inevitable that the technologies would filter down to products aimed squarely at us photographers. Calumet marketed a fixture called a Tri-Light in the late 1990s. It used three compact fluorescent bulbs in a silver metal reflector. Since the cost was low (around $250), I bought two of them and quickly realized that three bulbs didn't generate nearly enough to shoot

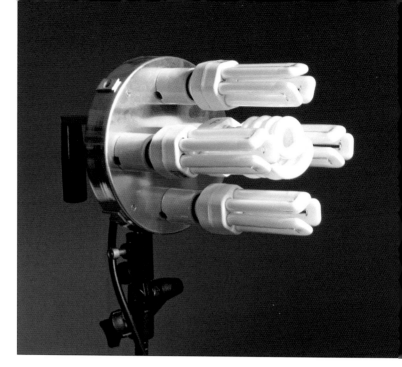

Above—One of the first relatively inexpensive fluorescent fixtures made to hold multiple compact fluorescent bulbs is the Westcott TD-5, shown here without any accessories.

early digital images with. Additionally, even though the bulbs were designated to be daylight balanced, they weren't very well color corrected and seemed quite blue.

I ignored store bought solutions for a while and kept myself happy by making my own crude fluorescent systems when needed. Then cameras got faster and a company called Westcott decided to jump into the field with a product called the TD-5 Spider Light. They built a heavy-duty bulb holder that uses five high-output compact fluorescent bulbs. It comes with a small softbox that is reflective silver on the inside and is highly heat resistant. Five 30-watt bulbs put out almost as much power as a 500-watt hot light, but it is much closer to daylight balance and uses a fraction of the energy. The cost for the fixture, the bulbs, and the softbox (the speed ring or attachment hardware is built into the fixture) is about $500. I say that the bulb holder is heavy duty because it is also designed to handle five 150-watt tungsten-halogen bulbs instead for a total of 750 watts of hot lighting.

When paired with the fluorescent bulbs and the highly reflective silver-lined softbox, I'm able to use this light for studio portraits and most small product shots. It's a move in the right direction. I figured that

Left—The Westcott TD-5, shown from the rear, is made of heavy metal and has its own built-in speed ring. There is a locking mechanism right under the power cord. When released, the head can be rotated. Right—This close-up view of the TD-5 shows three different power switches, which allow quick increases and decreases in illumination.

Left—This is the heart of the Interfit Cool Lite 9. The sockets are designed to handle 28-watt fluorescents and cannot be used with incandescent or tungsten-halogen bulbs like the Westcott TD-5. Right—The Interfit design has the bulbs sticking out at angles, so it's important to seat either the reflector or the softbox before installing the lamps!

product development had hit a stasis until this weekend when I dropped into my favorite camera store to see what was new. A company called Interfit hit the market in 2007 with two lines of fluorescent fixtures. Their first product was called the Cool Lite and featured two compact fluorescent bulbs in a metal dish fixture. Then came their Pro Lite line, which featured fixtures with more lightbulbs and more flexibility. The one that caught my eye was the top-of-the-line model

they call the Pro Lite 9. It features nine 30-watt fluorescent bulbs and comes with both a reflective metal dish and a silver-lined umbrella with an optional front diffusion panel. The polished metal reflector also comes with its own "sock" cover, just like a standard beauty dish from a flash manufacturer.

There are five switches on the back of the unit so that you can control the amount of power you get by switching the various bulbs on or off. The whole pack-

Top—Included with the Interfit Cool Lite 9 is this nifty 18.5-inch reflector, which adds a lot of punch when the compact fluorescents are used directly. **Center**—With nine 28-watt lamps, Interfit claims that the Cool Lite 9 pumps out light equivalent to a 700-watt movie light. And, as the name implies, the lamps stay relatively cool. You won't need gloves to handle this light. **Bottom**—Author's head included to give a size reference.

age was under $300! I flicked the unit on and was amazed at the amount of light this device was capable of throwing off—*without* any of the withering heat I would have expected from a tungsten light of the same output and softness. In years past, I would have told any aspiring portrait photographer that monolights or small pack and head flash systems were the only way to go when equipping a small studio, but the more I use these high-output, inexpensive lights, the more I can see the case for using them as a primary studio light. They are efficient to run, the light is soft and enveloping and, with the latest generation of digital cameras, there is no question that the light output is sufficient.

I expect that as the compact fluorescents get better and better and brighter and brighter, more manufacturers will bring out similar, competing products.

To whom would I recommend the fluorescent family? Well, anyone who does small video production (interviews and demos) with live models would do well to skip the hot lights and pick up several sets of lights like the Interfit Pro Lite 9s. Used as a main light with the umbrella attachment and its front diffuser screen, the light will be soft and flattering. When used with the hard reflector and no screen, the unit is good as a background light or a kicker light. These lights are equally usable in your portrait studio and for most still life setups. They are not powerful enough to compete with the sun.

Let's look at the fluorescent lighting fixture pros and cons.

On the plus side:

1. With products available in a wide range of prices, you're sure to find something to fit your budget.
2. The bulbs last for thousands of hours with very little color shift.

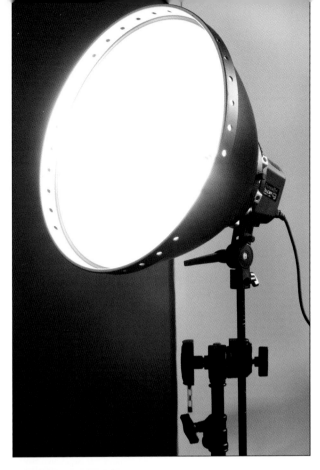

3. The bulbs are very energy efficient and generate very little heat.
4. The large surface area of the bulbs makes the lights naturally soft.
5. Continuous light makes composition easier.
6. They are fairly close to daylight balanced, but (and this is a big caveat) I would not mix most of the consumer level lights (like the Interfit and the Westcott) with daylight because I think there are color anomalies that would make globally color balancing a scene difficult. They should really not be mixed with other light sources if you need tight color control!

And now the cons:

1. Subtle color differences between most fluorescent tubes and daylight affect the ability to do global color balances. This is probably a good indication that, if you are using fluorescents as your dominant light source, the rest of your lights should probably be fluorescents with the same bulbs.
2. The very attribute that endears fluorescent lights to portrait shooters, the soft quality of the light, means that they will be hard to use in situations that require a concentrated beam of light, like spotlights and accent lights.
3. They are still relatively low output devices, which means you won't be stopping motion or using them as fill light sources in bright sunlight.
4. There are no color balanced, battery-powered fluorescents around, so you won't be mounting one on top of your camera and using it as a light source at a wedding or press event.

I first became interested in using fluorescent lights way back in the film days. Fuji released a color negative film called Reala that did a wonderful job handling mixed lighting, and it meant that shooting under fluorescent

lighting was a bit less of a nightmare. I had a project that called for shooting portraits of technology people in the giant factories, call centers, and server farms that were just spreading across the corporate landscape. Everyone wanted to show their executive standing in front of acres of interior space lit with ceiling-mounted fluorescent lights.

The standard practice at the time was to assume that the existing fluorescents were all around 30 points of green (as compared to daylight), so we'd set up a shot and put a 30-point magenta filter over the camera lens. That worked okay and usually, if we used color negative film, the labs could correct for the differences between our filter on the camera and the real color character of the existing fluorescent lights. But since all the existing light came from high above, it wasn't very good portrait lighting. It was particularly unflattering for people with deep eye sockets. We needed to practice good portrait craft and add lights to make photos that resembled good, standard portraits.

The standard lights of the time were electronic flash systems (daylight balanced). So we'd haul in our flash packs and heads and softboxes and light the guys. We'd put green gels over the flash heads so they more or less matched the ambient lights, place the magenta filter over the lens to balance everything out, and we'd do the trial and error thing to find the right combination of exposures.

With medium format cameras we were always aiming to shoot at f/8 so we'd have enough depth of field to cover our subject. In these cases we might want to use f/11 or even f/16 in order to show the factory background with some semblance of detail. Using a softbox with ISO 100 film and a ⅔ stop loss of light from our lens filter, we ended up belting out a lot of power.

But in order for the background to be well exposed, these small f-stops required ambient light exposures (in effect our second exposure) to yield shutter speeds of between 1 and 2 seconds. Yikes! That's a long time for an executive to hold a pose. It was also a huge

Right—We bring out the fluorescents when we need a nice soft source that doesn't give off a lot of heat.

amount of equipment to nurse just to get the right fill on someone's face.

One day, I had an epiphany. Why not fill with the same light source? I went to a hardware store and bought two fixtures meant to be ceiling mounted with standard tubes. Each fixture held two tubes apiece. Used in close enough, these would be our main lights. Used side by side behind a sheet of diffusion material, the two light fixtures gave off a nice, soft light. Used in close, they gave me a bit more exposure than the existing lights. They were a pain to wrangle into position but my assistants and I figured out ways to rig them. The only problem remaining was that nearly every building used a different brand of light tubes. We got into the habit of calling ahead to make sure the building maintenance people had a box of spare tubes. We'd use the local lamps and, nine times out of ten, everything matched up well. It sure beat hauling around the big studio flashes! And the overall balance of color and light was improved because the dominant light sources matched.

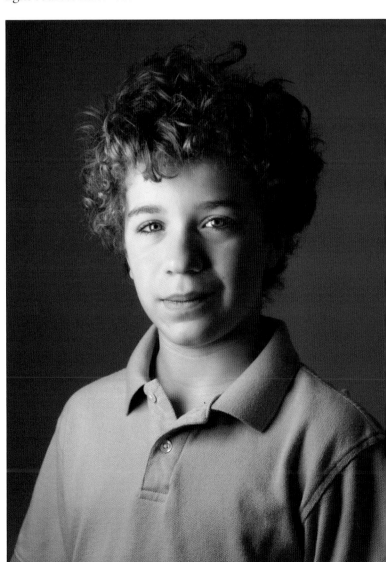

Above—Fluorescents have most of what I'm looking for in a portrait light. They are inherently soft and have an even gradation that flatters people's skin tones. They have enough power to allow you to work at a decent shutter speed and ISO sensitivity, but they make it easy to achieve a wide-open aperture that allows you to control depth of field.

But why use them now? The deal that made a new generation of fluorescent lights appealing to us was the radical evolution of compact fluorescents. These are the small, corkscrew bulbs that have their own, flicker-free electronic ballasts, better color correction, and a handy form factor. Several manufacturers have come out with fixtures that hold between two and nine of the compact bulbs and have easy attachments to use umbrellas, softboxes, or reflectors. The qualities that make them desirable are their easy portability and setup, their decent color balance, and their soft lighting.

In the old days, the lighting requirements of still photographers were very different than those of videographers. With the new generations of digital cameras using smaller and more sensitive sensors, the lighting distinctions are blurred. A few of these low-cost fluorescent fixtures make a good choice for the "all purpose" photographer who also does video interviews and product modules.

If I were starting out with a foot in both fields, these would be a good choice. I used a set recently and found it refreshing to have lights that displayed exactly what I'd be getting when I clicked the shutter. If you are interested in these kinds of lights and you don't have a big budget, there is little to keep you from buying cheap light sockets with attached cords for less than five dollars and lamping them with the latest bulbs. Group them together and give them a try and you'll have a decent light for less than $100.

 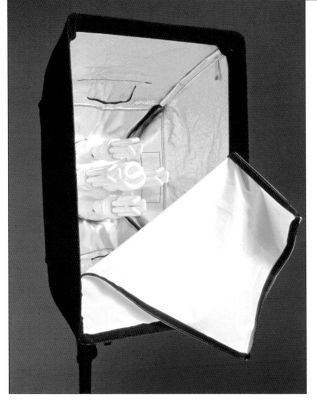

Top left and right—The Westcott TD-5 fluorescent light kit includes a well-engineered 20x30-inch softbox that is heat resistant. It yields a soft, continuous light that is very flattering when used close in on portrait subjects. **Below**—There's a lot to like about the new fluorescent fixtures. They're bright enough to focus quickly and accurately, but not so bright that your model will start squinting.

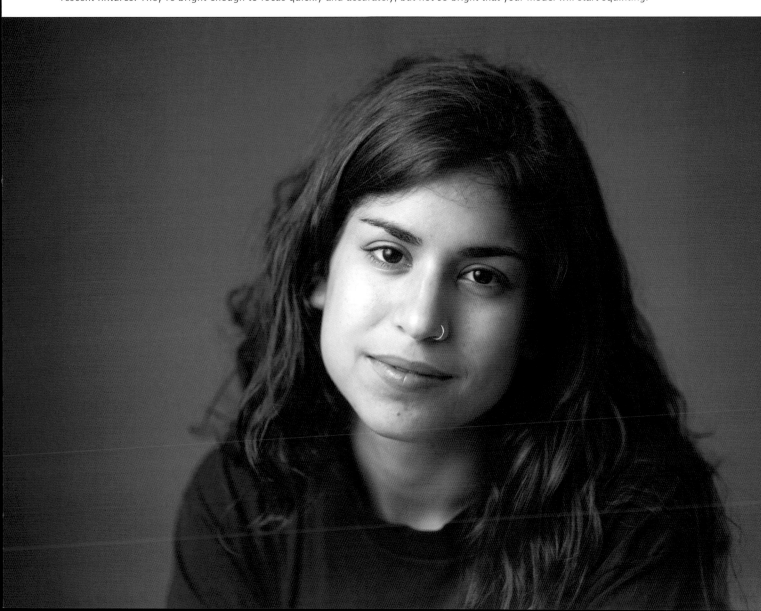

LIGHT-EMITTING DIODES (LEDs)

LEDs are the latest entry into the marketplace. The LED started life as an indicator on the panels of aviation equipment and home entertainment products. As the price, output, and sophistication of these solid-state light sources has improved, manufacturers have realized that they may soon become compelling choices for all kinds of photographers. The bulbs are small so they are typically ganged together in panels in order to put out enough light to be useful. Currently, the panels are still pretty pricey because their market share is too small to gain the price advantages of scale. Think of an LED light panel as being a board covered with little lightbulbs. Each lightbulb puts out a highly efficient light that can be made very color correct. They can be tuned to deliver light in very specific spectra, and since they don't put out a lot of infrared energy they are as cool to operate as similarly rated fluorescents.

The larger panels (16x20 inches and larger) are perfect for use as main or fill lights in portraiture, while

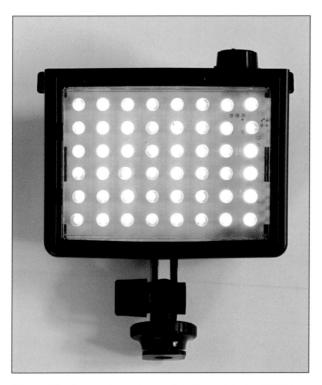

Above—The future of continuous light just might be LED lights. Right now a light from LitePanels that measures less than 5x5 inches sells for nearly $300. Prices will drop if lights are anything like the cameras we use with them.

smaller, ganged lights can be put in fixtures that will yield a tighter light beam. I'm not going into a lot of detail about these lights because they have yet to make big incursions into the everyday work of photographers. I think they will one day soon eclipse the use of fluorescents not only in photography and video work but in buildings and homes as well.

In addition to their clean color and good output efficiency they have a useful life that is typically stated in hundreds of thousands of hours! The replacement cost of these lights is close to zero. And, unlike fluorescents, they do not use toxic mercury in their construction and operation. At this point, they seem to be the greenest of the lights we currently have available. It's just a matter of time before you see panels for sale at places like discount hardware stores and as replacements for household incandescent bulbs.

They share with HMIs, tungstens, fluorescents, and all other light sources one weakness: because they are continuous light sources, it is difficult or impossible to freeze action with them the way you would with even the cheapest electronic flash. That glitch alone will ensure that electronic flash systems, in all their permutations, are here to stay.

FLASHLIGHTS: PORTABLE AND PRIMITIVE

The beginning photographer usually believes that equipment is the most important factor in producing a good photograph. They imagine that expensive and complicated lighting gear is required to produce really creative images. Nothing could be farther from the truth, as is amply proven by millions of beautiful images that are produced in naturally occurring light.

So some will look aghast when I recommend using a flashlight to light an image. Of course, as a confessed "gear junkie," I will admit that when I do use a flashlight I tend to reach for a Maglite. Higher-end flashlights now use tiny tungsten-halogen bulbs because they are more efficient, reliable, and sturdy than the traditional incandescent bulbs that your dad's hardware store flashlight from the 1970s relied on.

While even the biggest Maglite flashlight puts out only a small ration of contrasty light, the leitmotiv of

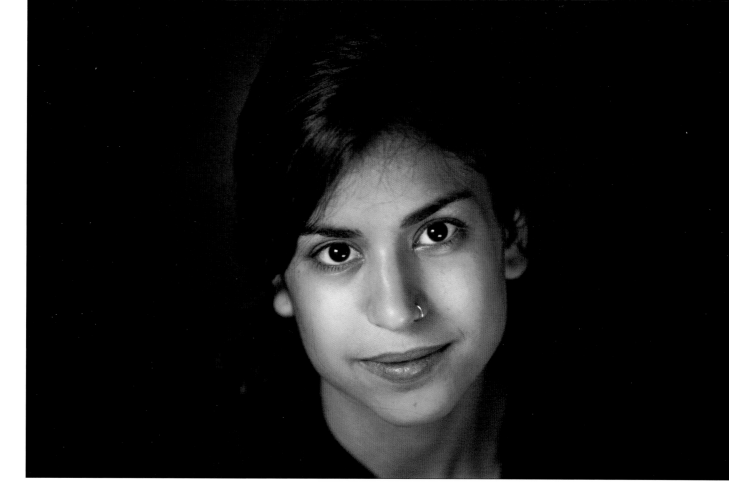

Photo—I got this idea from David Hobby at Strobist.com. I wanted to see if I could make a quick portrait with a couple of Apple PowerBooks and a cheap LED flashlight (used as a background light). If you look closely at Emily, you'll see the incredibly narrow depth of field that comes from using a lens wide open. While her eyes are in sharp focus, the hair on her forehead is not! **Diagram**—(1) Gray background. (2) LED flashlight as background light. (3) MacBook Pro on a projector stand as main light. The laptop was positioned about six inches above the subjects face and pointed downward. (4) Subject. (5) MacBook laptop sitting atop posing table. This computer's screen served as the fill light in the setup. (6) Nikon D700 with 85mm f/1.8 lens. Aperture setting: f/2.0. Shutter speed: $1/40$ second. ISO 3200.

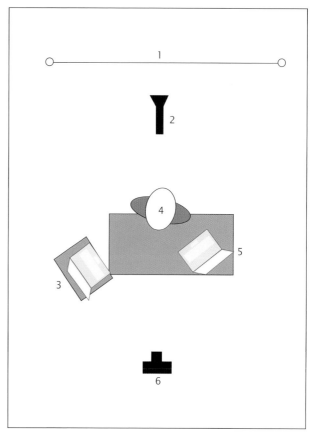

this book is all about the changes in photography that have been brought about by the ever-increasing quality of high ISO files from digital cameras and our changing styles of photography. Nothing is off limits as a lighting tool these days. The battery-powered flashlight has a bunch of good points. They are highly portable, can give you a very tight spot of light, and can project that spot over a good distance. They are (roughly speaking) tungsten balanced. Many are weatherproof, and they are nearly indestructible.

How would you light with these? My first brush with flashlights occurred when I was doing a shot of a

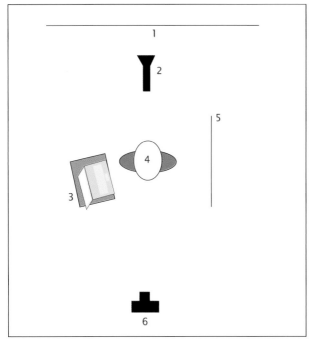

Photo—Emily patiently sat for me as I experimented with using only one laptop as my main light. I used a MacBook Pro with a 15-inch screen. I calibrated the screen to 5000K, filled the screen with white in Photoshop, and cranked the brightness all the way up. I used a Maglite, unfiltered, on the background, which explains the warm, reddish cast. There is a panel for fill over to the left of Emily's face. **Diagram**—(1) Studio wall as background. (2) Flashlight as background light. (3) Apple MacBook Pro 15-inch laptop. Screen used as light source. (4) Subject. (5) 40x40-inch sheet of foam core used to produce fill. (6) Camera with fast medium-length telephoto lens.

a flashlight and proceeded to experiment to find the optimum exposure time.

If I kept the flashlight moving, we could use a 15-second exposure, which produced a fairly even tone with good saturation. We were using medium format film cameras then, which made experimentation time consuming and costly. You could do the same thing with digital today and have nearly instant feedback.

So the primary use of flashlights up until now has been to "paint with light" by leaving the camera shutter open and literally moving the light around to get the effects you want. A few tips from someone who's been there: Wear black so you don't reflect light into the scene. Build a lens hood for your flashlight so no extra light spills from the sides (we always use "Black Wrap"—a black foil—to create a quick and easy

food dehydrator for a fitness magazine. My assistant and I brought in bags of sand and created a desert-scape. We gelled our main lights with warming gels to make the image seem hot. I wanted a bit of red glow in the front of the machine (we lit the set from the rear to emphasize the texture of the sand), so we made one exposure for the overall set and then put a red filter on

snoot). Keep the light in constant motion so you don't have hard edges or hot spots. Work out the pattern you want to follow and count to yourself to hit your proper exposure. You might also consider various sizes of flashlights, as each will have a different beam size.

In a pinch, I guess you could actually use these guys to light a scene or a portrait. Given enough flashlights and a camera like the D700 with its incredible low-light performance, I think you could develop a style doing all your nighttime shoots with nothing but flash-lights. Really, the only limitation would be trying to keep up with the available light in most venues. It's hard to see the effect of your lighting instrument if every light source around you is brighter.

Still, having a Maglite around the studio always comes in handy, even if it's just used for going out to check the circuit breakers when the power goes out.

Photographer David Hobby showed an example in 2009 of lighting people (close-in shots) with the light from and Apple iPhone screen and the screen of an Apple MacBook Pro. (The MacBook Pro screens are now lit by LEDs!) Was it an exercise in silliness? Far from it. It worked—and if you are looking for the right effect, it may be the perfect solution. My own version is shown on the facing page.

Photo—This image brings together so many weird approaches to unconventional lighting. We have the Apple MacBook Pro as our main light again. Under Emily's face is a piece of white foam core acting as a reflector. There is also a 4x4-foot panel to her left which provides good fill. The background is lit by the tiny 3x4-inch LitePanel LED light that I was testing at the time. It's amazing how little light one actually needs to do a portrait! **Diagram**—(1) Gray studio wall. (2) Flashlight as background light. (3) 15-inch MacBook Pro as main light, used at a 45 degree upward angle. (4) Subject. (5) White card. (6) 13-inch MacBook Pro as a frontal fill light. (7) Camera with fast, medium-length lens.

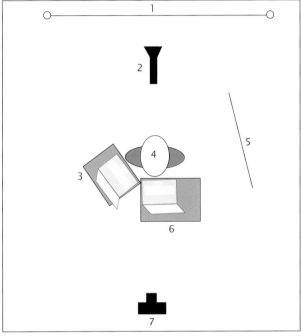

4. ACCESSORIES YOU'LL USE ON THE LIGHTS THEMSELVES

METAL REFLECTORS

This section is focused on the accessory reflectors that are available for many of the studio flash heads and monolights on the market. (Most movie lights—and hot lights in general—already incorporate their own reflectors, and fluorescent light units are mostly used with softboxes and umbrellas or they have their own built-in reflectors.) Part of the appeal of these lighting systems is that they are flexible and adaptable. There are specialized reflectors for many different applications. These interchangeable reflectors can radically change the character of the light coming from the business end of your studio flash!

The electronic flash head is like a blank canvas for photographers. The most flexible systems allow us to choose the reflectors we need to best do the shot in front of us right now. I own Profoto, so I'm going to use their reflectors as examples, but nearly all of the flash manufacturers offer a good range of metal reflectors that are made to modify the light from the flash tubes in a certain way.

Umbrella Reflectors. These are also called "spill kill" reflectors. These modifiers have a small diameter lip that keeps light from the flash tubes from spilling back toward the camera. A bare flash sends light in all directions, and although the body of the flash head or

Below—Different reflectors have different properties. The rule of thumb is that a bigger reflector yields a softer light. This is true most of the time, but the internal finish of the reflector and its shape also have a lot to do with the quality of light they reflect.

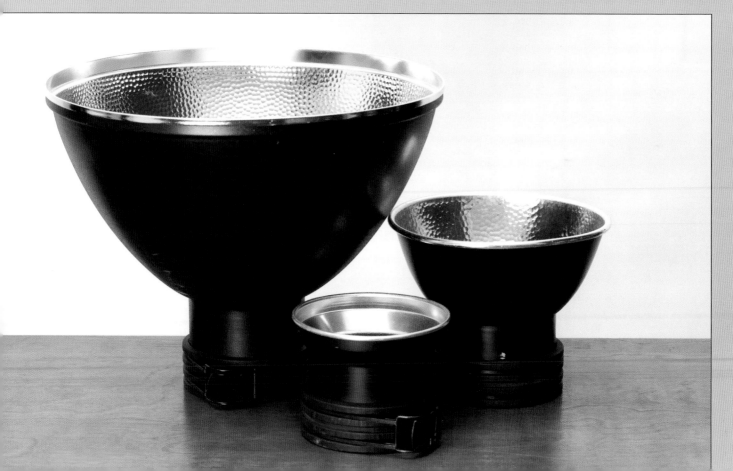

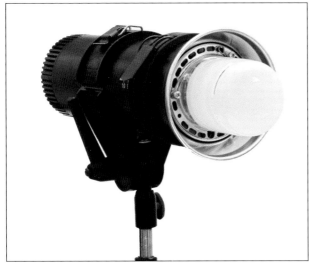

Top—Part of the charm of a well-designed system is the range of looks you can get with the combination of a good modifier system. Note the numbers on the side of the monolight shown here. The head can be slid forward or backward along the body of the flash to change the angle of dispersion for the flash. This allows you greater control when "tuning" the reflector and head for use with an umbrella or softbox. **Bottom**—Profoto 600 watt-second monolight with an umbrella reflector. The umbrella reflector can also be used in situations where you need a hard, almost bare-bulb effect, but with greater efficiency.

monolight blocks some light, you'll need an umbrella reflector if you want to keep the photons corralled into the front 180 degrees of your flash head. While the Profoto reflector (like all the light modifiers for the system) can be "zoomed" forward or backward to narrow or widen the beam, we mostly use them in a position that fills our umbrella with light and blocks any extra light from spilling around the edges. I call it "tuning the reflector" to the umbrella. Other manu-

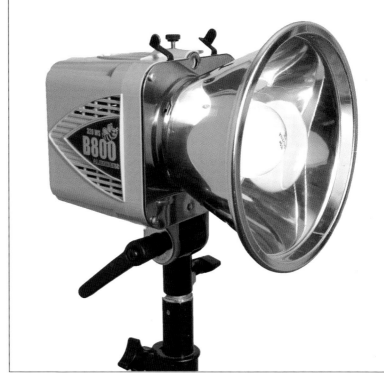

Above—This is the standard AlienBees monolight package with the included standard reflector. Note the two "ears" sticking up near the top. These are spring-loaded levers that hold accessories in place.

facturers design their spill kills so that they work well for most umbrellas. Even the simplest and least expensive ones from budget flash makers like AlienBees work well in its intended use.

I wouldn't use an umbrella reflector by itself as the light would be too uncontrollable.

Standard Reflectors. As the name implies, these are the all-purpose reflectors that usually come with the flash head or monolight. They are usually 7 to 9 inches in diameter and restrict the beam from the flash tube to somewhere between 90 and 120 degrees. They provide enough light control so if you bounce your flash from the ceiling, no direct light will strike your subjects. They are useful when you need to bounce your flash off a ceiling, a wall, or a big hunk of foam core. They can also be used as a decent substitute for an umbrella reflector. Usually, the interior surface is a pebbled metallic finish or a silver matte finish, as manufacturers try to steer a middle course between light efficiency and softness. Standard reflectors are also available with a highly polished interior for use with

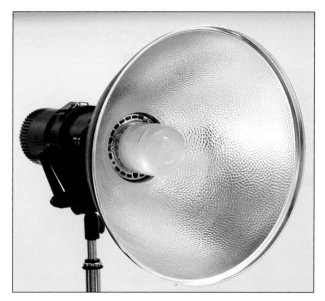

Above—Profoto lights offer an excellent selection of modifiers. This is their standard reflector, and it takes full advantage of the head design, which allows modifiers to be "zoomed" backward or forward on the body of the flash head or monolight. This allows one reflector to have a tighter or broader light pattern.

grids. Keep your standard reflectors handy. You will always find a use for them.

Magnum Reflectors. Every flash line seems to include one of these reflectors. Bigger than the standard reflector by at least a factor of two and a bit smaller than a beauty dish reflector, these allow for an output that is midway between the contrasty light of the smaller units and the very soft light of umbrellas and softboxes. Photographers who swear by these units use them because the bigger bowl and the wider diameter gives them more control when they want to use the edge or penumbra of the light. (The edge of the light can be softer and more interesting than the middle of the beam.) Master portrait lighters like to put a light over to the side and then rotate it so the main beam moves in front of the subject. At some point, they will see the penumbra effect and they'll know they've got the light right where they want it. I try to do that, but it is hit and miss for me, so I use the Magnum reflector to produce a nice, even source of direct light on a background plane or as the "delivery option" when pushing an even light through a diffuser or scrim. It has a softer character than the standard reflector, but it will still give your light some edge when used correctly.

Top—This is the front of a Profoto Magnum reflector. It is about 13 inches in diameter and does a good job of throwing a compact circle of light, which is slightly softer than the standard reflector. **Bottom**—This is a reflector size that seems lost in the middle region of lighting accessories—it is too big to be a hard light source but too small to be really soft for portrait work. Really, it is a very useful modifier that gives a good tonal rendering with snappy edges. Used in expert hands, it can be a very beautiful main light for dramatic portraits.

Beauty Dishes. A beauty dish is a large flat dish reflector in the range of 16 to 30 inches in diameter. Most have a white painted interior to reduce specularity and soften the light. Nearly all of them have a little panel that "floats" over the flash tube so that no

direct light is emitted from the reflector. All illumination comes from the white bowl. One specialty manufacturer even makes a 40-inch version, but the price is outrageous. So, here's the gist of the argument: I understand that the beauty dish is meant to be used close to a model's face; my fashion photographer friends even have a formula that says beauty dishes should be used at a distance equal to about 2x the diameter of the beauty dish. That's about 32 to 60 inches from the subject. What I'm supposed to see is "a soft, smooth light with crisp (but not hard) shadows that quickly falls off on the edges." I've owned a beauty dish for years, and I just don't see much of a difference between it and a well-tuned umbrella of the same basic

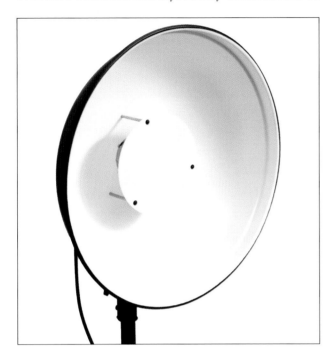

Top left—The design of a typical beauty dish seeks to collimate the light from a flash into a controlled but soft beam of light that falls off more at the edges than light from an umbrella or a typical parabolic reflector. Most beauty dishes are 16 to 30 inches in diameter and have a center reflector plate that keeps direct light from the lamp or flash tube from hitting the subject. The beauty dish evolved back in the late 1950s when glamour photographers were seeking a softer look from the very bright hot lights in use with the slow films of the day. The well-designed beauty dish has a look all of its own, and they continue to be popular with modern portrait photographers. **Bottom left**—A rear view of the Alien-Bees beauty dish gives you some idea of its relative size. Many location photographers are replacing their umbrellas and softboxes with beauty dishes because they are more stable in the wind. One problem with beauty dishes is that you can't tilt them down very far when they are attached to a conventional light stand. **Right**—This is a side view of a beauty dish on an AlienBees monolight. The beauty dishes range from simple to elegant, but all do the same job: they throw crisp light on a close by subject while hastening the falloff on the edges.

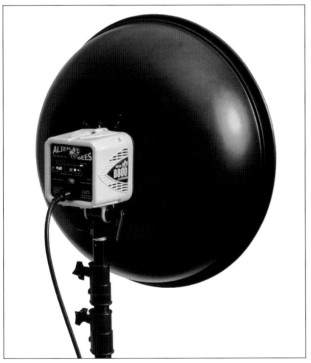

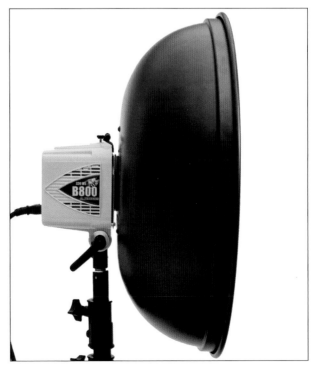

size. But take this with a grain of salt. I'm not a professional beauty photographer, and I admit that they're probably more sensitive to the nuances of their specialty. My biggest reason for choosing a small, black backed umbrella over the beauty dish is the difference between $22 (a little umbrella) and $300 (the cool beauty dish). My portraiture style usually calls for a much bigger and softer light source like a 60-inch umbrella or a big softbox. We'll discuss those accessories in one of the following sections.

Play with a beauty dish. You might find it irreplaceable. Then again, you might find it about as useful as a 20- or 32-inch umbrella. With all light modifiers, so much is subjective and dependent on your style. That's my two cents' worth.

Telephoto Reflectors. Some companies offer longer, narrower reflectors that are meant to throw a beam of light a long distance by concentrating it into a narrower pattern. These are usually marketed to sports photographers who are trying to get some light on an athlete at a distance. I've never felt the need for one, so I can only assume they do what they're designed to do, and if you have a burning need to light something 50 feet away you'll want to look into them. At least you now know that they exist.

All of the above reflectors are standards in most well-equipped equipment lines. There are lots more to choose from, but you needn't own every article in a manufacturer's catalog to do great work. My research tells me that most of my peers use one or two reflectors year after year and supplement those with one or two favorite attachable light modifiers.

UNIVERSAL MODIFIERS

I don't know why, but I think of the metal reflectors as an organic part of the lighting instrument. By that I mean that you wouldn't normally use a monolight or a studio flash head with just the bare tube unless you were experimenting with some sort of special effect. Right? So no matter which brand you end up with, you'll probably get the standard reflector and it will stay on the light until you have a need for a different looking light. When you do, you'll probably

choose what I call a "universal modifier." I call them this because most people will end up owning and using one of the two following modifiers—softboxes or umbrellas—for just about every shoot. The standard reflector is like the "kit" lens of the digital SLR camera world. It usually comes with the camera in the box for not much more money than the solo camera.

Softboxes. Let me get my prejudice out of the way at the very beginning. I love softboxes. I own way too many of them in way too many sizes. And I refuse to get rid of any of them! Here's why: from small to ridiculously large, softboxes have a very nice transition from highlight to shadow when you use them correctly. There's an old rule of thumb (like the one for beauty dishes) that says you should use them at a distance that is roughly twice the long dimension of the box (e.g., if you have a 16x20-inch box you'd use the softbox at about 40 inches from your subject). Of course, rules are made to be broken, and I often use my biggest softbox (about 54x78 inches) less than 2 or 3 feet from my subject. The second reason why I like them is that only the front diffuser panel of the softbox emits light, so there is no spill light bouncing around the studio, reflecting off of walls, and reducing the contrast I'm working hard to get. Finally, I like softboxes because I can take them apart, pack them, and transport them with relative ease. (That's something I've never said about multi-bulb fluorescent fixtures or big beauty dishes.)

Most popular softboxes are built like little fabric tents. At one end is a front diffuser with a pole stuck in a pocket at each corner. The boxes taper toward the rear where a metal "speed ring" holds the other end of the metal poles and provides an attachment point for the lighting unit.

Ostensibly, some research has gone into the design of softboxes to enable them to evenly distribute light across the front panel. Most softboxes bigger than 12x16 inches usually come with a rectangle of white cloth that's suspended parallel to the front diffuser, somewhere between the light fixture and the front cloth. Its purpose is to spread out the light. The reality is, with interchangeable speed rings and the ability

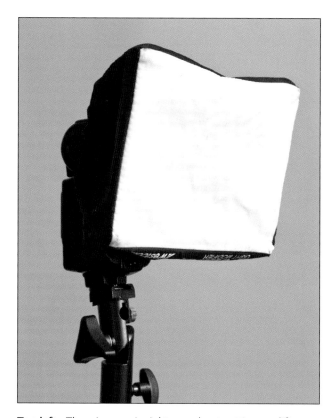

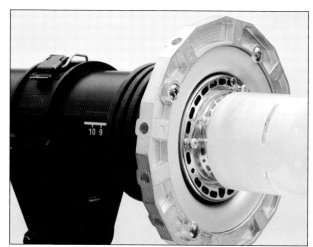

Top left—There is a mania right now about putting modifiers on small flashes, but people sometimes miss the point that a small light source usually needs a big modifier if it is to take the place of a heavier, bulkier light unit. While this small Westcott softbox—used on the front of a battery powered flash—will soften the edges of the highlight-to-shadow transitions when used close up, physics is physics. To get softer light, you'll need many more square inches of diffusion. **Top right**—When you shop for a speed ring, you should probably consider one that is made with eight sockets for softbox poles. The extra four sockets are there for those times when you want to use an Octabox or Octabank—and if you light portraits, you'll eventually want one. **Bottom right**—I make extensive use of softboxes in the studio and on location. For example, my standard light on a background is a small (16x20 inch) softbox used close to the background. This gives a nice halo of light around a portrait subject.

to accommodate many different flash heads, it would be nearly impossible to design a softbox with a perfectly even distribution of light across the front panel—and I'm not sure photographers even want that. Some of us even remove the middle panel so that the light is stronger in the middle of the box and falls off in intensity toward the sides. It gives you a greater ability to feather the whole softbox to be able to use the penumbra effect discussed above.

Softboxes come in a range of sizes and shapes. You can choose from tiny softboxes that measure 5x8 inches (designed for use on camera flashes) to those that measure 15x40 feet (from Chimera). The little boxes will set you back $20 or $30, while the big Chimera goes for a bit over $20,000. If you are shooting cars and trucks in a studio, you might want to check out the big Chimera model. For the rest of us, the range from extra small (somewhere around 16x22 inches) to medium (24x36 inches) to large (30x40 inches) and extra large (54x72 inches) should cover

HOW TO SET UP A SMALL SOFTBOX

First, lay the softbox out on the floor.

Hold the end of the speed ring that fits on the light up away from the box and insert one of the poles into one of the sockets.

Make sure the pole is all the way into the socket and that it is fully inserted into the softbox corner.

Insert the second pole into the opposite socket. You might need to flex the pole by pressing down on it to get it properly inserted.

Continue with one of the two remaining poles. It should be relatively easy to insert because there is no direct pressure from the opposite side.

The insertion of the final pole will probably require you to push the speed ring down toward the pole with one hand while flexing the pole with the other hand.

Flip the box over and make sure all four corner sockets at the "business end" of the softbox are properly seated.

Here's what the softbox should look like when it is set up.

Most softboxes have extra cloth with Velcro closures to fit tightly around the flash head. They prevent light from spilling out the back end.

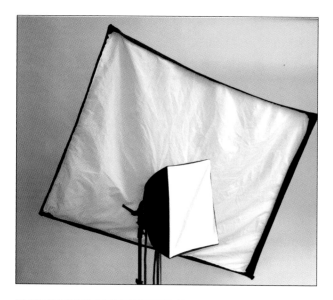

Above—This is what our final shot looks like. Softboxes give a soft but quick transition from highlight to shadow when used close in. The background glow was provided by a gridded electronic flash covered with a blue gel and used at full power into a black background for maximum saturation.

Top—Depending on how close you need to work and how soft you want to get the light, you'll need different sizes of softboxes to get the look you want. The softbox in the background measures 40x50 inches and it is my medium box. The box in the foreground is about 12x16 inches and is very useful for soft, close work with small objects. **Bottom**—When we light things in the studio we use plenty of softboxes. One reason is that they are soft yet controllable. I'm using a white card to block spill from my top box to the background. Note that I'm using black net to reduce the output of the softbox on the right because I can't turn down the older monolight I'm using any lower.

most of our needs, and even the largest of these will set you back less than $500.

You'll notice that all of the boxes mentioned are rectangles, but that's just the tip of the softbox iceberg. Softboxes are also available in a configuration called "strip lights" which are long, narrow softboxes. These are specialty modifiers that still life photographers use to put cool highlights on wine bottles. Fashion photographers use strip lights to light models, producing a quick falloff of light on either side of the lighting instrument. If you run a busy studio and find yourself in constant need of a softbox that has a ratio of, say, 21x84 (inches) or 14x56 (inches), then one of these might be right for you. Those of us who use strip lights once or twice a year might be better served by taking a large softbox we already own and creating a strip bank by masking off some of the big box with some black cloth.

Back in the 1980s, Elinchrome came out with a softbox called an Octabank. It was a large (72 inch) octagonal softbox that emitted a very elegant light and broke the mold for softbox formats. It was instantly snapped up for use in portrait and fashion studios around the world. A little cottage industry even

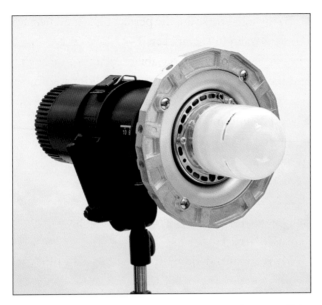

Above—This image shows a speed ring on a Profoto monolight. While there is no universal standard for the end of a speed ring that fits on the body of the flash head, the end that holds the rods of a softbox are pretty standard and allow for a wide range of softboxes to be used without headaches.

cropped up that did nothing but make adapter rings for every other manufacturers' flash heads. Eventually, Photoflex and just about everyone else came out with their own variation of the Octabank. It is a delicious light source for portrait work, but it is still (from a physics point of view) just another softbox.

My take? Every studio and corporate shooter could use one small, one large, and one extra-large softbox. Every manufacturer would like you to believe that their materials are superior or that their designs have transmuted the laws of science, but I don't see too much difference in the output from one manufacturer's softbox to the next. There might be some nice features you'd be interested in, like a nice extended lip that gives you the opportunity to attach cloth grids or vent holes to help keep the interior cooler, however. Most manufacturers make a second line that is specially constructed to work with hot lights. Do your homework before you plunk down the money. The dramatically cheaper units don't use the same quality parts and construction, but once you hit the sweet spot extra money doesn't buy dramatically better "usability."

A thought about speed rings—when you first set up your softbox and try to get the tightly flexed poles into the holes on the attached mounted ring, you will be forgiven if you assume that the speed rings were designed by sadists. The whole softbox thing depends on cloth being held in a certain configuration (and without wrinkles!) by highly flexed metal or fiberglass poles. The speed ring is the nexus for the poles. While it's not always the most elegant solution, it sure beats early mounting systems. The secret is to not put too much pressure on the poles when you assemble or disassemble the box. The better units allow you to de-tension the poles for disassembly by opening the little Velcroed pockets that hold the poles at the front diffuser of the boxes. Getting the poles into the softbox calls for judicious bending and a certain blind faith. Broken support poles are the number one cause of softbox failure. If you hear something go "snap," you will be looking for a replacement pole.

Word to the wise: read the setup instructions because it can be frustrating to try to get the poles into the slots on the speed rings when the poles are properly tensioned. You sure don't want to have a pole revolt and smack you in the eye! It happens.

Umbrellas. Want all the benefits of a softbox for less than half the price? Now we're talking about umbrellas. As much as I love my softboxes, I have a sneaking suspicion that I could do just as well for most setups with a nice selection of umbrellas, and I bet I could get by spending a lot less cash.

There's nothing complicated about umbrellas. Photography umbrellas are just like rain umbrellas, but they are white and (sometimes) they are built to a better quality standard than our typical rain umbrellas. White photo umbrellas are pretty cool because they fold down just like regular ones, but when they are opened they provide lots of square feet of soft, reflected light. The umbrellas that most photographers use are commonly available in the following sizes: 32 inches, 48 inches, 60 inches, and 80 inches. What do you get from progressively bigger umbrellas? Progressively softer light. That's about it.

White umbrellas are great and very efficient but have one shortcoming: light goes through the fabric and bounces all over the place, which messes with your

attempts to maintain the right contrast in the scene. But there's a simple fix for that. Many manufacturers make their photographic umbrellas with two layers of fabric: a white or silver fabric on the inside of the unit, where the light meets the cloth, and a black, opaque fabric on the outside to keep the light from spilling all over your set. The best are the models that allow you to remove the black layer and "shoot through" the umbrella, using the white fabric as a front diffuser instead of using the reflected light from the unit.

Several manufacturers take their umbrellas one step further. They supply a white diffuser screen that fits around your flash head and attaches to the tips of the umbrella rods to create an inexpensive but highly practical version of a softbox. My favorite units are made by a company called Photek. They call my two favorite umbrellas Softlighters. They are available in 48- and 60-inch varieties, and I have one of each.

To my mind these are the perfect light modifiers for most portrait photographers. They have everything: a nice, soft white interior; the ability to "shoot through"; and the option to use a diffuser for additional softness. At half (or less) the price of a softbox, they represent a good compromise between cost and features.

On the other hand, you may be looking to spend a good deal of money on umbrellas. If that's the case, note that several manufacturers have designed and produced umbrellas that range from 5- to 12-feet in diameter and fit the description of a parabolic or "focused" reflector.

My recommendations? If you shoot a lot of scenes in the studio that require white backgrounds, you'll want to get four identical white umbrellas with black backings to use in lighting your background evenly. The 32-inch umbrellas will give you a good, even spread of light without taking up too much space.

Below—There's a certain kind of umbrella I really like. I like the ones with black backings that keep light from spilling out 180 degrees from where you are trying to put the light. I prefer umbrellas that come with extra diffusion screens that fit over the front opening to make the light they send out even softer and more even. This is an 80-inch umbrella from Lastolite. It's a great value.

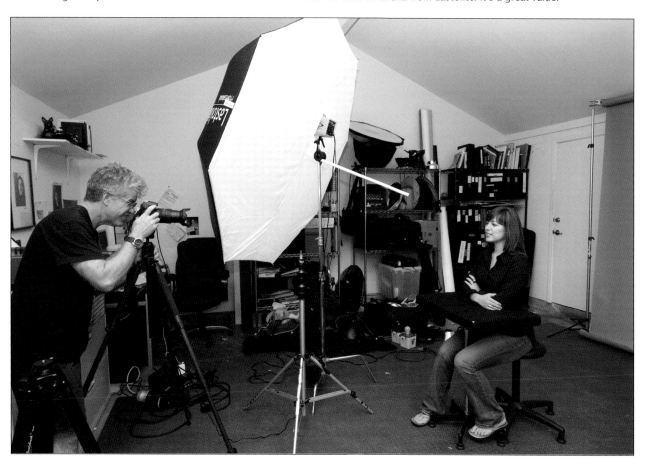

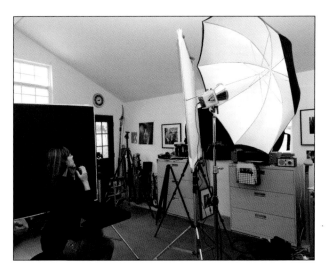

Top left—I love the look of a giant white umbrella used close to a subject. It gives me a beautiful wraparound light. In this image of Anne, I've added a black light subtracter to the opposite side to boost the contrast of the shadow/highlight ratio. **Bottom left**—Here's what it looks like from behind Anne. Notice how big the 80-inch umbrella is in relation to her. Also, notice how close in we used the black panel for subtractive lighting. **Top right**—A slightly different setup that uses the same basic idea: 60-inch Photoflex umbrella with a black panel to the other side.

If you shoot portraits, I recommend a larger umbrella as your main source because, when they are used close to your subject, they yield a soft light that wraps beautifully around a face. My number one recommendation is the 60-inch Photek Softlighter. If you prefer a slightly contrastier look, you might want to go to the smaller, 48-inch size.

It is also important to know that you can get photographic umbrellas made of materials besides soft white. An umbrella with a highly silvered surface adds a bit more efficiency. The trade-off, however, is that the light has a harsher quality with more specular highlights.

Some even make umbrellas with gold metallic fabric. The idea is to warm up the light bouncing off the surface. I've tried using these and using gold reflector panels but I've found the same problem that I get when mixing fluorescents with daylight it is impossible to make good, global color corrections! If you want to warm up the scene it's probably best to just do it with your camera's white balance. Better yet, shoot it in a neutral color setting and warm up your image in your processing software. Balcar made a series of um-

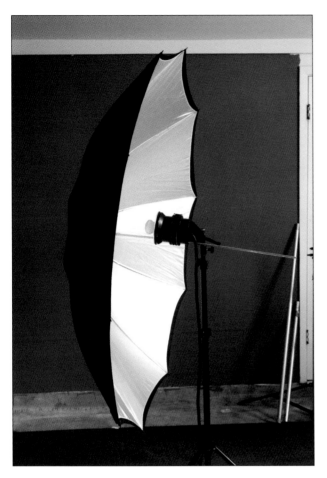 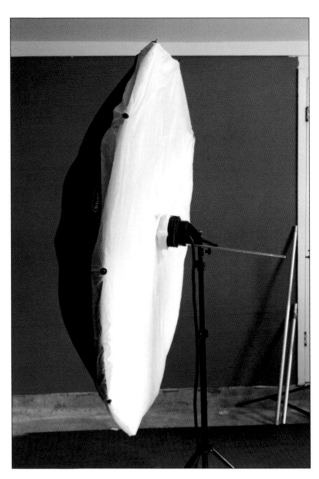

Left—One of the all-time-favorite (and pretty cheap) light modifiers used by thousands of photographers is the 60-inch Photek Softlighter. It's basically a nice umbrella with a black backing to prevent light spill. **Right**—The Softlighter becomes much more than an umbrella when you add its diffusion cloth. There's even an elastic collar that fits around most flash heads. Voilà! Now you have a 60-inch Octabank that you can set up in two minutes for less than $100.

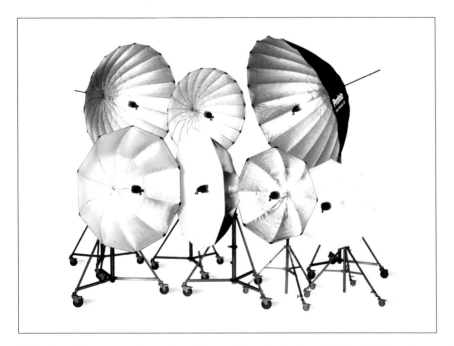 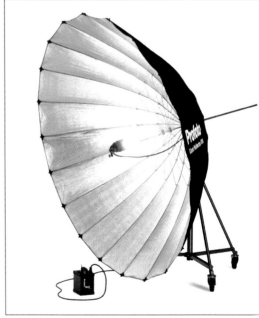

Left—Here is the range of extra large, focus-able umbrellas from Profoto. Similar units are offered by Briese and Broncolor. When used correctly, they can be focused so that they yield a sharp and directional light, like sunlight. When unfocused, they can be used as soft-lights like less "lofty" umbrellas. **Right**—This is not the light modifier for you if you are just starting out and working on a real budget. Cynicism aside, the light, when focused, is absolutely beautiful. Units like these are rented and used by fashion photographers when the right budget is available.

brellas they called "zebras," which use alternating panels of white and silver. Maybe they thought it was the best of both worlds. I have one and use it with a diffusion cloth.

Summing up umbrellas: These lighting accessories have been around for a long time and it's no mystery why: they provide a nice, soft light; they are inexpensive to purchase; they set up quicker than just about any other accessory; they are a snap to carry or ship; and they fit just about any light source you can come up with. Starting at under $30, why would you not have a few carefully selected versions sitting around the studio?

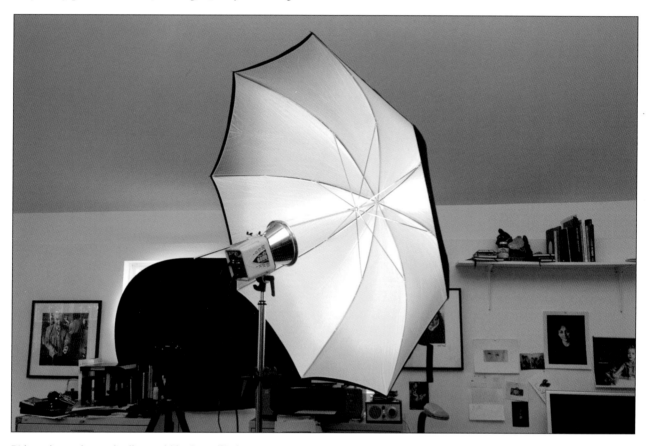

Did you know that umbrellas could be "tuned"? There is an optimum position at which the flash head illuminates the umbrella without any spill out the side. It is at this position that the umbrella is most efficient and controllable. Experiment by moving the light along the shaft while watching for spill.

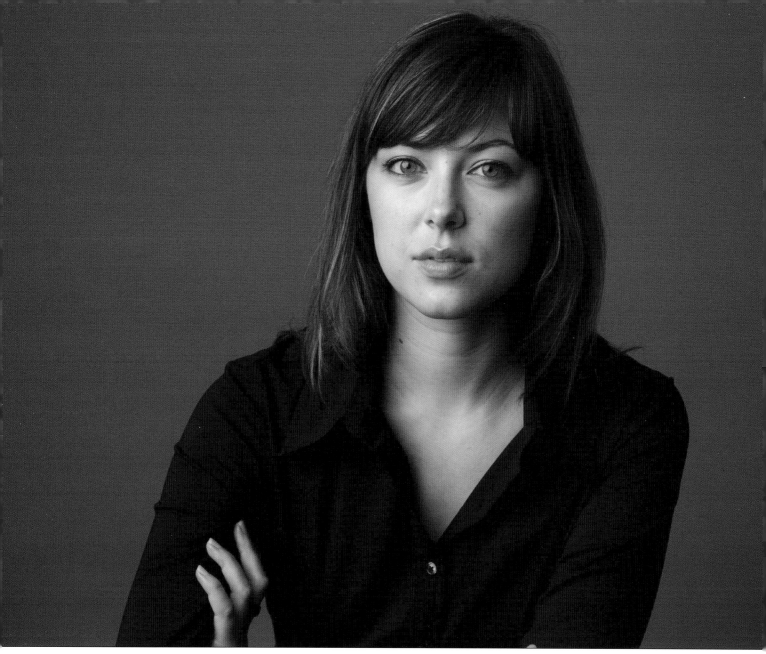

Photo—There are a lot of really fancy modifiers on the market, but the good-old-fashioned 60-inch umbrella, used with a good grasp of theory, can be wonderful! **Diagram**—(1) Studio wall painted neutral gray. (2) Subject, positioned 6 feet from back wall. (3) 60-inch Softlighter 2 umbrella with front diffusion. (4) 48x48-inch black subtractive lighting panel. (5) Fuji S5 camera with 28–105mm zoom lens, placed 6 feet in front of the subject.

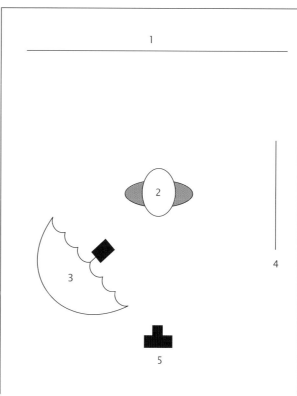

THE PHYSICS OF LIGHT

Whether you use softboxes, umbrellas, or just a big piece of foam core, you'll find that your lighting follows the basic rules I've talked about: (1) The closer the light, the softer the light. (2) The bigger the light, the softer the light. (3) The closer the light, the quicker the falloff, which generally equals subtly more dramatic portraits.

Here is a series of images that beautifully illustrate these points.

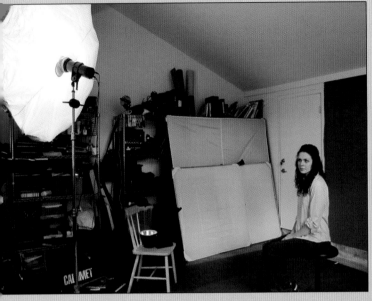

*Left—Let's see what happens to the overall quality of light as we move a typical light source closer and closer to the subject. Here's the setup with a 60-inch Photek Softlighter umbrella at 8 feet. **Right**—The 60-inch Softlighter umbrella with its front diffusion screen installed is positioned 8 feet from Leslie. The walls and the ceiling of the room are white. The actual shot shows the effect of the relative proximity of the light source to the subject. Camera: Canon G10. Manual exposure.*

*Left—Here is the same 60-inch Softlighter at 6 feet. See the "after" photograph to understand the subtle changes that closer proximity makes in the final image. Camera: Canon G10. Manual exposure and white balance. **Right**—When we move the Softlighter to 6 feet, the light softens as it wraps around the subject.*

Top—By moving the umbrella even closer, the light wraps around Leslie's face even more, adding a greater feeling of dimensionality to the image. Once the umbrella is closer than 4 feet, we start to see the falloff of light from one side of Leslie's face to the other. *Bottom*—When we move the Softlighter in to 4 feet from Leslie, all kinds of interesting stuff happens to the light. Transitions get softer, but at the same time the falloff increases.

5. OTHER LIGHTING ACCESSORIES

MODIFYING, MOVIE STYLE: SCRIMS AND SILKS

If you choose to light with hot lights or just want to do things in a different way, you can forego the softboxes and umbrellas and light the way cinematic directors of photography do—using a combination of panels. In movie parlance, any panel that has a fabric that is meant to diffuse light is called a "scrim" or a "silk." These generally range in size from 32x32 inches to 12x12 feet (larger silks are available, but they can be frightfully expensive and require a lot of manpower to set up and manage). Silks or scrims usually consist of a rigid metal rectangular frame made of interlocking aluminum rods that can be covered with a range of different fabrics. In the movie industry, where directors of photography like to have very tight control of their lighting, the white silk or nylon diffusing fabric comes in different strengths from less to more opaque. The most opaque fabrics provide the softest light (all other factors being even). Typically, the fabrics are available in ¼-stop, ½-stop, 1-stop, and 2-stop strengths. And of course they can be added in layers to provide exactly the look you need.

The same frames can be used with white panels that are totally opaque; when used this way, they serve as reflector panels rather than diffusers. Used with black panels they can be very effective as "subtractive" lighting instruments. When the panels are used to block light they are variously described as gobos (a quickie contraction of "go betweens"), cutters, or flags (in vernacular use: "Dude, can you flag off that light? I'm getting a vicious reflection."). If you need ultracheap blockers and reflectors, don't write off good-old-fashioned foam core boards. You can get them with white on one side and black on the other and then you've got yourself a good, convertible panel. The cool thing about most of the pro systems made for still photographers is that they can be broken down into very small packages for easy packing and moving. This is not the case with the traditional gear used in the movie industry, where heavy metal, noncollapsible frames are used.

These panel systems can also be used as "nets." Nets are black screens that let light through but cut it down, like neutral density filters for your lights. Just like the

Left—Black net is a wonderful way to cut down light on only part of a scene. It's great to use these Chimera frames if you are using very soft lights since the wraparound nature of the soft lights won't show a shadow from the edge of the frame. Look at the difference between the light on our model's arm versus the light on her hand—it is amazing since the hand is closer to the light source than the rest of the arm. **Right**—Chimera offers a frame and fabric system that is fast to use, collapses down to about 2 feet long, and gives you the flexibility to use diffusers, nets, reflectors, and black panels, which are vital for subtractive lighting.

"silks" for the cinema scrims, nets come in various strengths, the most common being 1- and 2-stop subtracters. To envision a net, picture an inky black screen material that looks like the stuff on a screen door but is made out of nylon or some other black fabric. These are just right for cutting down the light falling on parts of a main subject. A great example is that of photographing a person in a white lab coat. If you are using a medium softbox and you've aimed it at a person's face, the light may be way too strong on the closest shoulder. Left alone, the light will burn out the detail on the white lab coat. If you stick the appropriate sized net in between the part of the subject that needs to be darker and the light, you'll be able to knock down the exposure without the hard-edged shadow that would result from using a totally opaque light blocker.

The panels made for still photography tend to be a one-size-fits-all solution because most of the mainstream, compactible frames are either 4x4 or 4x6 feet and they have poles on all sides. Cinema productions use Matthews products called flags, and these usually have one side open with the fabric just stretched across. Because of this, they can be used very close to the subject or used with hard light without any danger that there will be a sharp shadow from a structural bar. These panels, with their open side for shadowless transitions, are used on every movie set and are also called "nets." More and more photographers are using this sort of specialized "grip" gear to gain more control over their lighting.

Additionally, the cinema products come in a range of sizes and shapes that give the director of photography a lot more control when he wants to dodge a specific size and shape of light off an actor or a set piece. True to the cinematic tradition of naming things using goofy names, the longer blockers are called "fingers" and the round ones are called "dots."

Screen material in black or with no color cast is a wonderful thing to have in your bag of lighting tricks. Here are the ways I find it very useful:

1. As a window blocker. Let's face it: during the better part of the day, the sunlight coming through

Above—Not every photo accessory has to cost a fortune. While I have a set of nets for my Chimera panels I find screen door replacement material at Home Depot hardware stores is just as effective and so inexpensive it is almost free.

windows is going to overpower all but your biggest lights. If you need to show a window in a scene and you need to see natural detail outside the window, you'll need to take action. A layer of 2-stop net will drop the intensity of the light coming through the glass but still give you believable detail when your camera looks through the window.

2. As a neutral density filter for your softbox. Here's the situation: you've set up a beautiful portrait shot at a cool location and you want to use a really wide aperture so you get that cool effect where everything just slides out of focus. In fact, the only thing you really want to have rendered crisply is

USING THE BIG STUFF FOR ALL THE RIGHT REASONS

California photographer Ken Brown uses big scrims because he has to. You see, he lights cars, and lighting cars is really about creating beautifully done reflections in very shiny and highly crafted sheet metal. Car photographers know that what you want to create with your lighting is long, wide, soft-edged reflections with no wrinkles, seams, or other imperfections that will show up on the mirrorlike finishes of the cars.

We'll take a look at Ken's setups on these two pages.

Here's what Ken says about the giant scrims he calls "sails": "I routinely use a 20x20-foot Matthews sail overhead to light cars, people, products, and whatever else requires a very large light source. Its size allows people the freedom of movement when shooting and it can even be used to light small sets. The light it produces is beautiful, likening the effect to an overcast

The car is surrounded by white reflector panels, but all of the light comes from one dominant light source, the 20x20-foot scrim hung on a special frame, over the top of the car. In this example, Ken is using four different light sources to provide light, but we know that the diffuser is the actual light source relative to the car.

Top—Ken's 20x20 foot sail is generally used close to the cars he lights so that the "transfer effect," the transition between light and dark areas, is seamless and gradual. The human was added for scale. *Bottom*—By tilting the sail and having one side closer to the subject than the other, Ken is able to introduce a subtle but important gradient from one side of the composition to the other. My question: Does Ken get to drive these cars around when he's finished photographing them?

day that can be angled and adjusted to suit one's fancy. While I primarily use the silk indoors, the frame came with tie downs and rigging for use outdoors. However, I have not been brave enough to try that yet."

Even though Ken uses his sail mostly for car shots, the large scrims had their origin in movie lighting where they were first used to diffuse sunlight and later used with large lights to emulate soft daylight.

About Ken Brown: Born and raised in Southern California, in the home of a classic car enthusiast, Ken learned to appreciate the sways of a tailfin and the sparkle of a chrome bumper at an early age.

California's film industry influences and attracts its young citizens, and for a while, Ken thought that would be his endeavor. Ken graduated from UCSC with a degree in Film Studies, but his career path took a detour when he discovered still photography.

Though his first love is the cinema—particularly film noir, chiaroscuro, and German expressionist cinematography—his still images retain the influences of this cinematic orientation. Ken's work represents the merging of these influences into automotive imagery.

Ken considers John Alton, George Hurrell, and Orson Welles his chief influences.

the subject's eyes and lips. You want to use an electronic flash in a softbox but you've dialed the light all the way down and there's still too much light to get you to f/2. Some smarty suggests moving your softbox farther from the model, but that will make the light contrastier and you won't get the effect you crave. You also don't want to change the basic look of your light. Pop a 2-stop net over the front and you'll have your preferred f-stop without messing with the physics of your light source. Wonderful. Also, you'll feel cool having proven that you are in total control!

3. The background darkener. This is my favorite use. Here's the setup: You are out on an exterior location and you're going to do a photograph of a person. You set up a 2-stop diffuser over the subject's head to kill the harsh, direct sunlight. You fill in the person's face but you want to use a wider aperture than f/16. Your camera syncs at $\frac{1}{250}$ second. The base ISO of the camera is 200.

A quick meter reading tells you that the appropriate exposure for every part of your scene that's not covered by the 2-stop diffuser should be f/11.5. Rats! You were hoping to shoot at around f/5.6 with your long lens. No problem. Put your 2-stop net on a frame and pull the fabric tight so there are no wrinkles to mess things up. Now have your assistant walk the frame into the background directly behind the subject. Have them go back until you can just see the edges of the frame, then come back a little bit until you lose the frame. Now the black net is covering the entire frame, perhaps 10 to 15 feet behind the subject. A long lens will help you keep the detail of the net out of focus and will reduce the size of the background that shows in the boundaries of the shot. Presto, you've dropped the exposure 2 stops, you've used the aperture you wanted, and you've gotten the balance you want between your foreground subject and your intended background. *(Note:* If you'd forgotten to bring the net along, you could find a line of green trees to shoot into. Even in direct sun, they will look good when exposed up to 2 stops over. Just stay away from showing the sky in the shot because it will go solid white!)*

You can buy screen material, nets, or Matthews cinema-grade instruments. It all depends on your budget. Each will do the job. A Matthews flag mounted on a special light stand with adjustable arms will give you unrivaled ease of setup and a vast range of adjustment. A roll of screen door material purchased at the discount hardware store can be stretched between two light stands and save you a ton of money. The other solutions fall somewhere in between.

Top—This is a 2-stop net that is normally used to keep light partially off a scene. Here's a likely scenario: You are lighting a doctor in a white coat with a large softbox. The light on his face is perfect, but you can see that the shoulder closest to the light is too bright and all the detail will be burned out. By using a flag to cut just the light on his shoulder, you'll be able to drop the exposure there without leaving a line between dark and light. **Bottom**—Again, the flags are color coded and the green surround designates this net as a "1 stop." You can see the effect by looking at the metal door in the background.

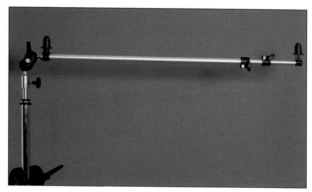

Top left—While I prefer hard-framed reflectors from companies like Chimera, I also use circular pop-up reflectors where speed and quick packing are essential. Here is a "five in one" unit showing the white side. Top right—Most pop-up systems feature a gold reflector side. I'm sure it's great for warming up an image, but I've never seen the point of using one to warm up only part of the scene. I prefer to make global corrections. Bottom—This arm is made to hold various sized collapsible reflectors on a stand. The reflectors can be placed exactly where they are needed and will hold their position. They allow for more precision than can be achieved by having a person try to hold a reflector still.

COLLAPSIBLE ROUND MODIFIERS

It was a smart inventor who came out with the wire sprung, round reflector panel that can be collapsed down to half of its working diameter. It was probably the same guy who invented the pop-up light reflectors for car windshields. These are really handy to have on location and in the studio. The first generation was a circular white cloth reflector that was tightly sprung by a tension wire band at the circumference of the disk. They were 32 inches in diameter. These lightweight reflectors caught on quickly, and soon the irresistible momentum of product line extension brought photographers the same kinds of cloth surfaces that could be found in cinematic reflectors, including translucent scrims (available in various densities), silver and gold surfaces, and black surfaces for use as light blockers.

The sizes grew larger. You can now get the pop-up reflectors in sizes as large as 4x6 feet. And they made them smaller. I have one that is about 12 inches in diameter.

The currently popular offering is to have all five surfaces, silver, gold, white, black, and translucent, in one package. The only version that hasn't been carried over from cinematic lighting accessories is the net surfaces. Not many articles have been directed at photographers about their use. I'm sure someone will mention it in a very popular book, and soon it will become all the rage.

If you are using these round reflectors, you'll need to have an assistant or an arm attachment to hold them in place at the top of a heavy-duty light stand. I prefer the collapsible panels because in the past I've had to

travel extensively, and when I've found a round pop-up reflector that was big enough for my taste it was too large, even when folded down to fit into my cases. The collapsibles can ride along with the light stands without any problem.

BACKGROUNDS

While not part of lighting per se, I want to mention backgrounds because they will often help to determine how you light a subject. You'll also want to know how to hang them. There is a healthy industry devoted to making cloth backgrounds for still photographers. Most manufacturers have settled on a standard width of between 9 and 10 feet and a length of 12 or 24 feet. Light stand manufacturers offer a number of models that will accommodate the 9-foot width, and they are fairly inexpensive.

Muslins. The least expensive backgrounds are made out of synthetic muslins and are dyed in one color. Next up the price ladder are muslins that are dyed in two colors, with splotches or variations that the manufacturers seem to think photographers will like. The next upgrade is "custom splotched" muslin.

Muslin has the advantage of being cheap and lightweight, which means it is easy for the manufacturer to handle and easy for photographers to carry around and set up. But it wrinkles. A lot.

Canvas. The next step up is to canvas, and here again you go through a similar evolution from primary gray through variations that are as splotchy as a Jackson Pollock painting. But with canvas backgrounds, you can actually ascend to an even loftier level . . . the hand-painted scenic background! These gained popularity during the 1950s (the golden age of portrait photography) when many studios invested in different painted backgrounds with scenes that might include a library shelf filled with leather-bound books (perfect for the student or lawyer portrait), a peaceful wooded glen (just right for children in matching outfits to stand in front of) and even cornier stuff like Las Vegas signs and tropical paradise renderings. In the 1990s, giant sky backgrounds were all the rage. If you want to sample the range of available cloth backgrounds, complete with sewn loops made for easy hanging on a background stand bar, you'll want to check out a company called Denny Manufacturing. They've got it all. They are online at www.dennymfg.com.

Hardware. The basic hardware you'll need in order to take advantage of these kinds of backgrounds is one set of background stands, complete with an adjustable cross bar, and a bag full of welder's clamps to hold things in place and stretch uncooperative fabrics.

Generally, muslin comes out of the bag highly wrinkled and, in spite of what the manufacturers say, the wrinkles don't "fall right out." While the manufacturers tried to get a style going that incorporated ugly fold marks and wrinkles, it didn't pan out when it got to the client approval stage. That's why photographers carry handheld steamers or spray bottles of water with them when they set off to use a muslin on a job. To combat the wrinkles, set up your favorite muslin. Stretch it out and hold it in place with your welder's clamps and then spray it with a fine mist from your spray bottle. In time (depending on circulation and humidity), the wrinkles will go away. (*Tip:* Make sure that your muslin wasn't made with colors that run! Test a small corner before fully committing to the above plan.)

Background Paper. Most studio photographers also keep a ready supply of background paper. It comes in two widths. One is 9 feet wide and the other (which I never bother to buy) is about 5 feet wide. You'll nearly always want the 9-foot variety. Pick up one roll of black, one of white, and one of thunder gray. A lot of shoots end up on either white (for stuff that will be dropped out in Photoshop) or gray (because it's a good neutral backdrop for portraits). You'll need to keep some in stock. The black gets used when we need to cover windows.

6. THE SUPPORT STAFF

You'll need to mount these lights, modifiers, and backgrounds on some sort of support before they start to earn you money and do their work, so it's time to talk about light stands, magic arms, clamps, super clamps, booms, and other utilitarian stuff. None of these things are cool and sexy the way a new camera or a big lens is, and you won't be able to wear them to a photo meeting or out on the town, but you'll quickly find that having the right gear makes all the difference in the world when you are trying to do your work.

LIGHT STANDS

Where to begin? If you always used your lights in exactly the same place, you could nail them to the wall and be done with it. But seriously, you want to be able to position your lights differently for every subject you shoot. Most of us choose to use light stands because they represent the best compromise between mobility, utility, and cost. But even in this narrow product niche, you'll find plenty of choices.

If you shoot with small, battery-powered flashes, you'll likely be able to get away with using smaller, cheaper light stands. I really like the Manfrotto model #3373, a very small stand with five sections. The stand goes up over 6 feet and does a good job of holding a Nikon SB-800 flash and a small umbrella. It's really good for light duty and is great when I need to carry around two or three small stands, but I'd certainly never put a 12-pound monolight on top of one. For general still photography use, where the worst-case scenario might be an 18-pound monolight or electronic flash lamp head with a 4x6-foot softbox on the

Above—There are many things to look for when buying a stand. One of the first is to make sure that the stand you select has a ⅝-inch stud for attaching industry-standard devices. Shy away from stands that don't use standard studs.

front, I would want something stout like the Manfrotto model #3364. This unit goes up to 13 feet and holds a maximum load of somewhere north of 30 pounds.

If you want the most popular professional stands for studio work, you might as well get Century stands

THE SUPPORT STAFF 99

Top—While hardly the most glamorous piece of equipment, the lowly floor stand is probably one of my most used pieces of gear. It sits right down at floor level and can securely hold a small softbox with a flash head. **Bottom**—The floor stand can bring a light down to floor level.

(also called C-stands). These migrated to still photography from the movie industry and come with a short arm that attaches to the stand with a grip head. The bottom part of the stand has three adjustable legs, and the whole bottom structure is referred to as a "turtle." The body of the stand comes in three basic sizes: 20 inch, 40 inch, and 60 inch. It's nice to have a stand that can support a light down low, so I have a 20-inch stand. It's also nice to have a stand that goes up high, so I have a 60-inch model. These stands are quite heavy, which is why I think they are best for use in the studio.

A Century stand with a couple of 40-pound sandbags is pretty darn stable. You can put a lot of weight at the top of a properly sandbagged Century stand and not worry about it. You might think you could do the same thing with just about any stand, but you'd be wrong. The majority of lighter-weight stands aimed at still photographers just aren't built to work well with sandbags. The only place to balance a sandbag is over one of the struts, and these are generally made out of aluminum and will bend and break if too much weight is stacked on them.

The Century stand is made even more useful because of its grip head (a clamp system) and its arm. The arm functions like a mini boom and can be the perfect thing to mount a flash head, flag, or scrim on. Since the termination at the top of a Century stand is so solid, it anchors the grip head and arm very securely. I've even used the arm to hang heavy props from with much success.

I've described a few of my favorite tools, but you should be aware that the range of available light stands is enormous. There are small stands that help you position lights just inches above the floor and there are stands that can be elevated to 30 feet. There are stands that are designed to be conveniently stacked when not in use. There are ultralightweight stands and there are brutally heavy stands with cranks that lift the sections up. These are called "wind up" stands, and they can cost upward of $4000.

There are a few simple rules that I like to abide by when I purchase light stands. The first is that I won't buy anything I can't carry myself, and that pretty much rules out the $4000 stand, which is good, because my second rule is to not spend more than $200 for a light stand. Every stand must go higher than 6 feet (with the exception of specially designed, floor-level stands). All future stands will be black. (I bought some silver-colored stands on the presumption that they would not get as hot in the Texas sun as black ones, but I rarely shoot outdoors and I find that reflective stands have an uncanny way of showing up in the shots in a way that only becomes obvious when the shoot is wrapped.)

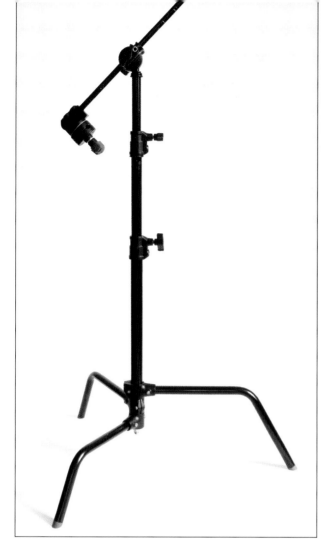

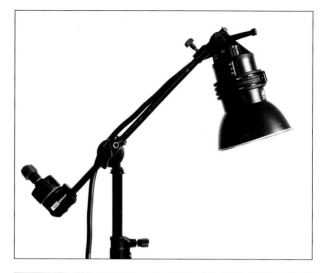

Top—This is one of the many uses of the Century stand arm and grip head mechanism. This fabulous stand system is often pressed into service as a mini boom. **Bottom**—The legs of the Century stand can be placed at different angles to fit around obstacles. A version of the stand comes with the top leg adjustable for uneven surfaces.

Top—The Century stand is a crossover from the movie industry. It's sturdy, reliable, and flexible. I use these in place of conventional light stands for many applications. **Bottom**—An important part of every Century stand is the arm with its incorporated "grip head." The grip head will hold Chimera panels and other accessories at many different angles.

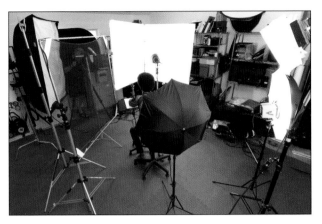

When we get working in the studio, we use a lot of light stands. It's good to have a mix of sizes because the smaller, less expensive stands really come in handy when you just want to fly a small piece of foam core into the mix. I count ten in this scene, but I'm not so good at "Where's Waldo?"

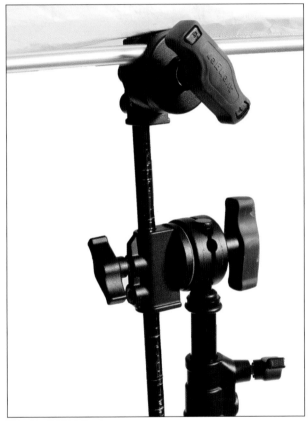

Top—The top leg of a standard Century stand is a wonderful place to put a sandbag. A sandbag is cheap insurance! **Bottom**— The grip head at the end of the accessory arm on a Century stand was made to hold reflectors and scrims at just the right angle, without moving. The big knobs let you really clamp things in place.

Stay away from light stands that have plastic locking collars at each section, since this is a weak point that will eventually fail. Stay away from thin, single piece aluminum legs. Stay away from stands that use tiny thumbscrews for the section locks. They are a pain to use and won't allow you to apply enough pressure to ensure that they'll stay locked when your stand is fully loaded.

Light stands aren't the only way to secure lights, they are just the most convenient way to secure lights that you'll want to move around and adjust. The stands I've talked about above are just my favorites, and you should know that every photographer is probably most comfortable with what they learned on when they were starting out, so you might want to do a little research at www.manfrotto.com and see what catches your eye. If you don't want to use the stands available from Manfrotto/Bogen, you'll want to check out a large supplier like B&H Photo and Video (www.bhphotovideo.com) and look into the stands available from other manufacturers.

In most product lines you'll find stands that are air cushioned, wheeled, wind up, compact, and general purpose. The air-cushioned stands have a pneumatic property that keeps the light from crashing down if you accidentally release a section lock without supporting the head. If you are clumsy, you might consider that "G-force" trauma is a leading cause of light

Top—Every gear rental house paints their gear a specific color. When gear comes from more than one rental facility (especially for a huge and complex project), it makes it easier to get equipment back to its rightful owners. **Bottom**—There's nothing quite like a truck full of gear to get the creative juices flowing. This is the inside of the back door of a lighting truck. Think 18 wheeler full of lights.

Top—As with anything else in the movie lighting realm, sandbags are color coded by weight! **Bottom**—Clamps seem to be the one tool that crosses over all disciplines—stills, video, and movie making.

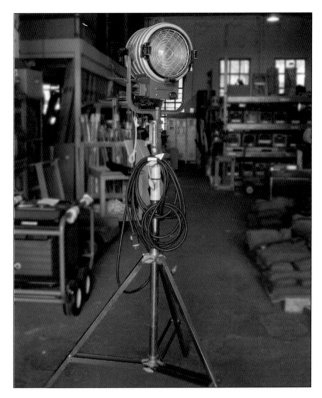

Above—A solid light deserves a solid stand. The stand itself weighs over 25 pounds. If you start to use movie lights in your work, you might want to suggest weight lifting classes for your assistants.

failure. If all of your time is spent in the studio, you might enjoy the luxury of wheeled stands because you won't have to lift them to reposition them for your shot.

I shoot a lot on location, so I need two kinds of stands. I need the smaller ones that will hold battery-powered electronic flashes when I feel constrained by time issues or an irrational desire to make every shoot minimalist. I prefer a stout stand like the Manfrotto #3364 for just about everything else because, at 6 pounds, they are still highly portable, and at 13 feet, they lift the lights high enough for my taste. You can't beat the price, either: they cost less than $100.

I really believe that everyone needs two specialty stands. One is a stand that has one leg that can be extended farther than the other two so that you can level your lighting support on uneven ground. I have a large and very sturdy Lowell stand that does just that. I know Manfrotto/Bogen also offer several. The second specialty stand every photographer should consider is the Century stand. It's just right for all those times that you need to sandbag the hell out of a stand and have it be immovable, unbreakable, and totally reliable. It's like the security blanket of light stands.

BOOMS

Booms are long arms that have a counterweight at one end and are meant to hold a light at the other end. When you need to suspend a light fixture right over the top of something, they are absolutely irreplaceable! The gold standard for most photographic studios is the Manfrotto Super Boom. This boom alone is almost $400, but it's worth every penny because you'll be able to suspend a heavy light over a set and control the angle and rotation of the light from a wheeled crank at the opposite end of the boom. This means you'll be able to fine tune your light without resorting to climbing on stepladders or stools, or lowering the light, adjusting it, raising it, testing it, and then doing it all over again. There are lots of other options, but the serious guys always end up with this sucker.

If you do mostly studio work, then bite the bullet and get the Super Boom. If you do mostly location work and only occasionally do work that calls for a boom, you might be able to get by with one of the many shorter (and cheaper) booms on the market like the Avenger 600 Mini Boom or the Matthews Baby Boom. Though they don't offer the adjustability of the Super Boom, they are quite usable with smaller loads. Rest assured, if you think $400 for a boom is pricey, it's just because you haven't been smitten by the charms of the $4500, 17-foot Matthews Maxi Boom.

In a pinch, I've used a $25 Matthews grip head and a removable middle section of a light stand as a boom. Always keep some good clamps in the bag. Photography is one of those fields where the practitioners do more improvisation than comedians.

CLAMPS

Speaking of clamps, no studio or location photographer should consider leaving home without a little set bag filled with clamps. This is what I fill mine with:

Left—Throughout this book you'll see references to sandbags. They might seem like overkill when you are hauling them around, but every light on a stand in an area accessible to the public should be sandbagged for the safety of your expensive gear as well as the safety of the public. **Right**—The grip head is the secret to the modifier system. It can be rotated on the arm and tilted up or down. If grip heads were removed from movie sets, everything would come to a halt.

Left—Set bag. There are hundreds of camera bags on the market, but this is not one of them. This is the type of bag that the grips on movie sets use to carry their tools, gloves, and clamps around in so they're ready in the blink of an eye. **Right**—The lowly wooden clothespin is too often overlooked. It will be sad when they are all replaced by plastic ones. In my studio, we use wooden clothespins to hold filters in front of lights. The wood might smoke a bit if it is heated up too much, but it won't melt! A well-designed reflector comes with a bit of a lip that works well when you need to hang things off the front.

Left—At the end of the day, it's the clamps that hold most photo shoots together. This is a plastic variation of the welder's clamp. It's great because it is lightweight. On the downside, it doesn't resist the damaging effects of heat like metal clamps do. **Right**—Among the cheapest of all useful photo accessories you can buy are the lowly welder's clamps that are available at all the large, discount hardware stores. From clamping cables up out of the way to holding your backdrop in place you'll use them on every shoot.

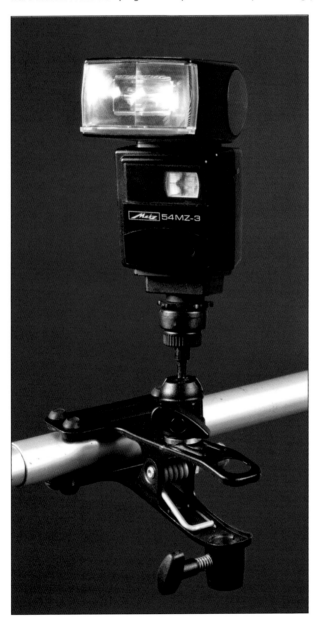

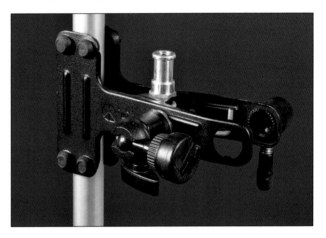

Left—This Justin Clamp from Manfrotto was used to hold a flash in place on a 1-inch pipe. The small ball head is a tremendous help in positioning small lights. **Right**—The Justin Clamp also comes with a standard ⅝-inch stud for attaching standard light heads or grip accessories.

1. *Clothespins.* I like to have a supply of old-fashioned wooden clothespins in case I want to attach a gel to a flash head or a tungsten fixture. Even the steady heat of a modeling light is enough to melt a plastic clothespin, which will result in a mess and a smoldering plastic smell. I also find them handy for non-lighting work like pinning a model's wayward frock or holding cables in place. A bag will set you back about two lattes and will last forever.

2. *Welder's Clamps.* We pick these up at discount hardware stores and use them to hold backdrops in position, clip big frocks into place, and generally grip stuff.

3. *Justin Clamps.* I love these. They're made to hold a small flash unit and will clamp securely onto just

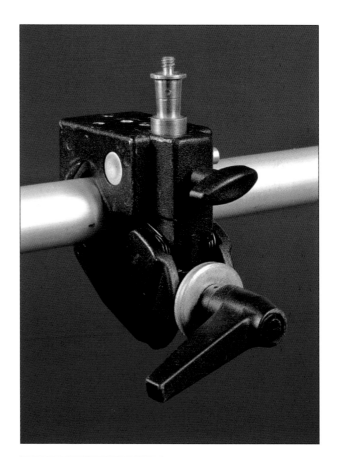

about anything. I've clamped them to chairs, doors, shelves, and tables. Keep a couple in your bag for those times that you've run out of light stands and you still need just a few more little accent lights.

4. *Super Clamps* (known as Maffer Clamps in the film industry). These bitey little devils will hold up just about anything. I once used two of these to hold up a hammock with a 160 pound model in it for a studio shoot. They have a hole on one side that will accommodate a light stand or an arm. They come with a stud in place so that you could clamp them to just about anything and then mount a heavy light on them. In still life sets I'll often have a bunch of these clamped to the edges of my shooting table holding short articulated arms with light blockers, mirrors, and other modifiers on them. They are pretty much indestructible!

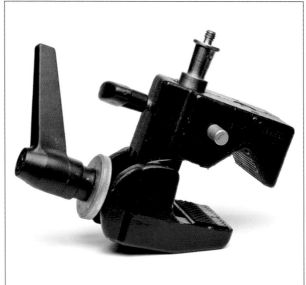

5. *Articulated Arms.* Bogen/Manfrotto makes this thing called a Magic Arm. You can put a Super Clamp on one end and then put just about anything you can think of on the other end and it will hold the object in place. We use them to hold cameras in precarious situations and to secure flash heads and other big stuff. You can unlock the arm, adjust it, and re-lock it—and whatever you position will not move. It's just a great problem-solving piece of gear.

6. *Gaffer's Tape.* Okay, gaffer's tape isn't actually a clamp, but it's a lifesaver. We use gaffer's tape for everything—*not* its nasty second cousin, duct tape. Gaffer's tape is easy to tear and sticks well. When you remove it from a wall it doesn't take the paint

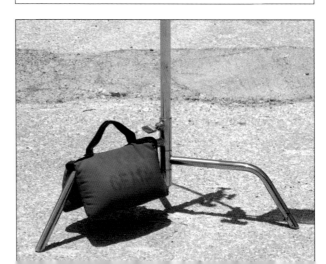

Top—There are many colors and widths of gaffer's tape available. We use the bright pink on the legs of our light stands when working in darker public areas so that the black legs are easier to see. Most pros stick with white, gray, and black. **Bottom**—Camera tape in many colors is used to mark settings and distances. I like tape in pretty colors.

with it. If you like tape in general, you'll love this stuff. I keep it in stock in white, black, and gray, but it is available in a wide range of colors, including dayglo magenta. Why? Well, I use it on the legs of my black light stands when we are shooting in an environment with very low light levels. It's a visual safety thing that keeps people from not seeing the legs in the dark and tripping over them. It also looks cool.

ATTACHING THE LIGHTS

Just about every light you buy (with the exception of on-camera flash units) comes with ⅝-inch mounting hardware. It's usually the hardware on the bottom of the fixture that allows the light to be tilted up and down and clamps onto the light stand. The connection can be friction locked with a knob. Here's my only advice on mounting gear: Make sure you've got the locking screw all the way in before you walk off and have a cup of coffee. If the screw is halfway in, the light might not sit securely on the stand. Always make sure the locking screw is backed all the way out when you go to mount the fixture on your stand. Secure it, clamp it down, and then give it a tug to make sure the connection is sound!

I would be remiss if I didn't mention two other mounting options for the busy studio photographer and one other option for the highly mobile shooter. Studio photographers sometimes use ceiling rail systems and mount their lighting equipment overhead so they can move it around the studio without having stands on the floor. Lights are mounted on scissor-like assemblies that can be raised and lowered while also being moveable along the rail's X and Y axis. Systems like this free up a lot of floor space and make sense for studios that do the same kinds of shoots over and over again. Companies like Foba make a basic system that is available for less than $5000.

Another variation that is popular with booms that are used in the same configurations day after day is wall mounting. This is a pretty limited application, but it can work well for photographers who repeatedly use the same setup to shoot products. It obviates the need for a light stand and the associated floor space.

If you are constantly on the move and don't have the luxury of setting up unattended lights, you should consider what we jokingly call "voice operated" light stands. Train your assistants to hold your light in their hand or at the end of a monopod or boom. The beauty of this simple solution is that you can constantly have them reposition themselves during a shoot. Before you dismiss this approach out of hand, you should be aware that the incredibly famous fashion and fine art

Left—Every part of the industry-standard Century stand is built for rugged reliability—even the mounting stud, which is carved out of solid metal. That makes for a very secure connection between light and stand. **Right**—The bare stud on a Century stand also incorporates rubber rings to cushion lights when changes are made.

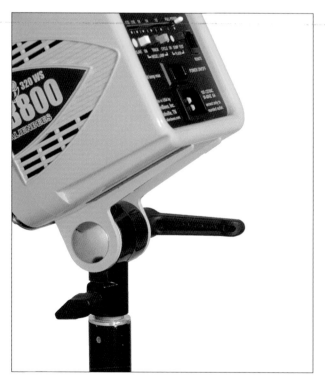 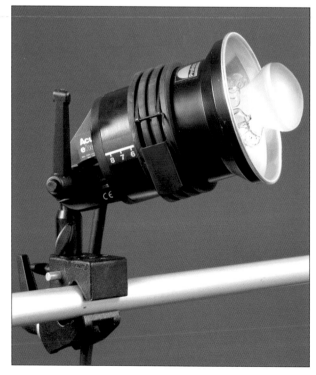

Left—One of the weak spots in the AlienBees mounting hardware is the plastic connector that attaches the unit to the light stand. While the connectors seem to stand up to wear and tear, they cannot be clamped down too hard without the risk of cracking. That, and the plastic against plastic friction lock for the unit's tilt control are the reasons why the pros who routinely use heavy light modifiers tend to upgrade to more robust units. The AlienBees are a wonderful value for amateurs and photographers who don't place heavy physical demands on their gear. Camera: Canon G10. Lighting: Westcott TD-5 with fluorescent tubes and fill cards. **Right**—The Super Clamp is one of the most useful tools in a photographer's lighting accessory kit. With the included stud that fits nearly all standard flash and hot light mounts, the Super Clamp can help you put a light just about anywhere and will hold onto it tenaciously.

Top—The worst thing to run out of on location is extension cords. I pack twice as many as I think I'm going to need. Running power from several circuits lowers the risk that we'll start popping circuit breakers during the shoot. **Bottom**—Better quality pack and head systems use very stout cables to connect the head to the pack. The thicker the wire gage, the less energy there is lost to resistance. The configuration of a good connector ensures your safety by eliminating current arcs when disconnecting.

photographer Richard Avedon used this very approach for many of his famous studio shots of models and celebrities!

EXTENSION CABLES AND POWER SPLITTERS

Every studio runs on electricity and requires an abundance of extension cables and cords. However, pack

and head systems have their own wiring needs. Most heads for pack and head systems come with fairly short cabling between the pack and the head. This is done to keep from losing power to line resistance. (Remember that the current going through the cable has been raised to a much higher voltage! This increases energy loss over distance.) Since the connection to the flash pack itself is by a proprietary, multi-pin plug, you must use a dedicated cable with corresponding male and female connectors on it. These cables are big and heavy so that they can offer less resistance; still, they absorb about 1 stop of energy for a 20-foot run.

Why is it important to know this? Well, if you have a pack and head system and you need to move a light pretty far from the power pack, you'll need to spend several hundred dollars and 1 stop to do it. This is yet another argument for using monolights or dedicating one head to each pack. I just thought you should know.

TRANSPORTATION

If you've chosen the minimalist route and want to try to do everything with three or four flashes, you'll still need a way to conveniently carry around your gear and the associated light stands and modifiers. I recommend a rolling case from a company like Think Tank, Kata, or LowePro.

A set of monolights or an electronic power pack and a few heads seem to want to travel in a hard case like one of the indestructible Pelicans or Tundra. Just make sure you get a case with a great set of wheels! Try to keep your case to less than 50 pounds so you can handle getting it in and out of rental cars without hurting your back. You'll also find that less than 50 pounds is the limit for domestic airlines. Anything over 50 pounds makes your luggage overweight and subject to extra charges on every leg of your journey.

Finally, if you will be lighting with a clutch of bigger hot lights, you'll likely want to haul your gear around in a truck or at least a Honda Element or similar vehicle.

Part of the fun of packing is the search for the ultimate case. Since every photographer seems to pick

different combinations of light and accessories, there is no one-size-fits-all case that you can plug into the packing equation. You'll need to search for the one that fits your inventory. Often it's multiple cases—a rolling case for the lights and a stand case for light stands, tripods, and light modifiers. Everyone has a different idea of what constitutes the best-case scenario.

 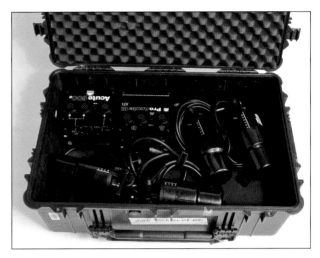

Left—The Pelican case is like the Kevlar vest for photo gear that travels. We've used the 1650 cases for nearly fifteen years and they're still in one piece. More importantly, so is our gear. Right—We reconfigure the inside of the Pelican cases for every type of assignment. For local shoots where the gear will travel by car, we don't bother with the foam padding or dividers. After we've tossed in the extension cords and a few speed rings we just handle everything with care. When we ship on an airline, we pad the tops and bottoms of the cases and get less stuff per case. Over time you learn what works.

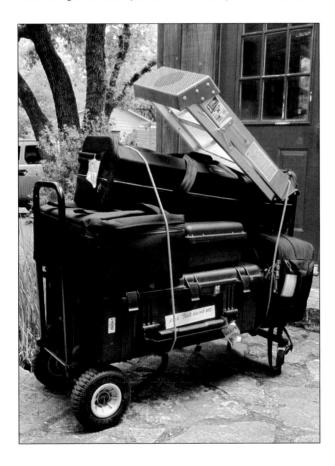

Left—Using a rolling cart keeps you from wearing yourself and your assistants down. It folds down far enough to fit easily in the trunk of most cars but extends far enough to carry just about anything. It will handle 500 pounds of gear. Right—The right luggage cart is one that allows you to take everything you need on location and get it into the client's building in one trip. The Honda Element is the ultimate lighting geek car. You can even fit a 9-foot roll of seamless into the car without removing the seats.

7. BUILDING YOUR PERFECT KIT

For the traveler, when it comes to building a lighting kit, the watchwords are "compact" and "lightweight." You'll want to sacrifice raw power for packability. My barebones travel kit, when I know I'll need to add light, is comprised of three SB-900s with an SU-800 remote module to trigger them. I also add

The first step is to "fly" a scrim over the top of our model to diffuse and cut the harsh sunlight. Please note that there is a sandbag on the stand!

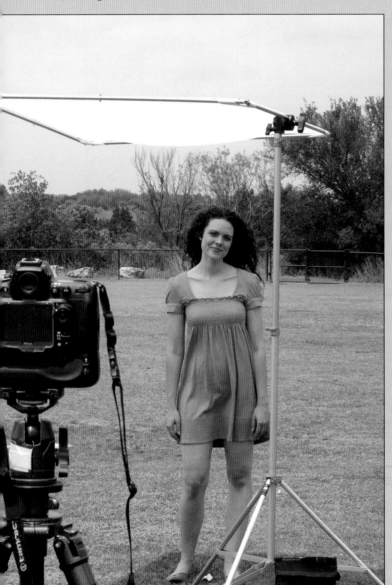

cheap radio triggers for backup. The SBs are joined by three of the Manfrotto #3373 small profile light stands. I'll throw in two umbrellas (32-inch, white translucent ones) and one LightSphere knockoff. I always bring a meter just in case I really want to know what's going on with the exposure. The final addition is as many rechargeable batteries as I can find in a pinch. I stuff the case with pre-cut color correction and color effect filters and I am ready to roll. I can get all this and a week's worth of clean underwear into one Think Tank Airport Addicted rolling case, and it fits into the overhead compartment on all large commercial planes. For mixed light locations, no other portable solution offers as much flexibility and power per pound.

LOCATION WORK

For the location portrait shooter I've got a different mix that isn't totally focused on size and portage. I live in Texas, and most of the time when we shoot portraits outdoors we're trying to overpower the light of the sun. I really need at least one light that can deliver enough power to push lumens through an umbrella or softbox and still give me f/16 at 100 ISO at a distance of 6 to 8 feet. That means a unit like the Elinchrome Ranger, the Hensel Porty, or my favorite, the Profoto Acute 600b. These are all pack and head systems that run on battery power. Typically, I'll take two of the Profotos and use one for my main light and one for a background or accent light. If I need a few more light sources for small accents, I'll also bring two small camera flashes like the SB-800s that we've still got around

the studio. Since I use the Profotos with bigger light modifiers, I want to bring along bigger stands, like the Manfrotto #3364s. When I'm outside, I make sure each unit is anchored to the ground with sandbags or water bags for safety's sake. The lights and accessories fit into a rolling Pelican case, and the stands fit into a semi-hard, wheeled case. Add a 48-inch Softlighter umbrella or two and the usual accessories, and we're ready for exterior or interior portraiture with few compromises. Add a few sheets of foam core, and we're ready to do great editorial and retail portraits on location, just about anywhere.

If you are shooting in the sun, don't forget to take a 1-stop scrim, either a collapsible one with a good holder or a Chimera or other hard-frame unit so that you can block direct light on your subject.

FASHION AND BEAUTY WORK

Fashion and beauty photographers who work in the studio have several needs that regular portrait photographers and travel photographers don't. Most work in studio environments so that they have ultimate control over their images. That means that many of them end up using big cameras (film and digital medium formats) and they use big lighting modifiers like softboxes to give the light a flattering softness with some directional control. Additionally, work destined for catalogs and advertising needs to have soft, noise-free skin tones, and that means using cameras near or at their lowest ISO settings. In the medium format digital world, this looks a lot like ISO 80. When you add it together, what you really need in order to shoot studio fashion is lots of power and fast recycle times. Add in the option of shooting full-body shots against a curved (cycloramic) wall and you'll also find that you need four additional flash heads just to light up the background. The bottom line is that you'll need big, fast monolights or several pack and head electronic flash systems to make it all work. My recommendations for a regional studio would be to get several power packs in the 2000–2400 watt-second range. You might not need all that raw power, but you'll be able to turn the packs down to half power in order to get the faster re-

cycle times you might need. You'll find appropriate pack and head systems from Profoto, Comet, Dynalite, and Speedotron. If you want to go the monolight route, be sure you buy units with built-in fans to deal with heat buildup during day-long shoots.

You'll want at least two packs and six heads or six 600 watt-second monolights. If you are shooting with national or international clients and you demand a no-compromise approach to fashion work, you'll want the new Profoto Pro Air 8 system. And again, you'll need two packs and six heads to be able to handle all kinds of work. You'll end up with an investment of around $30,000 just for packs and heads.

Can you shoot fashion with less of an investment? Of course. You can start with a set of AlienBees monolights and shoot with faster ISOs. You can go with all hot lights and develop a style that doesn't depend on capturing frozen motion. I'm just including the Profoto Air 8s so you know what's out there and why it is sought after by the top pros in the field. The most important thing to remember is that you are being hired for your vision, not for the gear that you own!

THE ULTIMATE OUTFIT

What if you want to go with the "full Monty" and outfit the ultimate studio? I'd say you'll need a trust fund or a visionary banker, because the financial investment will be breathtaking. First of all, you'll probably want to have every flash head ceiling mounted. Then you'll want trolleys packed with high-powered studio electronic flash power packs. Depending on what type of subjects you photograph, you could work with big power packs from Speedotron, Broncolor, or Profoto. Dynalites top out at around 2000 watt-seconds and are really better used as powerful, on-location systems.

Finally, think of the coming convergence. The people who predict the future are all saying that soon we will be turning to video for at least a portion of our professional incomes. What this says to me is that we've got to think about our lighting investments to take into consideration the idea that our subjects will be moving! And that means continuous light tools. Just on a cost and power basis I think we can safely

eliminate LED lighting in the short term. That leaves HMI, tungsten, and fluorescent lighting. HMI is wonderful and matches daylight color, but the systems are brutally expensive. Tungsten is robust and the output is satisfying purely from a power point of view, but the 3200-degree color temperature means more problems when trying to mix them with daylight, and their energy use is off the charts. Fluorescents are efficient and in the color ballpark when compared to daylight, but their output is a bit limited and the size and fragility of the bulbs makes traveling with fluorescents more problematic. So how is a photographer to decide?

As a one-person business with a pathological avoidance of large entourages, I try to keep things light and simple. I can't afford the cost of owning HMIs. Instead, I'll rent them from the cinema rental house we are lucky to have here in Austin. But they are still expensive, so I will only use them on paying jobs where I can get client approval for their cost.

If a job calls for video, I'll press my tungsten hot lights into service because I already have them and their consistent output is easy to deal with on the job. But, if I were starting out my business right now, without any real inventory, I'd be easily swayed by the new, high-output fluorescent fixtures from Westcott and Interfit. They are quiet and run cool and, when not trying to match full sun, they do put out a decent amount of power. Your mileage may vary, but if you are trying to press a Canon 5D Mark II or a Nikon D90 into service as a commercial video shooting rig, you'll find that their clean ISO performance makes them a good match for the power output of these new, low-cost fluorescent units. And the cost of acquiring them is quite low.

A BUYING PHILOSOPHY

Look, this book is about lighting gear, and I wanted to introduce you to a whole range of instruments and go over their intended uses, but that doesn't mean that I advocate buying a bunch of gear at the outset of your business venture. I think it's a lot better to bootstrap your way into acquiring inventory, getting pieces only when you need them for a series of jobs and only when

you know that you'll be able to recoup your investment costs in a very short amount of time.

I recommend that you rent gear that you don't need very often. Don't consider buying it until you have rented it five times or more in a given year. This will keep you from buying things like tremendously long telephoto lenses when you might only shoot surfing once every ten years. It might also keep you from getting a Profoto Air flash system (instead of a small car) when you only need to shoot dancers leaping into the air, frozen at the zenith of their arc, once or twice a year.

If you do need to buy the gear, look to the future when you make your initial acquisitions. Buy lights in a system that is expandable or scalable. You might want to start with a small power pack and head system, so make sure that the heads will work with a bigger power pack down the road so that you have the option of upgrading without having to trade in all of your existing equipment. Once you've found a system that works for you, stay in that system for "horizontal" purchases. You might start with a pack and head system and then decide you also need a monolight. If so, try to stay with the same systems, as all of your modifiers will probably fit the new light as well as the older one.

Be consistent when you purchase new monolights or flash heads. Some manufacturers offer plain flash tubes and UV corrected flash heads. There are arguments for both, but you should choose one and stick with it so that the colors match from source to source. That's important when you are using all of your flash heads on a shoot and want to be able to make global corrections to your files. Additionally, understand that your ability to shoot quickly is limited by the recycle time of your slowest unit. If you buy a state-of-the-art pack and head for your main light but use slower technology for your background lights, you may have obviated most of the advantages of the newer lights. They'll have to sit and wait for every other light in a scene to recycle before they are ready to go again. If you outpace your other lights, parts of the scene not lit by the main light might be underexposed or the background lights might not fire at all.

When buying hot lights, you'll have more leeway to mix and match, as different sized lighting instruments usually have different diameters and take different sized accessories. Also, since the bulb in the fixture determines color and output, the same bulb in fixtures from several different companies usually has the same characteristics. When buying hot lights, keep in mind your actual uses. While fresnel spotlights are very sexy, they are 50 to 100 percent more expensive than regular, open-faced floods with the same power ratings. If you love soft light and are always bouncing light from large white reflectors or putting light through white silks and scrims, you may save good money by just going with the regular lights. Conversely, it's the very quality of light coming from a fresnel-covered lighting instrument that sometimes compels me to use hot lights in the first place. If you are like me, you'll have a mix of inexpensive and efficient floods and a selection of fresnel spots. This way, you can light a scene most of the way with some bounced light while using the spots to throw in nice slices of accent light to bring depth to a scene.

Remember, whatever you like to use in the hot light category will require you to work in the confines of a location's electrical power constraints or cause you to bring along your own electrician to do a "tie-in." Try to get by with the least number of fixtures and the lowest power you can.

Buying Used. There is a simple test for buying used hot lights. Put them on a stand and fire them up. If they go ten minutes with no smoke and no other issues and the controls are smooth, workable, and lock tightly into place, you can buy with impunity. Buying used hot lights is a bargain since there is very little to wear out and they are very straightforward to repair.

I'd be more careful when buying electronic flash units. If you are in the market for a camera flash and you do this for a living, buy a brand new one. Small, battery-operated units can sustain invisible damage if they are fired too fast at full power too many times in a row. You won't be able to see it, but the faults may manifest themselves weeks or months down the road. If you buy them new, you will know their provenance.

If you are buying an electronic flash system that uses a rechargeable battery, you should set up the system and recycle it at full power, waiting for it to fully recycle at least twenty to thirty times to make sure nothing is amiss. Try all of the controls (even the ones you might never use on one of your own shoots) and try plugging in the charger as well. A light that's been used is better than one that's been in the closet for several years because the electronics need to have electrical power flowing through them on a regular basis to keep the components up to snuff. If the battery tends to run down quickly, be sure to factor in the replacement cost of a new battery and weigh this total closely against the cost of a new unit.

If you are buying a used monolight or pack and head system, you'll want to plug it in, turn it on, and go through every control on the box and on the heads. You'll want to test it at full power and minimum power and every setting in between. Does the audible recycle indicator work? Do the modeling lights ratio correctly? Does the sync socket work without misfires? Does the box get hot to the touch while it's just sitting there idling?

If you've tested it for half an hour or so, you can be relatively sure that you'll get a decent unit. Most electronics fail catastrophically, so you'll find out about any defects or faults in the first ten to twenty minutes of working with a light unit.

Caution: It's not always a good idea to buy much older models or brands of flash equipment because they may lack the critical safety features that are being incorporated into the latest stuff.

The one category I have no trouble buying used gear in is the support equipment. Photographers always seem to attract more light stands than they ever really need. Sometimes they buy out the inventories of retiring or failing studios with an eye on cameras and lights and get the light stands as part of the package. If you can get your hands on them, get the biggest, heaviest, and easiest to operate for your studio. Get the best quality lightweight ones for your location kit. You can expect to pay less than half of the usual retail price. This also goes for tripods, providing that all of

Above—Even in the new digital universe, lighting experts know that it's important to bring all the different color temperatures in a scene into the same solar system. Rolls of gel are available in a wild variety of colors.

the adjustments work as they should and that any included tripod head is smooth and its locking levers work as they should.

GET A GOOD LIGHT METER

There is a common conception that, with the availability of LCD screens on the backs of cameras and the ease of bringing up histograms for each digital image, the separate light meter is no longer necessary or relevant. Nothing could be farther from the truth. If you are young and new to photography and you've only had experience shooting digitally, you might think that a meter is like an odorless albatross around your neck and that it has no use. But you might find, after working with a digital camera for a couple of years, that film is still around—widely used and widely available—and that people are doing really nice images that look very different from the work being produced by the mass of digital-only photographers. You'll need to have a flash meter to work with film, as most cameras have no built-in flash metering at all.

You may find that what you saw on your LCD screen bears little resemblance to what you'll see on your computer monitor and that the correct use of a meter might have saved you time and effort fixing things on your computer. And you may find a meter a lifesaver if you need to make sure that the ratios between lights are correct.

I find myself using a meter more and more these days, even though I have a number of state-of-the-art digital cameras. Each camera shows me a different histogram of a scene than every other camera because all of these cameras are working as "reflected" light meters, which means that their readings can be thrown off by the subject's reflectance or the presence of large amounts of bright areas or very dark areas. Even the best multi-point evaluative meter will yield overexposed skin tones for a waist-up portrait of a man in a black tuxedo. Conversely, a portrait against a white wall is almost always underexposed, as the camera's reflected meter sees the majority of the scene being white. The camera's reflected meter always wants to make everything average out to 18 percent gray!

A good handheld light meter gives you two ways to measure exposure. You can take a reflected light reading or an incident light reading.

Here's the difference: With a reflected meter, you aim the meter's sensor at a scene and it measures the light that is reflected off the scene. This is really great if the scene you are metering is a block away or a mile away and you can't get any closer to take a more accurate reading. But several things throw off the accuracy of reflected light readings:

1. The meter is calibrated to expect that everything in the world, if put into a light blender, would average out to about 18 percent gray. So when a meter sees a black object, it tries to make it 18 percent gray and overexposes the object by 2 stops or more. When the reflected light meter sees a white object, it will deliver readings to make the object 18 percent gray. In fact, the only time a reflected meter gives you a reading that doesn't require your knowledgeable intervention is when the object you are metering is 18 percent gray.

2. The meter measures everything that falls within its view and averages the reading. This means that, in a typical outdoor scene, if the meter measures both the supermodel in your foreground and the bright sky in the background, it will assume that both objects have the same relative importance and will factor them both into the reading. A large swath of bright sky will offer the largest percentage of measured area and will cause the meter to underexpose your supermodel. A very unhappy outcome is assured.

Most multi-meters (ones that offer flash and ambient metering capabilities) have a device that resembles half of a Ping–Pong ball stuck to them. That's really an incident dome that integrates the light falling on it and allows for an accurate incident light reading. With an incident light meter (or a meter used in that mode), you are measuring the actual light that is falling upon the object of your interest. It is absolutely indifferent to light or dark area distributions because those are a manifestation of the light's reflection, not an absolute measure of the quantity of light falling on the object. When used correctly, the incident meter is both color blind and tone blind and so doesn't require the kind of interpretation that a reflected light meter does.

Usually at this juncture in an explanation about differing meter methods some smarty pants wants to argue that reflected meters are better because you can meter the subject from far away. The example given is usually something like a fierce polar bear or a nuclear blast. But here's the funny thing: if you are standing in daylight and the polar bear is standing in the same kind of daylight a mile away from you, the kind and quality of light falling on you and the bear will probably be identical. Therefore, if you make a reading from your position, chances are high that the reading will be correct for your ferocious polar bear as well.

If you find yourself close enough to measure the light coming from a nuclear blast, you have other problems to occupy your few remaining minutes.

In practice, you'll find that very few professional photographers use the reflected light metering capa-bilities very much, if at all. Nearly everyone who uses a handheld meter uses it in its much more accurate incident mode. And the more picky the photographer, the more likely they are to use a handheld meter. There is one in each of my equipment cases. I suggest you use one too.

Which brand should you buy? It doesn't matter. Pick up a good Minolta, Sekonic, or Kenko meter and be done with it. If it measures flash and ambient light and gives you the ability to measure in both the incident and reflected mode, it's a good meter. Calibrate it with the camera you use the most and then use it as often as you can!

THE WRAP-UP

What to buy? If you are doing photography as a business, my best advice is to buy as little as you can and use it for as long as you can. I know people who have the latest Nikons and I know professionals who are still getting along just fine using a D1x and really, there is very little difference between their work when all is said and done. People with the least amount of gear it takes to get the job done seem to spend a lot less time worrying about equipment and a lot more time actually doing their art.

If you are starting out as a portrait photographer, you could probably do great work with just two lights and a handful of accessories. Looking back over the years, I find that I could have done most of my best work with just two 300 watt-second monolights and a hunk of white foam core board. You could get started with two AlienBees monolights, an umbrella or softbox, and a couple of light stands.

Starting out this way is great. Use the lights you have until your growing style butts up against the limitations of the lights. At this point, you'll have a much greater understanding of what you might need to buy next.

If you intend to do still life photography, you might want to start with tungsten lights because you'll be able to take advantage of small spotlights and big soft-lights for a very modest amount of money. Since you can extend the exposure time to accumulate light, you

Above—They call these apple boxes. Studios all over the world use them when they need to elevate something on the set or when a photographer needs to temporarily be a little taller. They come in three sizes: "full apples," "half apples," and "quarter apples." They are stable and stackable. Sometimes the low-tech stuff makes all the difference in the world.

can shine an inexpensive light into a large source, like a bed sheet or a white wall and have the benefit of a big spread of light (ensuring a soft effect) without the expense of bigger or more powerful fixtures. Be sure your studio can be completely darkened during daylight hours so you don't have any contamination from daylight. After you've mastered the nuts and bolts of lighting products with hot lights, you'll know what you might need to acquire next to round out your business tools.

If you are mixing video and photography, you'll need hot lights or fluorescent lights. I've listed two examples for fluorescents and shown a number of hot lights. You'll have to decide what attributes are most critical for you. Do you need lights that run cool? Do you need small spotlights? Is your lighting style one that uses big soft washes of light or smaller, dramatic lighting effects? Each parameter will drive you toward one light source or the other.

I guess you can see that my basic advice is to always start small and simple and to complicate and acquire only when you have mastered what you've got and feel hampered by the limitations of your equipment.

Another common question is, "How much better are the expensive brands?" This is a tough one for me. I started out with next to zero in capital and boot-

strapped it every inch of the way for the first ten years or so. I made do with cheap gear and do-it-yourself accessories that worked okay. But once the business was profitable and we had some money in the bank, I started taking a good, hard look at my lighting gear and decided to buy some decent stuff. I started out with Norman electronic flash equipment and owned an 800 watt-second pack and two of the 2000 watt-second PD 2000s, and they worked well for me for nearly a decade. In that decade a lot of advances were made in flash circuits and technology, and I decided to lighten my load (and not for the last time) by getting rid of the 30-pound Norman packs and replacing them with Profoto electronic flash equipment.

With the increased efficiency of the lights and modifiers, I was able to cut my core lighting kit's weight in half without any decrease in performance. In fact, I gained greater control because each pack now had a rheostat to fine-tune power levels in addition to the switches that would throw each bank into half-power mode.

But what I really gained when I switched to the Profoto gear was a selection of light modifying accessories that mounted more easily to the heads and gave me a nicer looking light source. Additionally, every pack or monolight I bought came with the ability to click one switch and then be able to use these lights on European 220V systems or US 120V systems (you will have to switch out the modeling lights when switching between the two electrical standards). Now I could use my lights anywhere in the world!

Are more expensive lights magical? No! I've owned AlienBees and, given the same power output, there is nothing I can do with the Profotos that I could not also do with the AlienBees. But the important caveat is that at some point the AlienBees run out of power.

The more expensive lights are very well built, but Paul Buff, the owner of AlienBees, makes the point that the Lexan plastic he uses in his lights is incredibly strong and resilient. If I traveled all the time in the United States, I would probably settle on the Alien-Bees units because they are inexpensive enough to be nearly disposable if mistreated by baggage handlers. In

the studio, the Profotos are likely to outlast most competitors' models by dint of their robust (but relatively heavy) construction.

Are AlienBees and Profotos the only brands of studio flash to consider? Hardly. Every city will have its own take on flash equipment based on what the local dealers carry and what the top pros use. One of my competitors has a rack full of 2400 watt-second Speedotron Black Line strobes that he feels are indestructible and elegant. Another editorial shooter swears by the same models of Norman flashes that I used to have.

I have several friends on the East Coast who swear by the Swiss brand Broncolor, and an equal number of friends on the West Coast use the Japanese brand Comet. You like what you get used to and you learn to like what works. A really valuable part of assisting photographers before you start your own studio is the opportunity to work with lots of different brands of lights. If you use five or six different systems through the course of a year, you'll get a really good sense of the ones that seem to make sense for you.

There is a tendency now toward asking questions about brands on web forums and then depending on anonymous posters' advice on various brands and models. I can't think of a less sensible way to proceed. In the first place, the professionals who have the most experience using the widest range of equipment are probably not attracted to the same forums that beginners are. So, essentially, the beginners are advising the beginners. If one person has a good experience and they are an exceptionally good writer with a fervor to spread the word, they can create an incredible buzz around a product line that may be mediocre in regular use. The brand's number one feature may be price.

You may find that good handling or better accessories trump price if you work with your gear five to seven days a week. Also be aware that most of the people who populate the photo gear forums come from occupations like information technology (computer guys) and may have day jobs as software engineers or system administrators. Their use of their gear may be constrained to weekend shoots with models, and they may not run up against the shortcomings in the gear that would really vex someone who used it forty or fifty hours a week.

Finally, if you are listening to the recommendations of amateurs, you might not get realistic information about reliability and cost of ownership. These folks

Photo—Portrait of Bob Davis, former CEO of USAA Insurance Company. Shot for an annual report. The lighting must match the subject. This image makes use of multiple softboxes. **Diagram**—(1) Small softbox at low power provides highlight and fill for background. (2) 333 watt-second monolight with standard head fitted with a 20 degree grid. This was used to light the wall behind the subject. (3) Subject, Bob Davis. (4) Medium softbox used with 300 watt-second monolight, optically triggered. (5) Rollei 6008i with 150mm lens.

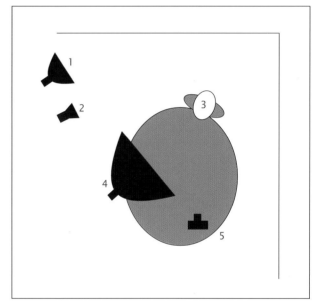

Left and right—I thought I'd throw in a couple preliminary ad comps from our Texas Gas Service shoot to show you how art directors end up using the photos.

aren't routinely putting their stuff on airplanes and flying around with it, nor are they working in industrial environments or the great outdoors with their gear. If you really want to get a sense for how a piece of gear will fit your shooting style, the best way is to rent it for a week and give it a thorough workout. See if you really need high power (if you are a portrait photographer, anything over 600 watt-seconds is going to be a waste, and getting the power down to a reasonable shooting level is going to be a nuisance).

A quick riff on deciding between umbrellas and softboxes: There always seems to be a lively debate going on somewhere on the web or in magazines about which light modifier is best. Here's the real answer: From a physics point of view, all that matters is the square footage of the light-emitting surface and the distance from the light-emitting surface to the subject. The light from a 6-foot-wide umbrella and a 6x6-foot softbox will look very much the same if you put them each in the same position and at the same dis-

tance from the subject. Go with the one that fits your needs.

So many of these arguments are cooked up to sell products to people who are insecure in their knowledge of photography. Don't be the kind of photographer who looks at a DVD presentation by a photographer who has long since stopped working for real clients and is now little more than a shill for photographic equipment manufacturers. Get all the way back to the physics of photography and make your choices based on the way you like to look at things.

Here's a sad but true story: There is a professional photographer who worked for many big-name clients such as *National Geographic, The New York Times,* and others. He was featured in a few catalogs for a Japanese camera manufacturer, and this got him a lot of media play. He started teaching workshops about lighting and photography. When the small light craze hit about three years ago, fueled partly by the Nikon CLS flash system, this photographer was sitting on a

public relations gold mine, which he proceeded to harvest. Last year, he did a demonstration overpowering the sun with a dozen or so Nikon SB-800 flashes (figure that twelve of these flashes would run about $4800 for a regular customer). It was the height of silliness as one Profoto Acute 600b battery-powered flash at closer to $2000 could have provided the same light. But many amateurs looked to his example and took it as a bold new style. They are piecing together inefficient systems with much potential for failure instead of buying the lights that are right for them, and they are doing it with total disregard for the reality that this photographer is paid by the manufacturer and probably gets the lights from them at no cost! Ah, the continuing folly of the Internet education model.

The bottom line is to understand that everyone has a different style and everyone's tools will, out of necessity, be different and widely varied. Using the same lights as a photo superstar doesn't mean that his or her style will be conveyed to you. Using the same beauty dish will not make up for the lack of a professional model and makeup person. Using the same spotlight will not make you the next George Hurrell, and using an Octabank won't get you in the same league as Annie Leibovitz. To really be successful and to have fun with photography in the long run, you need to invent or find the style of lighting that really resonates with you and continue to hone it for years to come.

So, how do you find a style? Look to naturally occurring light and see what kind of light really appeals

Above—Everything always looks weirder from the back of the set.

to you, then apply your knowledge about different modifiers and light sources and figure out how you can replicate that sort of light. Then spend months and years lighting and shooting and fine tuning until one day people say, "I saw a photograph of yours at XXXXXX the other day. I could tell it was yours because I recognized the style!"

In a nutshell, that's what all of this is about.

THE BEST AND THE WORST
Here's my top-ten list of lighting equipment I love and would hate to live without:

1. Profoto Acute 600b battery-operated electronic flash. Now I can shoot with a big softbox anywhere!
2. Black Manfrotto Century stand with grip head and arm. This will hold any light with security and grace.
3. Sekonic flash meter. You can shoot and chimp, shoot and chimp, etc., or just take one meter reading.
4. Calumet 54x72-inch, low-profile softbox. Soft with perfect transition to shadows.
5. Lastolite 82-inch white umbrella with black backing and front diffusion panel. Gorgeous on faces.
6. Bag full of 15-foot sync cords for my Profoto lights. The flash photographer's security blanket.
7. Set gloves. For handling hot lights and accessories and background paper.
8. Twenty-pound sandbags. These anchor my world, safely.
9. Nikon SB-800 camera flash. The ultimate mini flash.
10. Desisti 300-watt tungsten, fresnel spotlight. It's perfect when you need that little spot of light plugged in 20 feet away.

Here is my top-five list of annoying lighting styles:

1. Anything with a bright, white rim light.
2. Lighting that is not motivated by any light found in nature.

3. Hard light on soft faces.
4. Portraits lit by two lights of the same power at 45 degree angles to the subject on both sides (ugly, flat with shadows).
5. Portraits with overly dramatic kicker lights.

Here is my very short list of the best lighters I've seen:

1. Natural light: Wyatt McSpadden
2. Dramatic portraits: Albert Watson
3. Beauty portraits: Victor Skrebneski
4. Fashion: Nick Knight
5. Black & white portraiture: Irving Penn

Trial and error goes a long way in the learning process, but you will do better if you have some guides along the way. The best I've experienced are books. Start out with basic books on lighting by well-respected writers. I remember reading *Photography* by Henry Horenstein and Russel Hart (published by Prentice Hall and now available in a revised edition) that helped me understand the basic building blocks of photography. Once you've got the very basics down, it's time to start reading about the specialities you are most interested in. I love portraits, so I naturally gravitated to Chris Grey's *Master Lighting Guide for Portrait Photographers* (Amherst Media). If I were interested in lighting as it relates to weddings, I'd get Steve Sint's book, *Wedding Photography: Art, Business & Style* (Lark Books, 2005). If you want to know more about studio work, you could do worse than getting my second book, *Minimalist Lighting: Professional Techniques for Studio Photography* (Amherst Media). You could amass a good collection of these books and refer to them on the bus, on a plane, or at a coffee shop for far less than the price of one very specific and very tangential DVD.

Read more. Read fast and play with the lights. That's the best way to learn.

INDEX

MINIMALIST LIGHTING
PROFESSIONAL TECHNIQUES FOR
STUDIO PHOTOGRAPHY

Kirk Tuck

Learn how technological advances have made it easy and inexpensive to set up your own studio for portrait photography, commercial photography, and more. $34.95 list, 8.5x11, 128p, 190 color images and diagrams, index, order no. 1880.

MINIMALIST LIGHTING
PROFESSIONAL TECHNIQUES FOR
LOCATION PHOTOGRAPHY

Kirk Tuck

Use small, computerized, battery-operated flash units and lightweight accessories to get the top-quality results you want on location! $34.95 list, 8.5x11, 128p, 175 color images and diagrams, index, order no. 1860.

COMMERCIAL
PHOTOGRAPHY HANDBOOK
BUSINESS TECHNIQUES
FOR PROFESSIONAL DIGITAL PHOTOGRAPHERS

Kirk Tuck

Learn how to identify, market to, and satisfy your target markets—and make important financial decisions to maximize profits. $34.95 list, 8.5x11, 128p, 110 color images, index, order no. 1890.

ILLUSTRATED DICTIONARY
OF PHOTOGRAPHY

Barbara A. Lynch-Johnt & Michelle Perkins

Gain insight into camera and lighting equipment, accessories, technological advances, film and historic processes, famous photographers, artistic movements, and more with the concise descriptions in this illustrated book. $34.95 list, 8.5x11, 144p, 150 color images, order no. 1857.

EXISTING LIGHT
TECHNIQUES FOR WEDDING AND
PORTRAIT PHOTOGRAPHY

Bill Hurter

Learn to work with window light, make the most of outdoor light, and use fluorescent and incandescent light to best effect. $34.95 list, 8.5x11, 128p, 150 color photos, index, order no. 1858.

SCULPTING WITH LIGHT

Allison Earnest

Learn how to design the lighting effect that will best flatter your subject. Studio and location lighting setups are covered in detail with an assortment of helpful variations provided for each shot. $34.95 list, 8.5x11, 128p, 175 color images, diagrams, index, order no. 1867.

STEP-BY-STEP WEDDING
PHOTOGRAPHY

Damon Tucci

Deliver the top-quality images that your clients demand with the tips in this essential book. Tucci shows you how to become more creative, more efficient, and more successful. $34.95 list, 8.5x11, 128p, 175 color images, index, order no. 1868.

THE ART OF CHILDREN'S
PORTRAIT PHOTOGRAPHY

Tamara Lackey

Learn how to create images that are focused on emotion, relationships, and storytelling. Lackey shows you how to engage children, conduct fun and efficient sessions, and deliver images that parents will cherish. $34.95 list, 8.5x11, 128p, 240 color images, index, order no. 1870.

50 LIGHTING SETUPS FOR
PORTRAIT PHOTOGRAPHERS

Steven H. Begleiter

Filled with unique portraits and lighting diagrams, plus the "recipe" for creating each one, this book is an indispensible resource you'll rely on for a wide range of portrait situations and subjects. $34.95 list, 8.5x11, 128p, 150 color images and diagrams, index, order no. 1872.

DOUG BOX'S
GUIDE TO POSING
FOR PORTRAIT PHOTOGRAPHERS

Based on Doug Box's popular workshops for professional photographers, this visually intensive book allows you to quickly master the skills needed to pose men, women, children, and groups. $34.95 list, 8.5x11, 128p, 200 color images, index, order no. 1878.

500 POSES FOR PHOTOGRAPHING WOMEN

Michelle Perkins

A vast assortment of inspiring images, from head-and-shoulders to full-length portraits, and classic to contemporary styles—perfect for when you need a little shot of inspiration to create a new pose. $34.95 list, 8.5x11, 128p, 500 color images, order no. 1879.

MASTER POSING GUIDE FOR WEDDING PHOTOGRAPHERS

Bill Hurter

Learn a balanced approach to wedding posing and create images that make your clients look their very best while still reflecting the spontaneity and joy of the event. $34.95 list, 8.5x11, 128p, 180 color images and diagrams, index, order no. 1881.

ELLIE VAYO'S GUIDE TO
BOUDOIR PHOTOGRAPHY

Learn how to create flattering, sensual images that women will love as gifts for their significant others or keepsakes for themselves. Covers everything you need to know—from getting clients in the door, to running a succesful session, to making a big sale. $34.95 list, 8.5x11, 128p, 180 color images, order no. 1882.

MASTER GUIDE FOR
PHOTOGRAPHING HIGH SCHOOL SENIORS

Dave, Jean, and J. D. Wacker

Learn how to stay at the top of the ever-changing senior portrait market with these techniques for success. $34.95 list, 8.5x11, 128p, 270 color images, index, order no. 1883.

JEFF SMITH'S GUIDE TO
HEAD AND SHOULDERS PORTRAIT PHOTOGRAPHY

Jeff Smith shows you how to make head and shoulders portraits a more creative and lucrative part of your business—whether in the studio or on location. $34.95 list, 8.5x11, 128p, 200 color images, index, order no. 1886.

THE PHOTOGRAPHER'S GUIDE TO
MAKING MONEY

150 IDEAS FOR CUTTING COSTS AND BOOSTING PROFITS

Karen Dórame

Learn how to reduce overhead, improve marketing, and increase your studio's overall profitability. $34.95 list, 8.5x11, 128p, 200 color images, index, order no. 1887.

ON-CAMERA FLASH

TECHNIQUES FOR DIGITAL WEDDING AND PORTRAIT PHOTOGRAPHY

Neil van Niekerk

Discover how you can use on-camera flash to create soft, flawless lighting that flatters your subjects—and doesn't slow you down on location shoots. $34.95 list, 8.5x11, 128p, 190 color images, index, order no. 1888.

LIGHTING TECHNIQUES

FOR PHOTOGRAPHING MODEL PORTFOLIOS

Billy Pegram

Learn how to light images that will get you—and your model—noticed. Pegram provides start-to-finish analysis of real-life sessions, showing you how to make the right decisions each step of the way. $34.95 list, 8.5x11, 128p, 150 color images, index, order no. 1889.

CREATIVE WEDDING ALBUM DESIGN WITH ADOBE® PHOTOSHOP®

Mark Chen

Master the skills you need to design wedding albums that will elevate your studio above the competition. $34.95 list, 8.5x11, 128p, 225 color images, index, order no. 1891.

CHRISTOPHER GREY'S **STUDIO LIGHTING TECHNIQUES FOR PHOTOGRAPHY**

Grey takes the intimidation out of studio lighting with techniques that can be emulated and refined to suit your style. With these strategies—and some practice—you'll approach your sessions with confidence! $34.95 list, 8.5x11, 128p, 320 color images, index, order no. 1892.

THE BEGINNER'S GUIDE TO PHOTOGRAPHING NUDES

Peter Bilous

Peter Bilous puts you on the path to success in this fundamental art form, covering every aspect of finding models, planning and executing a successful session, and getting your images out into the world. $34.95 list, 8.5x11, 128p, 200 color/b&w images, index, order no. 1893.

PORTRAIT LIGHTING FOR DIGITAL PHOTOGRAPHERS

Stephen Dantzig

Dantzig covers the basics and beyond, showing you the hows and whys of portrait lighting and providing demonstrations to make learning easy. Advanced techniques are also included, allowing you to enhance your work. $34.95 list, 8.5x11, 128p, 230 color images, index, order no. 1894.

FREELANCE PHOTOGRAPHER'S HANDBOOK, 2nd Ed.

Cliff and Nancy Hollenbeck

The Hollenbecks show you the ins and outs of this challenging field. From to starting a small business, to delivering images, you'll learn what you need to know to succeed. $34.95 list, 8.5x11, 128p, 100 color images, index, order no. 1895.

JEFF SMITH'S SENIOR PORTRAIT PHOTOGRAPHY HANDBOOK

Improve your images and profitability through better design, market analysis, and business practices. This book charts a clear path to success, ensuring you're maximizing every sale you make. $34.95 list, 8.5x11, 128p, 170 color images, index, order no. 1896.

JERRY D'S EXTREME MAKEOVER TECHNIQUES FOR DIGITAL GLAMOUR PHOTOGRAPHY

Bill Hurter

Rangefinder editor Bill Hurter teams up with acclaimed photographer Jerry D, revealing the secrets of creating glamour images that bring out the very best in every woman. $34.95 list, 8.5x11, 128p, 270 color images, index, order no. 1897.

PROFESSIONAL COMMERCIAL PHOTOGRAPHY

Lou Jacobs Jr.

Insights from ten top commercial photographers make reading this book like taking ten master classes—without having to leave the comfort of your living room! $34.95 list, 8.5x11, 128p, 160 color images, index, order no. 2006.

PROFESSIONAL DIGITAL TECHNIQUES FOR PHOTOGRAPHING BAR AND BAT MITZVAHS

Stan Turkel

Learn the important shots to get—from the synagogue, to the party, to family portraits—and the symbolism of each phase of the ceremony and celebration. $34.95 list, 8.5x11, 128p, 140 color images, index, order no. 1898.

500 POSES FOR PHOTOGRAPHING BRIDES

Michelle Perkins

Filled with images by some of the world's most accomplished wedding photographers, this book can provide the inspiration you need to spice up your posing or refine your techniques. $34.95 list, 8.5x11, 128p, 500 color images, index, order no. 1909.

THE BEST OF WEDDING PHOTOJOURNALISM, 2nd Ed.

Bill Hurter

From the pre-wedding preparations to the ceremony and reception, you'll see how professionals identify the fleeting moments that will make truly memorable images and capture them in an instant. $34.95 list, 8.5x11, 128p, 150 color images, index, order no. 1910.

THE BEGINNER'S GUIDE TO UNDERWATER DIGITAL PHOTOGRAPHY

Larry Gates

Written for the "regular guy" photographer, this book shows you how to make smart technical and creative decisions—and get great results without breaking the bank. $34.95 list, 8.5x11, 128p, 160 color images, index, order no. 1911.

ADVANCED WEDDING PHOTOJOURNALISM

Tracy Dorr

Tracy Dorr charts a path to a new creative mindset, showing you how to get better tuned in to a wedding's events and participants so you're poised to capture outstanding, emotional images. $34.95 list, 8.5x11, 128p, 200 color images, index, order no. 1915.